THE CHARLES M. RUSSELL BOOK

by HAROLD McCRACKEN, Litt. D.

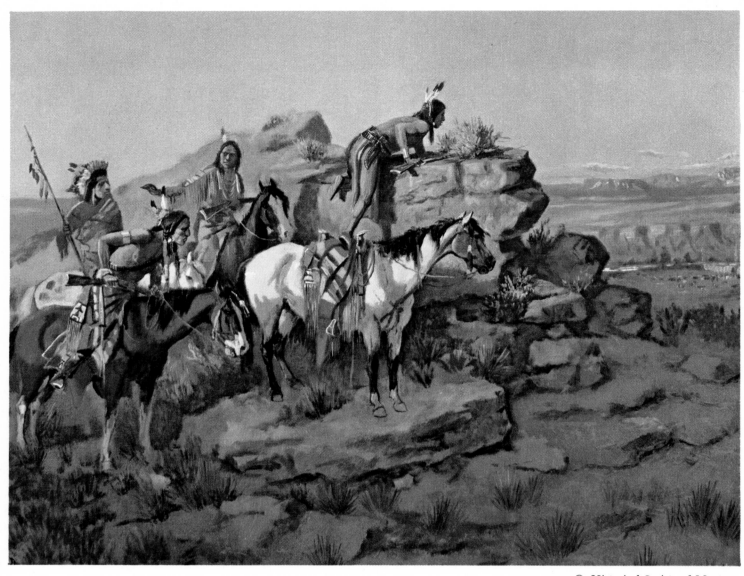

WATCHING THE SETTLERS

The Charles M. Russell Book

THE LIFE AND WORK OF
THE COWBOY ARTIST

By

Harold McCracken

GARDEN CITY, N.Y.

Doubleday & Company, Inc.

ACKNOWLEDGMENTS

THIS WRITER wishes to pay acknowledgment to the long list of those whose assistance and co-operation have made possible the preparing of this book. Foremost among these is the Historical Society of Montana; director Dr. K. Ross Toole, and chief librarian, Miss Virginia Walton, whose tireless delving into their great wealth of material on the subject has been most valuable; and Michael Kennedy—all of whom read and checked the manuscript before it went to the printers. I wish to thank the Trigg–C. M. Russell Foundation of Great Falls, particularly William H. Bertsche, Jr., and Lee M. Ford. Thanks are due too to Frederick G. Renner, for his assistance regarding the works of Charles M. Russell; A. V. Cheney, who rode the range with the cowboy artist; the estate of Nancy C. Russell; Mary Joan Boyer; the Missouri Historical Society; E. Walter Latendorf; George E. Mushbach; William Davidson; Richard W. Norton, Jr.; David B. Findlay; Walstein C. Findlay, Jr.; Newhouse Galleries; James Graham and Sons; Kennedy Galleries; Mark H. Brown; Clarkson Potter; the Amon G. Carter Foundation; Isabel Russell Wenneis; Robert M. McBride Company; The Leader Company; Hammer Galleries; my late son, H. Conrad McCracken, who began the collecting of the material which resulted in this work; and the many others whose assistance has been so valuable in the assembling of both pictures and text for this memorial to the cowboy artist.

HAROLD MCCRACKEN

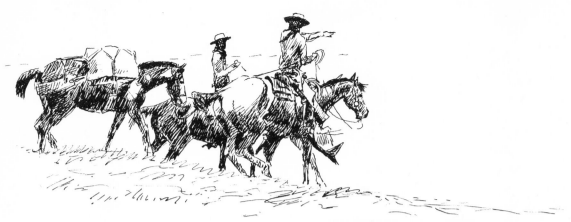

CONTENTS

ILLUSTRATIONS

Color

Black and White

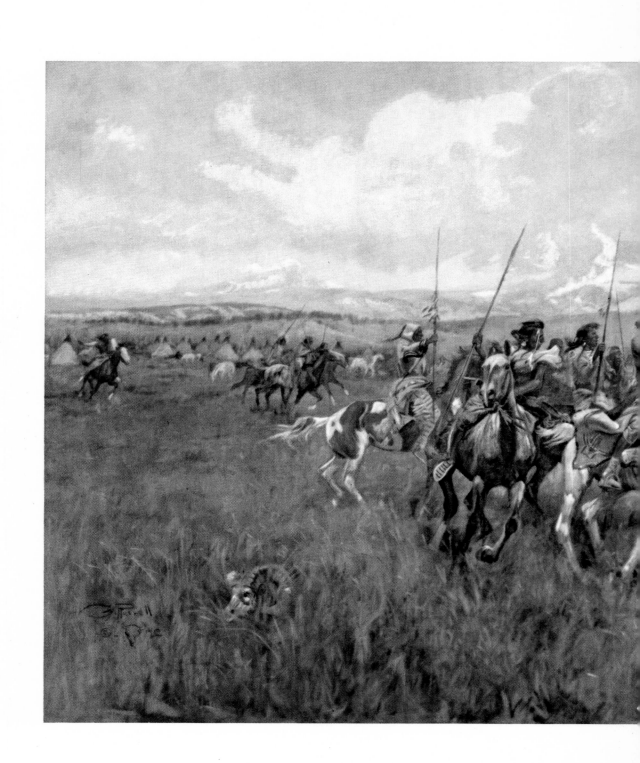

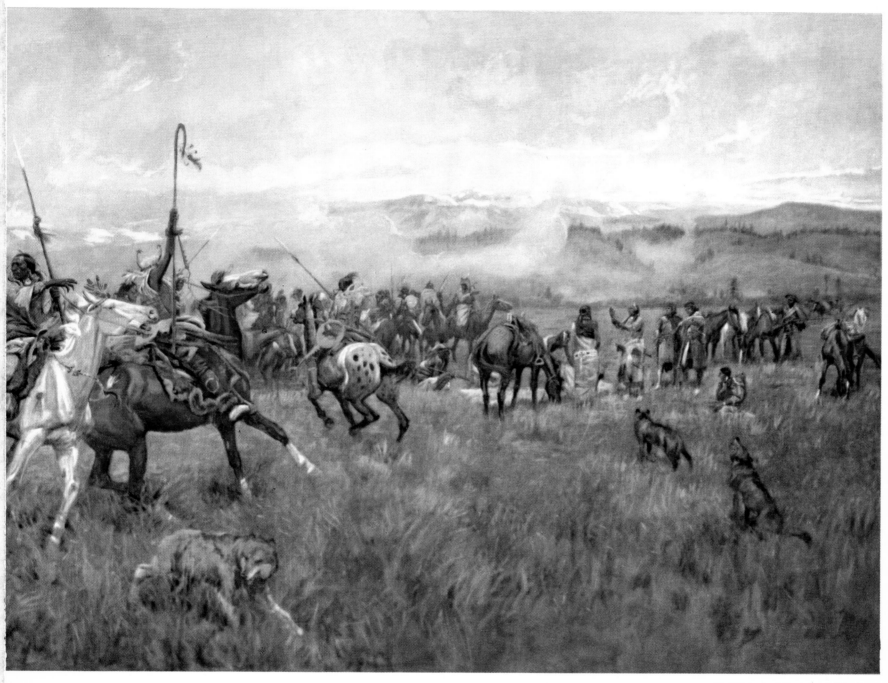

LEWIS AND CLARK MEETING THE FLATHEAD INDIANS

THE CHARLES M. RUSSELL BOOK

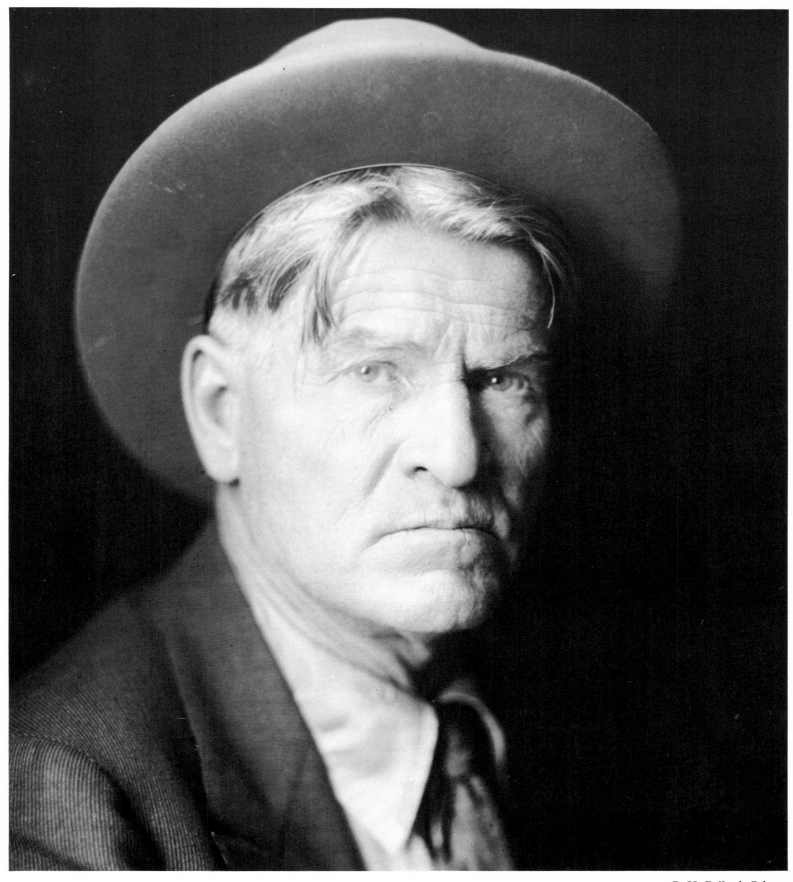

CHARLES MARION RUSSELL

THEY'RE ALL PLUMB HOG WILD

CHAPTER I

A Paradox in Chaps

CHARLES MARION RUSSELL was a cowboy. He was as rough and wild as any of the old-time Montana buckaroos with whom he lived and traveled from the time he was sixteen years old. No one knew cowboy life more intimately, or was better qualified to record the dramatic era of frontier history in which he played a part. Yet no one ever pursued a more contradictory or unorthodox career.

"We all knew Charlie as 'Kid Russell' back in those days..." reminisced a lean old rawhide who had once shared chuck-wagon grub and followed cattle drives with the eccentric young painter. Nearly seventy years had passed since "those days" and there were very few of the old-timers left. But this one, Kid Amby, remembered well, for he had never left the old range that was once the buffalo prairie. "The first time I worked with Charlie Russell was on the Judith roundup, or rather the Judith Basin Pool, over at old Utica," he said. "I was just a kid, but Charlie was the sort of character you don't forget. He was the queerest sort of cowboy I'd ever seen. A homely, awkward cuss—all his clothes looked like they'd been junked by some reservation half-breed. Even his face looked like he had some Injun blood in him. A big brimmed hat didn't have any crown or shape to it—like he'd slept in it many a rainy night on the range. His leather pants had seen the last of their second-best days—one leg tucked in a boot and the other hangin' out like a squaw's dress. At first I figured he was just a no-good drifter who'd dropped in for a free feed—but it didn't take long to see that he was really one of the bunch and stood damn well with the best of 'em."

But was this character of the cow country all that one naturally thinks of as a rough-riding cowpuncher? When pressed to give an opinion, Kid Amby hedged a bit and then answered frankly: "He was no roughrider at all. Charlie was always afoot in the saddle, when it came to real cowpunching." Then Kid Amby quickly added, with a sparkle coming into his grayed eyes and a smile spreading over his wrinkled face: "But don't get me wrong —he was one of the swellest guys I ever knew. Everybody liked Kid Russell. Sure, he wasn't even a good night-herder. About all he could do was tell stories and make little sketches of the funny things that happened. We'd hurry in at night, just to listen to his yarns and laugh

13

Historical Society of Montana

A BAD DAY AT SQUARE DEAL DAN'S

at the pictures he drew. Nobody ever thought he'd amount to anything. But Charlie had *lots* of friends. And there wasn't a cattle outfit, big or small, that wouldn't hire him. He helped to keep us happy.''

Later in the conversation, which took place in the little parlor of his modest home in the old Montana cow town of Stanford, Kid Amby made a slight correction. While his wife was out of the room, he said, chuckling, "There was *one* time when Charlie could ride like hell. That was when we came to town, to have a few drinks, and—to see the girls. There was nobody in the outfit that could beat Kid Russell to the front door of the hottest place in town.''

A ragged jester and good fellow of the roundup camp, Charlie Russell lived and loved the life of the toughest profession of the early pioneer era in the West. Fate cast him in the incongruous role of artist and poet—a role forced upon him by some inescapable destiny and which for a good many years he seems not to have taken quite seriously. Self-taught, unschooled, and entirely unorthodox in almost every respect, he was to become one of the most distinguished personalities in the field of western documentary art. Certainly no other painter has had a more devoted legion of serious admirers, past and present, in high places and low.

Even when Russell achieved recognition and acclaim, however, the rough outward manifestations of his earlier days were never quite polished away. He continued to wear the old

brand marks with pride, and he remained steadfast to the old traditions and to his old friends
—cowpokes, bullwhackers, bartenders, Indians, preachers, and the horses he had ridden. He
was deeply devoted to the ways of the Old West before the white man's civilization was
imposed upon it. To this idealism was joined a homespun philosophy; a poetic expressive-
ness that penetrated far below the surface of things; a darting wit that tickled but never
stung; a charity for all mankind, deep as the Montana basins he had known and broad as
the unfenced prairies he had ridden. His subject was the bygone days of that Old West—
in all their drama, pathos, tragedy, and humor—and he was a storyteller, through the me-
diums of documentary art and literary poesy.

"You marvelled that one man could possess in such degree two gifts so closely related
and yet so wide apart," wrote Irvin S. Cobb, the humorist.[1] "I valued his friendship as one
of the biggest things that ever came into my life... The world is finding out what some
found out while he was alive—that Charlie Russell was one of the greatest creative crafts-
men of his race and times."

He was by nature extremely reticent, modest, and insular; but there was something
about this rough cowboy artist that drew men into his friendship. It happened in the old
days of roughneck saints and sinners, both whites and blanket Indians, and it happened later
with the eminent individuals he met. "My brother," he would say, "when you come to my
lodge, the robe will be spread and the pipe will be lit."

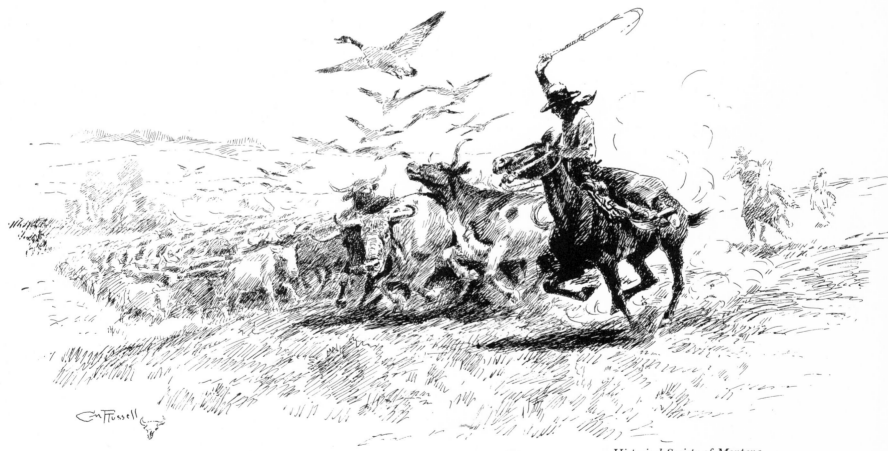

Historical Society of Montana

STAMPEDED BY WILD GEESE

"He wasn't just 'Another Artist'. He wasn't 'just another' anything," wrote Will Rogers.[2] "In nothing that he ever did was he 'just another . . .' He was a great Philosopher. He was a great Humorist. He had a great underlying spiritual feeling, not the ordinary customs and habits that are supposed to mark 'What the well-dressed Christian is wearing this season,' but a great sympathy and understanding for the man of the world, be he 'Injun' or White. . . He didn't think a 'paved street' made a better Town. . . In people, he loved Human Nature. In stories, he loved Human interest . . . He not only left us great living Pictures of what our West was, but he left us an example of how to live in friendship with all mankind."

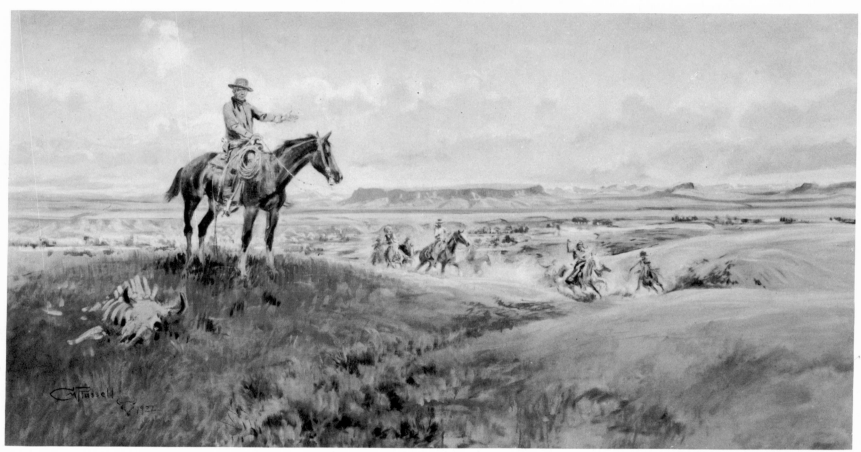

© *Historical Society of Montana*

CHARLIE RUSSELL AND HIS FRIENDS

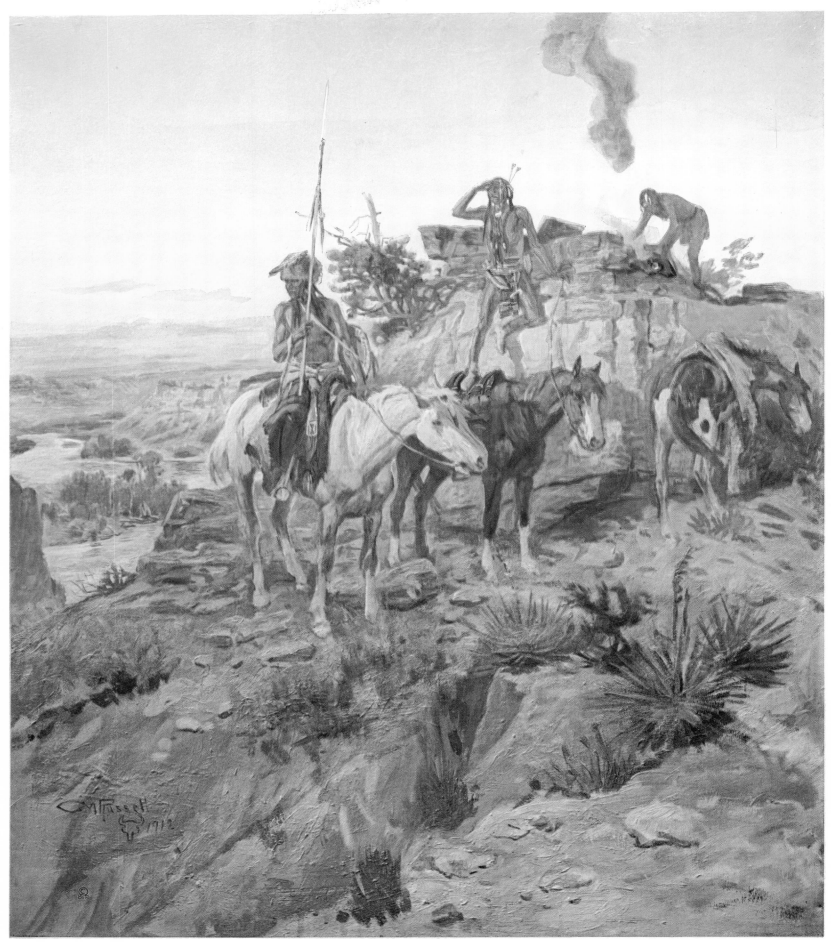

SIGNAL FIRE

UGHT WITH THE GOODS

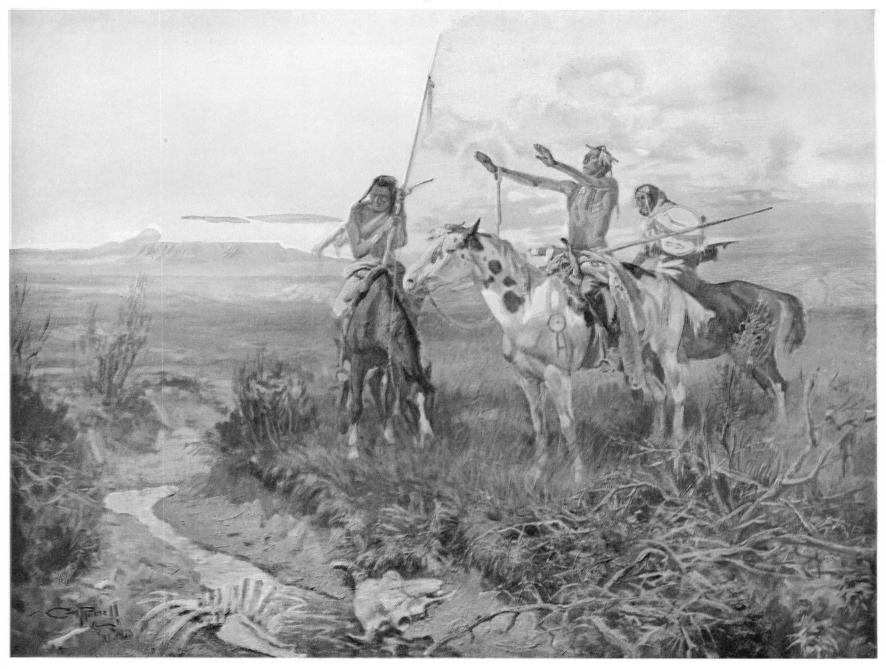

SUN WORSHIPERS

CHAPTER II

When Adventure Calls

THE INDIAN OF THE PLAINS AS HE WAS

IT WAS in St. Louis, Missouri, on March 19, 1864, that twenty-nine-year-old Mary Elizabeth Mead Russell presented her husband, Charles Silas Russell, with a son who was to become known as "the cowboy artist." Born in the fifth year of a long and happy marriage, he was the third of six children. He already had a little brother and sister, Bent and Sue; and three more brothers, Edward, Guy, and Wolfert, were to follow. This second son was named Charles, after his father, although the family soon nicknamed him "Chaz" to avoid confusion.

It is unfortunate that Charlie Russell left so little of an autobiographical nature from which to reconstruct the story of his life. There has been a considerable amount of contradiction and misinformation in what others have reported and written about him. Even the date of his birth has been widely misquoted. In a brief and extremely cursory account of his own life in *Outing Magazine* for December 1904, Russell himself stated: "I was born in St. Louis in 1865." This error was later corrected by his wife in her Biographical Note in the book *Good Medicine* and is substantiated by the Bureau of Vital Statistics of the City of St. Louis. It has been the purpose of the present writer to clarify as many such discrepancies as possible.

The Russell clan had been noted for large families. This branch of it sprung from one Joseph Russell, a plantation owner of Rockbridge County in the western part of colonial Virginia. He had ten sons and two daughters; and at an early date the family moved to eastern Tennessee, from whence three of the boys—William, Joseph, and James—moved on westward to help make history in and around St. Louis. About 1805, William became the owner of a 432-acre tract of land in the Oak Hill sector at the southwest edge of St. Louis. James Russell acquired this land from his brother about six years later, arriving there a widower after having wandered about for some time. It was James who became the leader and laid the foundation of the clan's fortunes in that section of the country. He was the grandfather of Charles M. Russell.

The family had become prosperous and prominent in industry and civic affairs in the

fast-growing metropolis at the gateway to the great West. The half-century-old estate in the Oak Hill suburb, where the cowboy artist spent his early boyhood, was strongly reminiscent of a colonial Virginia plantation. The large homestead and its nearby slaves' quarters were shaded by big oak and walnut trees and surrounded by flower beds, vegetable gardens, orchards, vineyards, lanes lined with Osage orange, and meadows with grazing cattle of fine breed.

The Russell family had operated the most extensive coal diggings in the region, supplying the city of St. Louis with an almost constant procession of slow-moving ox teams. After the coal bunkers had provided affluence for two generations, fire clay began to be mined on the extensive family lands. That was about 1860, and along with other business enterprises it led to an expansion into industrial properties of considerable proportions. Large plants were built to convert the fire clay into tiles and brick for the construction of blast furnaces, gas works, rolling mills, and the like throughout the country. The Parker-Russell Mining and Manufacturing Company soon became the largest firm of its kind in the country. But the manufacture of fire brick was only one phase of the little family industrial empire, which also included extensive fruit farms and vineyards, as well as the coal mines. As the enterprise developed, the management came to include the Parkers, who were members of the family by virtue of the marriage of George Ward Parker to James Russell's daughter Russella Lucy. The future cowboy artist's father was secretary of the Parker-Russell Fire-Brick Company, most important of the interfamily holdings, which at the time produced more than

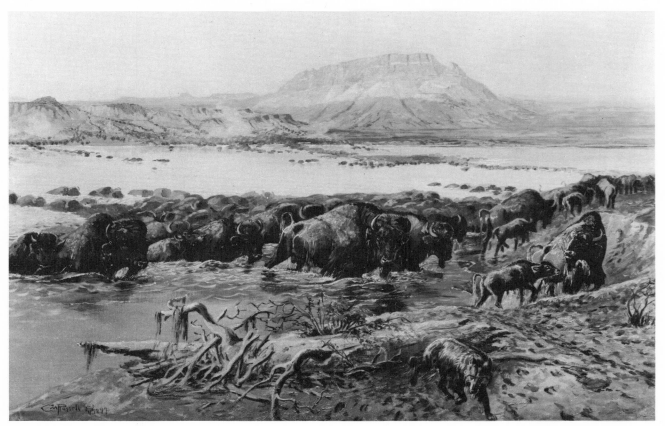

Findlay Galleries, N.Y.C.

BUFFALO CROSSING THE MISSOURI

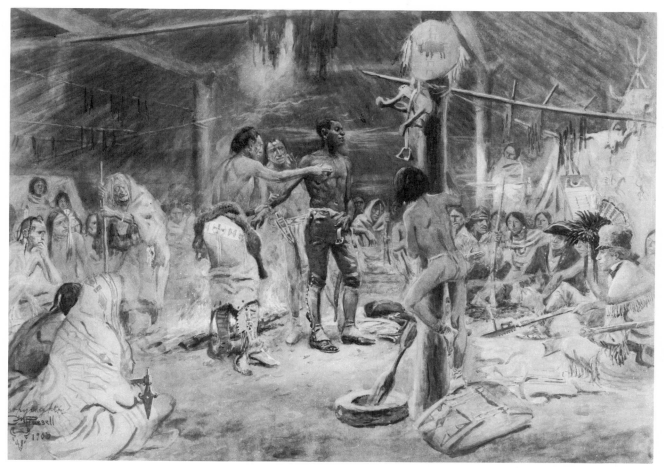

Historical Society of Montana

"YORK" IN THE LODGE OF THE MANDANS

half of all the fireproof retorts in the United States and Canada. Thus the lad's inheritance promised him a golden future. But fate had other plans for him.

There was extraordinary pioneer blood in little Charlie Russell's veins. James Russell, Charlie's grandfather, married into a famous frontier family. The St. Louis *Missouri Republican* for October 5, 1826, records the event as follows: "MARRIED – on Friday evening last, by Rev. Mr. Giddings, JAMES RUSSELL, Esq. of Cape Girardeau, to Miss Lucy, eldest daughter of Silas Bent, Esq." Most references to the marriage connections between the prominent Russell and Bent families erroneously state that Lucy Bent became the wife of Joseph Russell. This mistake is made in the genealogy *The Bent Family in America* (Boston: 1900), and it is probably from that source that most writers have copied the misleading information. It was definitely James Russell who married Lucy Bent; this fact is further corroborated by the Missouri Historical Society and by an entry in a Russell family Bible.

Lucy Bent was twenty years younger than her husband when she became his second wife. It was after Lucy that their daughter was given her second name; and after Lucy's father that the future artist's father, Charles Silas Russell, received his middle name. Lucy had four brothers—Charles M. Russell's great-uncles—who made names for themselves out West. William, Charles, George, and Robert Bent were all engaged in the lucrative fur trade. George Bent had been active in the region which became the state of Montana. Brother

Charles had pioneered the Santa Fe trade; and he was appointed Governor of New Mexico Territory by General Stephen Watts Kearny in September 1846, although exactly four months later he was killed by the Pueblo Indians in an uprising at Taos. The most celebrated of the brothers was William Bent. In 1832 this famous frontiersman had built the first trading post on the Arkansas River and become the first permanent white settler of what is today the state of Colorado. In association with Ceran St. Vrain he shortly afterward built Bent's Fort, one of the most famous frontier trading posts in the Old West. The exciting exploits of these adventurous kinsmen could hardly fail to have had a dynamic influence upon any lad— particularly one with the proclivities of Charles Marion Russell. It was quite natural that "Uncle William" should become the hero of his boyish dreams.

Historical Society of Montana

THE FIRST WAGON TRAIN WEST

Maybe this had something to do with why Chaz loved to go galloping about on his little pony in wild-West fashion when he was barely old enough to hold on. In the recollections of members of the Russell clan, it is reported that he was frequently the dismay of the neighbors, as he rode about with total disregard for well-kept lawns and flower beds. He was equally notorious for his distaste for school and everything connected with it. A strong, sturdy lad—although short and stocky—he seems to have been born with a contrary and rather wild temperament. His heavy shock of dark blond hair was always tousled, and he was inclined to be untidy in his dress. His unkemptness is somewhat surprising in view of the fact that his mother was extremely fastidious; and his sturdy good health contrasts curiously with his mother's frailty and intermittent ill health. Chaz's father was a particularly mild man who believed that quiet counseling was a better means of training one's children than whipping them. The Russell home was a particularly sedate one, in which religious principles and cultural interests were emphasized.

During the time when Charlie was passing through his most impressionable years, in the 1870s, he was exposed to many other contagious influences. St. Louis was still rich with the memories of such other heroes as Lewis and Clark, Zeb Pike, Kit Carson, and many more like them; Buffalo Bill was fast becoming a national figure. The waterfront was alive as it

never had been before with all sorts of river craft coming and going, crowded with adventurers and loaded with supplies. Some of these adventurers were old-timers with well-worn buckskins and weathered countenances; but most of the travelers bound for the magic lands that sprawled out around the upper Missouri and its tributaries were young men making their first trip into great adventure. The incoming boats were heavily loaded with huge bales of buffalo hides and rich cargoes of furs, and brought back fresh news of bloody fights with Indians and of fortunes in virgin gold being dug out of little stream beds by hundreds of lucky men.

Among the warehouses were expanding wagon yards, harness shops, mule and horse barns, gunsmith shops, and supply houses for many new phases of pioneer development in the West. Employment offices with big signs lured men to help build the new railroad across the plains and through the mountains. The slogan "Go West young man!" was well known in every household. And there was a flood of "dime novels" to fan the flames among the young in heart. There had also appeared on the western scene a new type of individual who was completely capturing the public imagination. He was as virile, colorful, and distinctively dramatic as the scout, mountain man, or any of the earlier-day paragons of frontier knighthood. He was a little of all of them rolled together—Indian fighter, gun man, vigilante, and pioneer. This was the cowboy.

Dreams of adventure are as natural to most boys as the measles, only some have them more seriously and with more lasting effect than others. In such an environment and with such a natural susceptibility, what lad could have escaped infection? Before Charlie Russell came into his teens he began playing hooky from the Oak Hill School and spending more time around the waterfront and the horse barns. The rough characters there liked the lad and took time to answer his questions and tell him bits about the life far out where the river boats and wagon trains were destined to go.

JIM BRIDGER DISCOVERING GREAT SALT LAKE

Another thing about Charlie, he had a native artistic talent. Long before he was old enough to run away to the waterfront, he began spending a considerable amount of his time indoors at drawing and even modeling. According to the recollections of nephews and cousins, there was a great profusion of these boyish sketches. They showed the same singularity of interest which dominated the work of his later life—Indians, cowboys, bucking horses, and wild animals. His attempts at modeling have proved to be equally significant. Out of soap and large Missouri potatoes, raided from the family kitchen, Charlie carved likenesses of neighborhood characters, pets, and livestock. A number of his boyhood pictures and sketchbooks have been preserved by members of the Russell clan and by collectors of his work.

Although there is no evidence that Charlie received any assistance or guidance in his boyish artistic efforts, the drawings steadily improved and in the modeling he graduated to using clay from the family diggings. There is a family story that one of the most ambitious of his early attempts at sculpture was fashioned on a school slate for a base, when he was about twelve years old. Some versions say it depicted a cowboy on a horse, while others indicate that the rider was a jockey in the act of jumping a fence. But it seems to have made such a favorable impression that Charlie's father had a plaster cast made of it which was submitted to the County Fair. The entry is said to have won a blue ribbon—which, if true, was his earliest artistic recognition.

It was only natural for father and mother Russell to have definite plans for Charlie's future. A college education was a foregone conclusion, as was an executive position in the Parker-Russell enterprises, for the big plant was steadily prospering and expanding. The lad's obsession to be a wild-West cowboy was considered a phase, and his interest in drawing and modeling was not taken very seriously. That he had developed a marked aversion for everything connected with schools and teachers was accepted by his parents as one of their more grievous trials and tribulations. There was nothing really bad about the boy. Quite the contrary, he had an unusually good-natured disposition and was extremely devoted to his mother. The whole situation was taken as nothing more than a boyish propensity for dreaming about life in the wild and woolly West.

When Charlie was only thirteen he contrived a ruse by which he might spend more time around the waterfront and escape the penalties of playing hooky from school. With the aid of a chum, Archie Douglas, he composed a note stating that he was being sent to visit a relative; and with the carefully forged signature of his parent it was delivered to his teacher. Thereafter each morning for almost two months he started out for school as usual, but hid his books and spent the days in glorious freedom around the river docks and stables. When his father finally found out, Chaz refused to return home at all, and spent the nights as well as the days in the back streets and by-ways of the big waterfront, among the saloons and gambling houses, where it was easy for a runaway lad to find asylum. All the family's frantic efforts to locate him proved futile. He tried hard to get on one of the boats bound for the navigable end of the Upper Missouri; but being unsuccessful in this, and urged by some of the waterfront men to wait until he was a little older, he finally returned home. His parents were so relieved to have him back that the severe punishment they felt he deserved was restricted to the most earnest of parental supplications. But it was already too late to change him.

As the problem became more acute, and Charlie slipped further backward in his school-work, his mother and father decided that a military academy might be the solution and thereupon made arrangements for him to attend the Burlington Military Academy at Burlington, New Jersey. As a special inducement for him to apply himself seriously to the curriculum at the new school, he was promised a trip out West. This tempting reward was all that was needed to get him to go, but the ultimate results neither improved his grades, changed his attitude, nor in any way altered his determination.

There has recently come to light a boyhood sketchbook attributed to Charlie Russell during his brief stay at the Burlington Military Academy. After careful examination by Joe De Young, who worked in Russell's studio under his tutelage during the last ten years of the cowboy artist's life, it has been declared genuine.[1] The little book contains twenty-six crude drawings, all of cowboys, Indians, and the like, complete with horses, guns, and western background.

Returning home at the end of the first term at the academy, Charlie steadfastly refused to go back. More than ever he rebelled at all forms of personal restraint, even in such little matters as learning to spell. The seriousness of the situation was now plainly evident. To try to help matters, his father engaged a personal tutor, but this was wasted effort. Charlie was sent to a local art school, with the hope that it might prove to be an avenue of serious interest, but he had enough of this in a very few days. "Hell . . . they just tried to teach me to draw a straight line," he said about it a long time afterward.

Finally aware that their son was going to leave them and go West, either with or without their permission, Mr. and Mrs. Russell gave in. He was still only fifteen years old, but his father decided to make some plans for him. Perhaps, if he got a real dose of the rough life, he would be content to come back and settle down in a comfortable home and a secure future in the Parker-Russell enterprises.

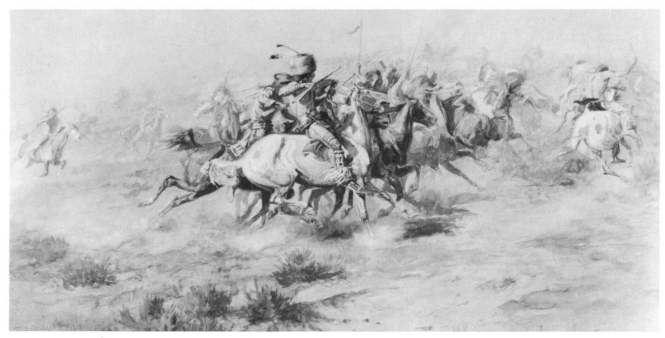

Newhouse Galleries, N.Y.C.

CUSTER'S LAST STAND

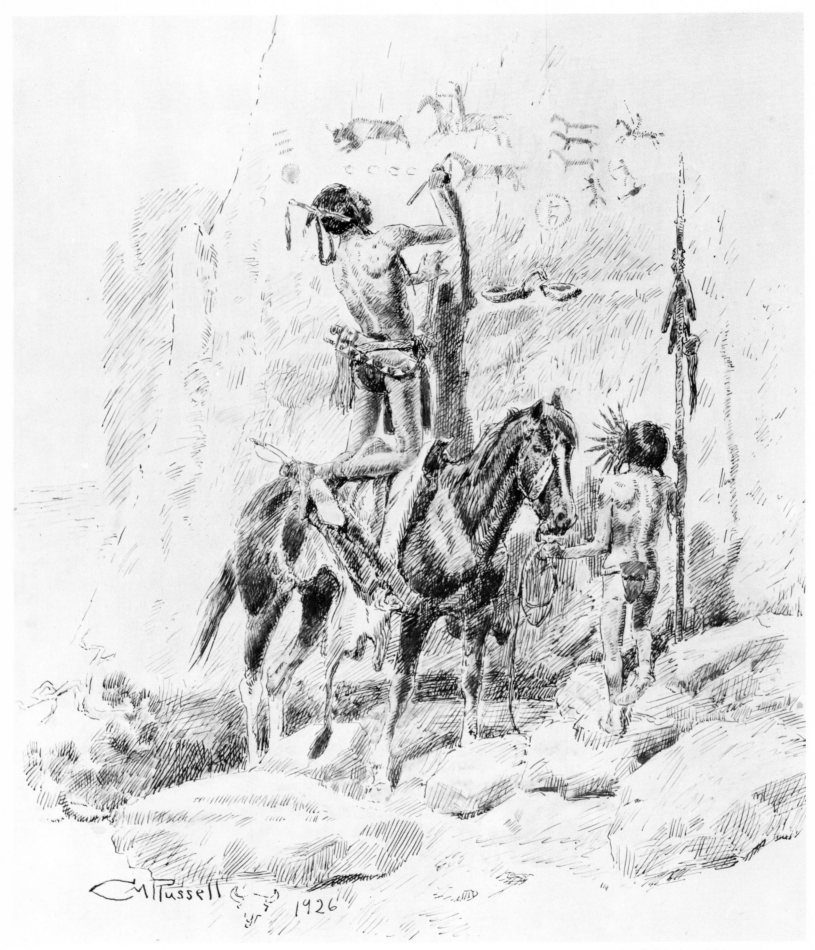

AMERICA'S FIRST PRINTER

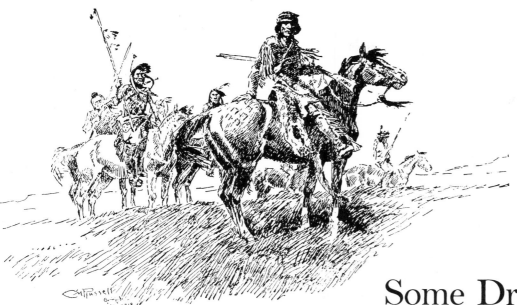

WATCHERS OF THE PLAINS

CHAPTER III

Some Dreams Come True

FIVE DAYS before his sixteenth birthday, in mid-March of 1880, Charlie Russell was given a wonderful present: his parents' permission to go on a trip West, including some definite plans. Hardly able to comprehend that all his hopes were suddenly to be realized, Charlie listened as his father unfolded the good news. A friend of the elder Russell had a son who was part owner of a ranch in Montana, and this young man was at the moment on a visit to St. Louis. His name was Wallis Miller and he went by the nickname of "Pike." Father Russell had discussed the possibilities of Charlie's going back with Pike, and in fact it had all been arranged. The one difficulty, however, was that the young rancher was leaving the next day. He was going by train, as far as possible, and then would journey by overland stage and then by horse and wagon. The newly established ranch was in a remote part of Montana, known as the Judith Basin, about two hundred miles from the town of Helena. It was a dangerous part of the country. There was trouble with the Indians and with white rustlers as well, who were stealing horses and endangering the lives of settlers. But still, this seemed to be an excellent opportunity and of course if Charlie really wanted to go . . .

It is doubtful whether anyone in the big Russell homestead slept very much that night. The excitement was naturally too great for Charlie. But his mother and father lay awake for different reasons. They must have had a fearful premonition that the parting on the morrow was to be much longer and more difficult to endure than their wishful thinking had led them to hope.

On March 15, according to plan, Charlie bid his parents farewell. The trip westward by train across the great plains and through the mountains in the early spring of 1880 was hardly as dramatic as making the journey by covered wagon, but it was a lot more comfortable and less apt to discourage a sixteen-year-old adventure seeker. The ornate "palace-cars" of the Union Pacific were the last word in transcontinental travel—a strange contrast with and bold intrusion into the land through which the train chugged and rattled at the phenomenal speed of almost twenty miles an hour, *day and night*! There was even a small hand-pumped organ in the "parlor car," where the exclusive first-class passengers might gather

with their crinoline ladies for a bit of sociability when it got too dark to look out the windows for Indians, cowboys, and possibly a real live buffalo. For the sum of $17 in greenbacks one could even engage a berth in which to sleep, all the way from St. Louis to San Francisco. There was also a "tourist class," restricted to less comfortable quarters in cars equipped with bare wooden seats and a large coal stove at one end where the travelers could make coffee and heat their own food. Here the passengers had to carry their own family bed rolls. The train made scheduled stops throughout the journey, for the passengers to get meals at advertised rates of 75 cents and $1.00. Greenbacks were used as far west as Salt Lake City, but beyond only silver or gold currency was generally acceptable.

There was romantic drama centered in those early-day trains. The passengers were a motley assortment from high strata and low—wealthy miners, landowners, fur men and cattlemen, returning to their frontier estates from visits in the East; army men, tin-horn gamblers, carpetbaggers, and prostitutes. Some had taken part in the exciting episodes of the old days and many others were speeding westward for the first time. Here was the tense atmosphere of the West without its bitter realities. It was an easy way to become chronically infected with the life of adventure.

At Ogden, Utah, Pike Miller and Charlie Russell had to leave the Union Pacific and

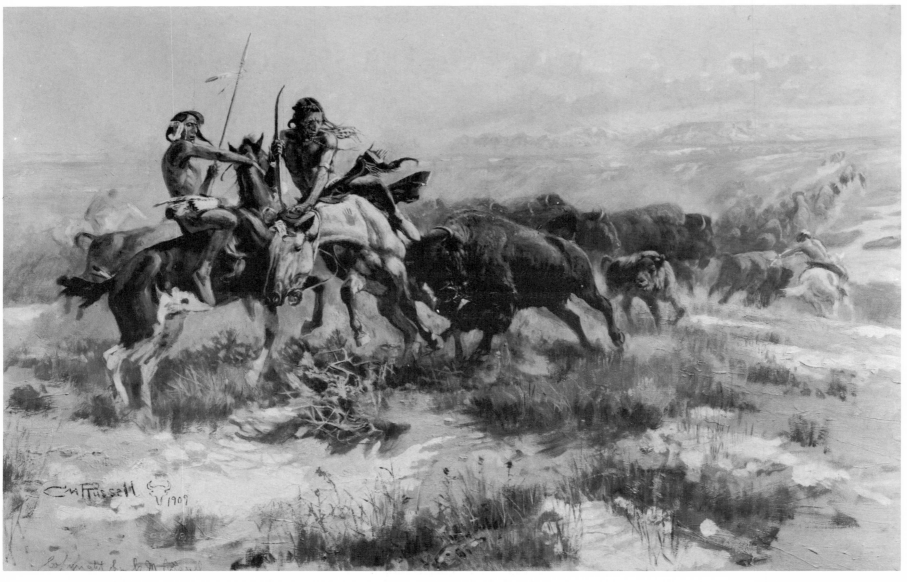

Newhouse Galleries, N.Y.C.

THE WOUNDED BUFFALO

change to the Utah Northern for the rest of the train trip, which took them northward across Idaho to the border of Montana Territory. The journey now became increasingly rough. The Utah Northern was a narrow-gauge railroad, with none of the comforts or conveniences of the swank Union Pacific. It was in the midst of a frantic construction program to reach the booming mining and cattle country of central Montana, racing with the Northern Pacific Railroad which was rapidly approaching the eastern border with the same objective. On January 1, 1880, advance construction of the Utah Northern had reached the continental divide at a place where it marked the southern boundary of Montana. The first iron rail was laid and the first spike officially driven within that Territory at 10 A.M. on March 9.[1] It was in that same month, when the first trains were wobbling their way barely across the border to the little construction town of Red Rock, that Charlie Russell first set foot in his adopted state.

The town of Helena was still more than 150 miles away. A stage was scheduled to leave each day, although the exigencies of weather and other circumstances beyond the control of men and horses frequently disrupted the planned departures. That spring was an unusually bad one, with sub-zero temperatures and lots of snow. One of the stage outfits had only recently become bogged down in a blizzard on the winding road through the mountains, and the passengers had narrowly escaped being frozen to death. There were other difficulties. The drivers and guards were always well armed, with six-guns and rifles, against the possibility of a holdup by the predatory fraternity of lawless road agents and itinerant outlaws which infested such routes of travel. Here was the beginning of a personal existence in which a gun, and a know-how in using it, was a man's best friend. Tenderfoots, or "pilgrims" as they sometimes were called, were wisely cautioned that it was not healthy to be arrogant or pugnacious when confronted with the salutation, "Put up your arms, you sons-a-b——s!"

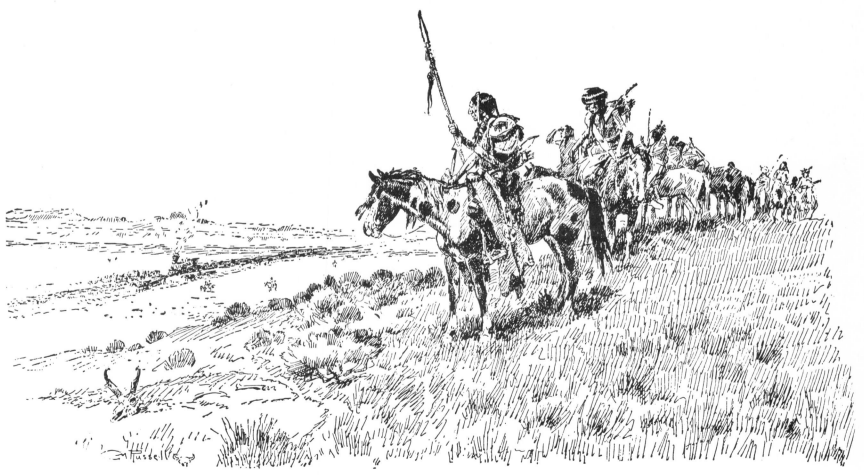

CHEYENNES WATCHING UNION PACIFIC TRACK LAYERS

Road agents were noted for itching trigger-fingers. They usually wore a pair of revolvers, supplemented by a double-barreled shotgun of large bore and loaded with buckshot. These accoutrements were not mere decorations. Their indiscriminate use was a serious profession of the men who stopped stages at unscheduled places.

The two young travelers from St. Louis reached Helena, however, without encountering anything extraordinary beyond the usual discomforts of cold and of constant bumping over a rough frozen road.

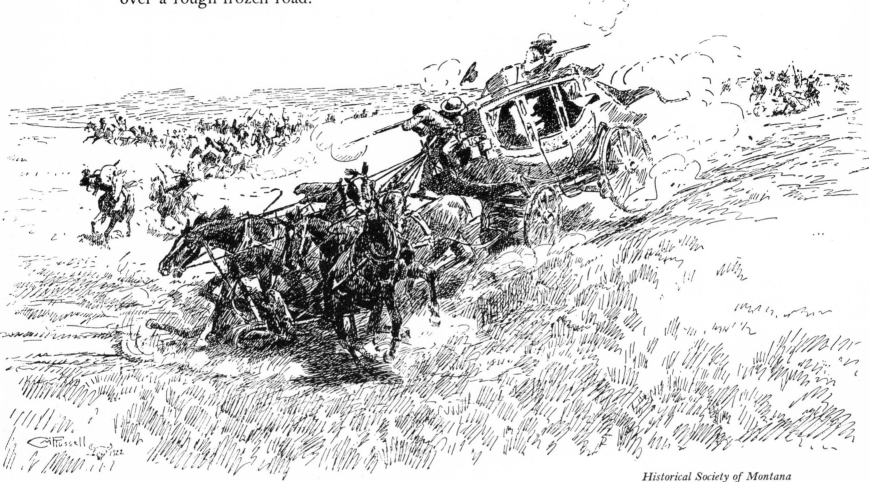

Historical Society of Montana

THE OVERLAND STAGE

When Charlie Russell first visited the town that was to become the capital city of the state of Montana, it was a sight for young eyes and emotions such as his. The town was already sixteen years old. In July 1864 a destitute party of overland fortuneseekers bound for the far Northwest had accidentally discovered gold in a stream bed which they named "Last Chance Gulch." The gold was found in such marvelous quantities that a sizeable camp quickly grew up along both sides of this gulch. Unlike many such places, after all the gold was dug it developed into a permanent settlement and the more dignified name of "Helena" was adopted. By 1880 it had a population of around 3,600—give or take a few hundred, from week to week, as the ever shifting populace came and went. Half a dozen or more times a day stagecoaches came rattling into town or out; and big wagon trains, pack trains, and groups of itinerant hombres on saddle horses were constantly coming and going.

Helena had become the thriving commercial and financial center of a broad section of the Northwest. Here were the headquarters of the rapidly developing cattle and sheep empires. The town's merchants were supplying about two-thirds of the various forms of merchandise consumed in all Montana Territory and much of Idaho. The town had several hotels, which were quite pretentious for a frontier community—among them the St. Louis and the International—with their broad piazzas and spacious dining rooms and lodging of advertised elegance at the rate of $2.00 per day. There were a couple of well-established banks, lots of saloons, and two newspapers. One of the latter, the *Weekly Herald*, in the issue of April 1, 1880, had an article expounding the rapid development taking place in the region. As supporting evidence it claimed that "Immigrants are coming into Montana at the rate of 75 a day." Yes, things were really booming on the old frontier.

Most exciting to young Russell were the individuals he saw jogging along on spirited saddle horses or wandering in and out of the saloons. Here were the men of his boyhood dreams, the flesh and blood of all the romantic stories he had heard and met on the pages of dime novels he had secretly read—weather-browned cowboys with worn leather chaps and six-guns strapped to their hips; bullwhackers; wagon bosses; buffalo hunters; long-haired adventurers with "a load of hay on their skulls" and the stains of tobacco juice in their whiskers; squaw-men in fancy moccasins; and frequently a blanket Indian with the stare of a hungry wolf in his eyes. Long before, Charlie had made up his mind that these were to be

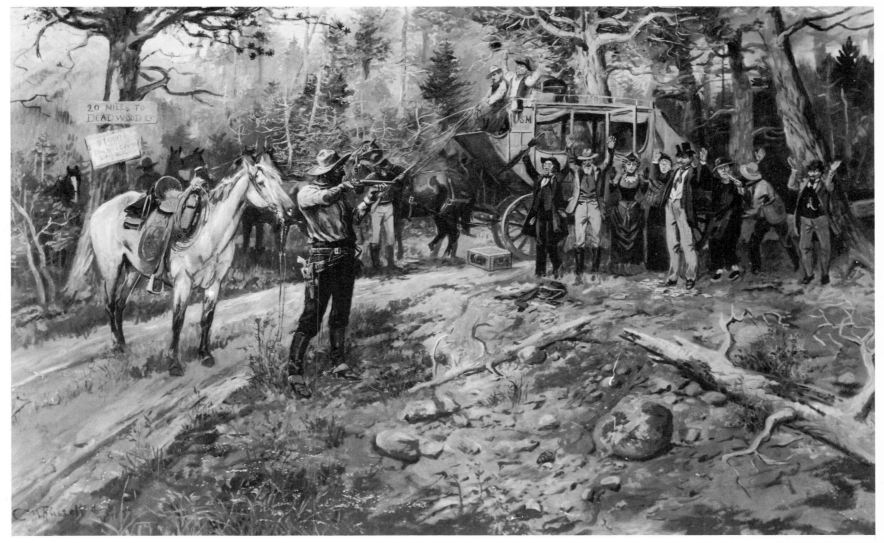

Amon G. Carter Foundation

HOLDING UP THE STAGE

his adopted people and that he would live the life they led. Now that he actually walked among them, he was more determined than ever.

A first-hand impression of Charlie Russell at the time of his arrival in Helena was given years later by Colonel Shirley Ashley, long a resident of Montana. Pike Miller had known the army officer previously and was invited to bring his young companion along for a meal at the Ashley home. "I really had never seen as green a looking boy as Charlie Russell was the first time he came to see me," the Colonel related.[2] "After we had lunch, Miller said that Russell had an idea he could draw some and might become an artist. He turned to him and said: 'Charlie, show Mr. and Mrs. Ashley what you can do.' The lad took a piece of

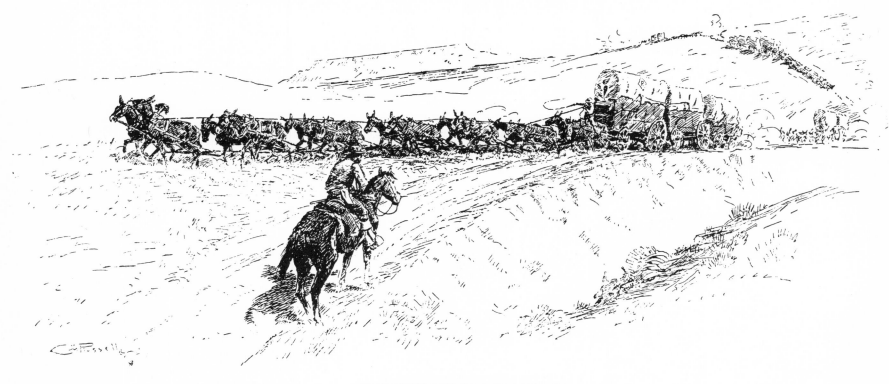

FREIGHTING FROM FORT BENTON

wax from his pocket and made a little horse, which we kept for years . . . Charlie's hair was much too long and I thought he needed shearing."

The recorder of the above quotations was the well-known Montana cattleman Alva J. Noyes. In his earlier days as a cowboy he was known as "Ajax." He had worked on the roundups with Russell, up in the Chinook country below the Canadian border. In a lucid account of those hectic early days and the individuals who made them, he related that Charlie once told him: "Pike Miller and I stayed in Helena about two weeks. We bought a four-horse team and a wagon. The leaders were saddle horses . . . not the best, but a fellow could ride them. We started out for the Judith Basin by way of Diamond, White Sulphur Springs and Judith Gap."[3] Ajax was about as rough an individual as any of the cowboys, although he summed up his early impressions of Charlie Russell by describing him as "that uncouth Missouri boy who came to Montana with Pike Miller."[4]

It is not difficult to understand the exuberance with which Charlie set out on that two-hundred-mile trip to the Judith Basin. He had two horses of his own. One of these could be

saddled and ridden when the road was good, or they could both be hitched ahead of Pike's horses to aid in pulling the wagon when the going was bad. With a load of supplies and with weapons for routine self-protection as well as for obtaining game for food along the way, the two young travelers were now entirely on their own. They followed the stagecoach and freight road that trailed across the large open prairie basin, toward the rocky and timbered gulches that climbed up to the higher plateaus. All around them the high mountains were heavy with the winter snows, which added an erratic white rim to the distant horizon. In the lower country there was still a lot of snow and the road was muddy under the sun's early struggle toward spring. It was a harsh time to be introduced to this rough expanse of the West, but here was a lad's lifelong dream at last being unfolded.

DEATH IN THE STREET

One did not have to go far out of Helena to see herds of antelope on the rolling prairie, and there was always the possibility of seeing buffalo. Along the way they passed an occasional freight outfit, sometimes strung out for as much as a quarter of a mile on the muddy road. The individual units generally consisted of three massive wagons, each topped with the traditional canopy of dirty canvas and hauled on their creaking way by a dozen or more oxen or mules, all straining and grunting and spotted with the grimy foam of sweat. Sometimes the sweat was stained with blood, from the heavy yokes and harnesses that rubbed their hides. But most of the time the young travelers along this frontier road saw only the prairie stretching away to the snowy mountains.

It was little more than thirty-five miles to Diamond City. This clutter of sod-covered log huts scattered along the rough floor of the gulch of the same name had been one of the most fabulous gold camps of the West. The diggings were still producing their rich clean-

ups of the elusive yellow stuff, and memories were fresh with such stories as an individual who stumbled onto $4,000 in a day and three or four partners who took out close to a million dollars in a season. Here too were recollections and occasional recurrences of the dramas of claim jumping, saloon fights, and shooting duels in the road outside, and of vigilante necktie parties and bloody tragedies at the hands of renegade Indians. All one had to do was open one ear to any man at the bar, to have it filled with the sort of realism that made the dime novels seem like sleazy parodies. If you got tired of hearing stories about Diamond, there were a lot of similar camps not too far away, with their own unholy history—places such as Confederate Gulch, Kan Kan, Ulidia, Yogo, and a lot more that were only in the making.

This was the sort of stuff that young Charlie Russell ate up hungrily—the sort of education for which he had a greedy appetite. He had an extremely keen sensibility for the dramatic and a remarkably retentive memory. In later years he repeated the stories he heard during these earliest days of his experience, with the greatest of detail even to the dialogues in which he had first heard them. Nearly a quarter of a century afterward, in putting on canvas and drawing board the pictures which made him famous, he also drew from these early scenes and impressions with such fidelity that the individual participants were readily identifiable by those who had known them. This was true of both white men and Indians, and sometimes even of the horses they rode.

The frontier wagon trail which Charlie followed on that first trip into the Montana hinterland offered more than the human drama along the way. The route skirted the west flank of the beautiful Big Belt Mountains; then up through heavily timbered gulches and over low divides to higher prairie plateaus; along the scenic Musselshell River from its tiny source; between the rugged ramparts of Castle Mountains, the Crazy Mountains, and the Little Belts; then across the wide buffalo plains that led through Judith Gap into the Judith Basin. The game increased, both in abundance and variety, the farther they went. And camping under the stars, the two young travelers slept with guns within easy reach, for the nights were filled with shadows which could easily conceal renegade redskins on the prowl—for here was an attractive opportunity to steal a few horses and a white man's wagonload of supplies.

WHEN SIOUX AND BLACKFEET MEET

WILD HORSE H[

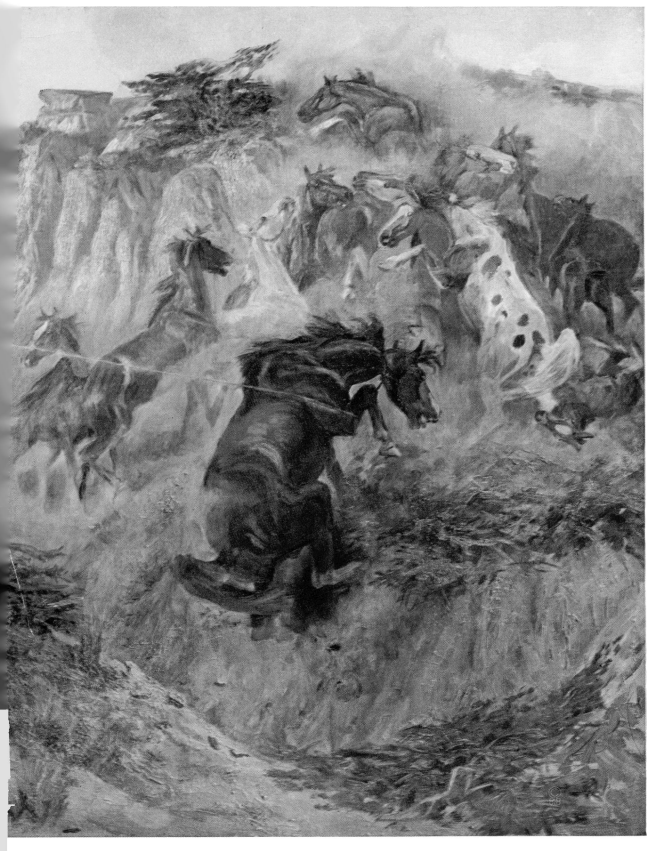

UNTERS

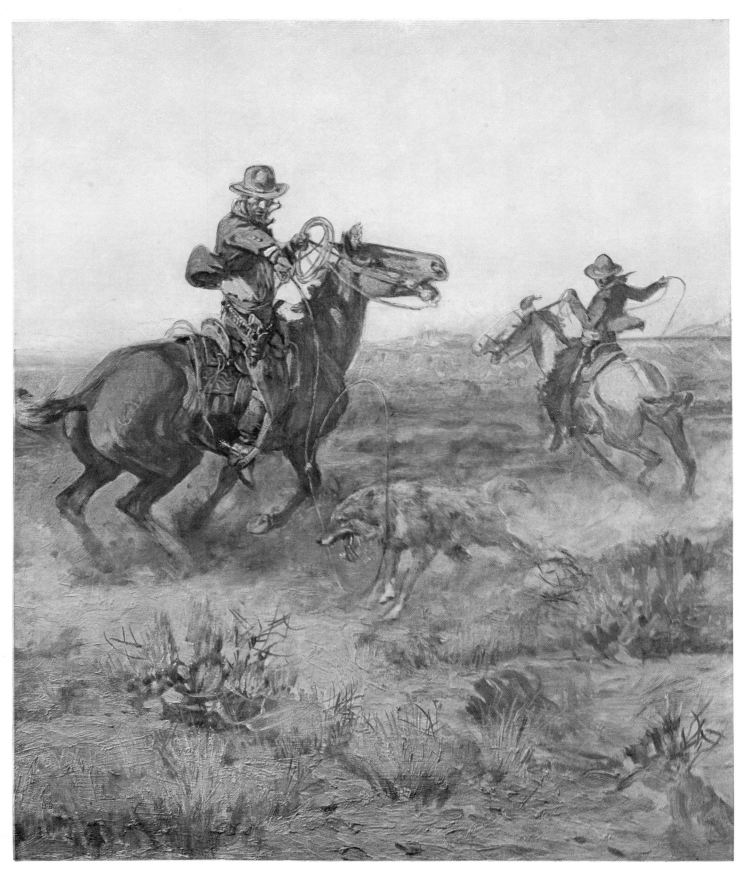

SAGEBRUSH SPORT

CHAPTER IV

Destiny on the Judith

NIGHT was drawing its curtain over the Judith Basin as two tired travelers let their horses come to a stop. The poor animals' sides heaved and their flanks trembled as the steam rose from their wet bodies into the frosty air of the gathering darkness. Through the last several days it had taken all four horses to drag the wagon along the trail of a road, along which the wheels were continually heavy with mud and constantly bumped over frozen hillocks. One of the horses had played out and the others were in bad shape. The mid-April weather had been at its worst, spitting snow mixed with sleet and rain. But now it had turned even colder and the wind was filled with big flashes which threatened to develop into a late blizzard. The two young men climbed stiffly down from where they had been huddling on the wagon seat. They were wet. It was little more than a mile to the end of the two-hundred-mile overland journey—but their horses could go no farther.

The wagon had stopped in front of a low cabin, from the window and open doorway of which a pale golden light glowed invitingly. The little log ranch house belonged to William Korrell, who only the year before had brought his wife into this rough country to help him establish a home. It was a little more than a mile southwest of the Utica stage station on the main road. Another short mile farther on was the more pretentious log building of the adjoining ranch of Pike Miller and his partner Jack Waite. The two travelers had gotten an unusually early start that morning and pressed forward as hard as their horses could take it, with the hope of reaching their destination that day; but from Utica the road was extremely bad, and with such a short distance still to go they were compelled to pull in at the Korrell cabin to seek shelter for the night.

After the horses were taken care of they went inside, where a hot meal and a big heating stove awaited them. While they ate, Pike told about his recent trip to "the States." Then the men moved their chairs closer to the stove to smoke while Mrs. Korrell washed the dishes and listened to a continuation of the conversation.

Pike's young companion, introduced merely as "Kid Russell," had not said very much. Tired as he was, he had managed to dig a small bundle out of his personal duffle and carry it

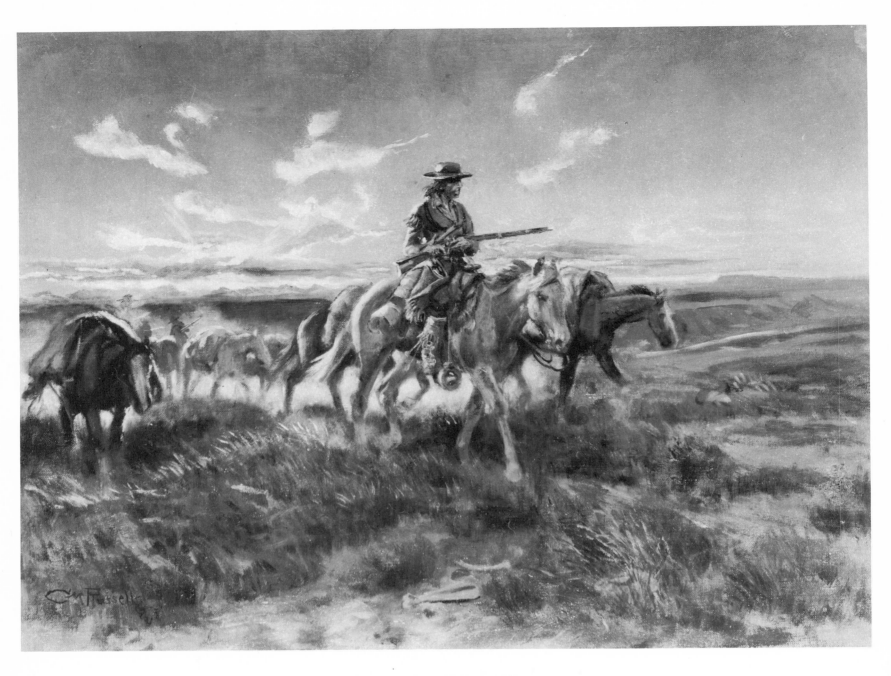

THE FREE TRADER

into the cabin. As soon as the meal was finished he picked up the little bundle, and with his back to the rest carefully unwrapped it to see how the contents had withstood the long trip.

"It was a paint box," related William Korrell a good many years later,[1] "containing a number of small paint brushes, some water colors, black crayon and a ball of beeswax . . . all wrapped in a flannel cloth. Pike told me that Charlie had an idea he could draw . . . that the Kid had been continually running away to 'go West' . . . and that his folks had tried vainly to keep him in school."

Once again Pike insisted that his young companion "show the folks what you can do, Kid . . ." and Charlie modestly complied. "He painted a few horses on the backs of some old envelopes," Korrell related. "They amused us very much, but we placed very little value upon them and they were eventually burned in my heating stove."

During that night it snowed hard. In the morning it was obvious that the slush underneath the snow would make traveling even harder than it had been the day before. So, anxious

to get to his ranch without delay, Pike set out on foot, leaving the Kid to get the horses hitched up and bring the outfit the rest of the way alone.

From the beginning Charlie knew that Pike Miller and his partner ran a sheep ranch. The dime novels had enlightened him on the wide difference between herding woollies and riding the range with cowboys. For Charlie, the fact that he was to visit a sheep ranch rather than a cattle ranch had lent disappointment to the trip, although he had considered it relatively unimportant in view of his desperate desire to go West at any cost. As the realities unfolded, however, Charlie's anticipations proved entirely idealistic. In his dreams of the West he had pictured himself in the role of a romantic knight in the saddle, enjoying all the glamorous excitement of the wild frontier without concern for any of its routine difficulties, drudgeries, or necessities. He didn't mind riding horseback through the sleet and cold, or sleeping in damp blankets, when there was the chance of a surprise attack by hostile redskins. But being stuck by himself out on the range with a big bunch of smelly sheep was a long long way from the realization of his dreams. He had also come to realize that neither Pike Miller nor his partner had any altruistic feelings as far as he was concerned. They had merely acquired a new sheepherder and chore boy; and one, moreover, whom neither of them seemed at all happy to have.

Charlie wasn't much of a sheepherder. In fact he wasn't much good at any of the tasks

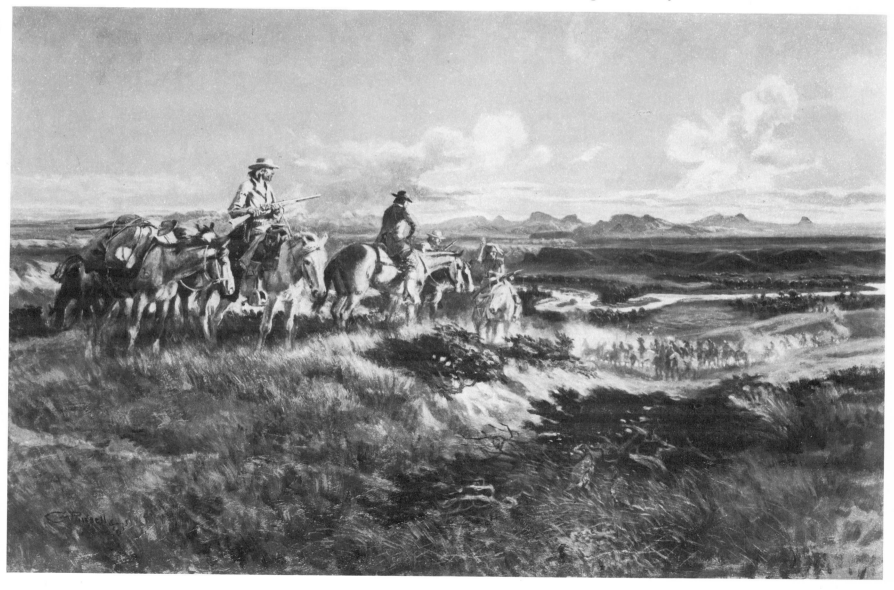

WHEN GUNS WERE THEIR PASSPORTS

assigned to him. These are facts which he frankly admitted on numerous occasions in later years. It was a critical time of year for the sheep raisers, and Charlie would lose the animals as fast as they were turned over to him. He hated the sheep and everything else about his first job in Montana from the very beginning. It wasn't long before he began boldly abandoning his flock and wandering over to the Korrells to tell them his troubles. The couple had taken a sympathetic liking to the big lazy kid from St. Louis, although they were extremely doubtful whether he would ever fit into the raw life of the new country.

It seems more than likely that Pike and his partner decided to make life so disagreeable for the Kid that he would quickly terminate his visit and return home or wander off to some other fate. But the last thing on earth that Charlie wanted to do was to go back to St. Louis,

THE CHRISTMAS DINNER

although he soon decided to quit the Miller-Waite ranch. He started inquiring around for another job that was more to his personal liking than playing Bo-Peep to a flock of woollies. He talked to Korrell about this, and Bill, trying to help him, found out that the man who ran the Utica stage station was looking for someone to herd the relief horses that were kept there.

As soon as Russell heard about the prospective job, he hurried straight to find Pike Miller and announce that he was leaving. Then he began gathering together his few belongings. During the less than two months since he had arrived in the Judith Basin he had sold the horses acquired in Helena and acquired two typical western cayuses, a black mare and a beautiful pinto. The latter had been purchased from an Indian named Bad Wound, for forty-five dollars, when Russell and Miller went up to the Piegan camp on a horse-buying trip. The only reason Charlie was able to acquire this pony was that it was considered a "ghost horse"—and that story was later woven into a literary classic by Russell. The fine saddle horse he named "Monte" and it was destined to become one of his most cherished friends—

ridden over thousands of miles of rough country and kept with him until its death twenty-five years afterward. "We were kids together . . ." the cowboy artist frequently explained, affectionately. "We have always been together. We don't exactly talk to each other, but we sure savvy one another."[2]

Loading the little black mare with his blankets crudely lashed onto her back, and riding Monte, Charlie hurried in to the Utica stage station to get the new job. He had no money and had not even bothered to take any grub along. The man who was looking for a horse wrangler, however, had evidently heard about young Kid Russell and turned him down. Charlie always insisted that "Pike Miller saw the party first and told him I was no good. Part of it may have been true, for I'll confess I was a bum sheepherder."

LAST OF THE BUFFALO MEAT

Not knowing what to do now, Russell rode slowly back up the Judith River. He had a lot of thinking to do and wanted to be alone. Two things were certain—he would not go back to St. Louis, and he would *not* return return to sheepherding. But what else was there? The prospects were mighty dismal. He was already hungry, but didn't have so much as a piece of hard bread or the money to buy any. He didn't have a frying pan to cook a piece of wild meat of his own obtaining. The Judith Basin in June 1880 was one of the roughest and least civilized sections in Montana. There were a few gold diggings in operation up on Yogo Creek and scattered in other sections of the high Little Belts, but he was neither a prospector nor a miner. Some cattle outfits were beginning to range sizeable herds over in the eastern section of the Judith Basin, but the sad showing Charlie had made on the sheep ranch aroused

doubts in his own mind that he would get a better reception among the cattlemen than he had had at the stage station. He felt it was useless to seek employment at any of the struggling little ranches. About the only community of any consequence in the whole basin was over in the extreme northeast at Reed's Fort—later to become the city of Lewistown—but that offered no hope. Nothing he could think of seemed a likely possibility. About all he had to go on was an independent spirit and a determination to make this country his future home.

When Charlie wandered away from the little Utica stage station he did not follow the main road but headed Monte blindly up the trail along the Judith River. This led to practically nowhere back in the mountains. But the hand of some destiny must surely have been guiding him—even when he came to an attractive place and decided to camp there for the night. Dumping his blankets on the ground, he built a small fire and sat down beside it to do some more thinking. He had no food, although he did have the makings of a cigarette.

In the afternoon the sixteen-year-old boy was startled to see a horseman followed by three loaded pack horses coming down the river trail. The stranger of course saw Charlie sitting alone by his fire and stopped his own horses a short distance away. There was no salutation between them. After surveying the scene for a few moments, the man swung down from his horse and began methodically to remove the saddle and then unpacked the others. Then he walked over to where Charlie was sitting smoking a cigarette. Just what transpired during that meeting can best be told as Charlie Russell himself recounted it in later years.[3]

"Hello, kid . . ." said the stranger. "Where's your grub and camp oufit?"

"Haven't got any," replied Russell.

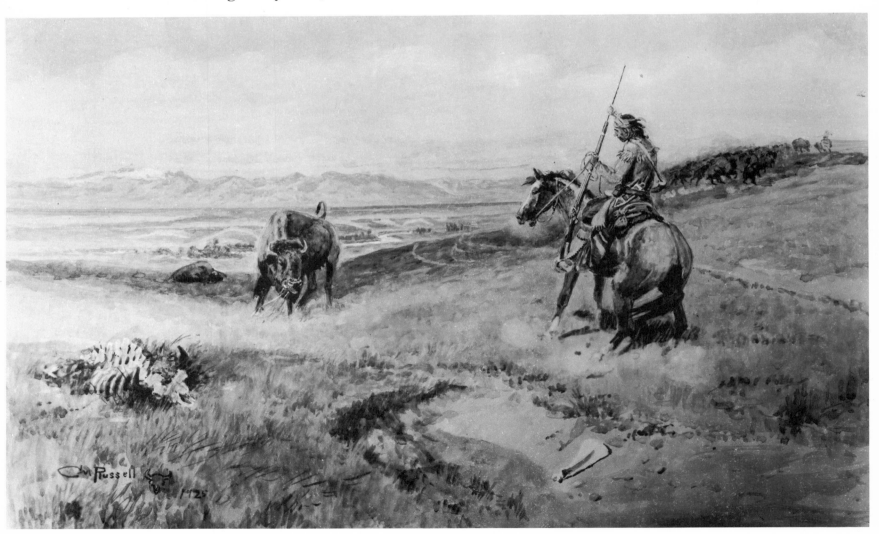

Findlay Galleries, N.Y.C.

WHEN GUNS WERE SLOW

"Did you eat at noon?" inquired the man, who wore old buckskin breeches and a low-crowned wide-brimmed hat; had a heavy shock of curly dark hair, a large moustache, and a couple of months of coarse beard on his face. He looked rough, although his voice was surprisingly soft and friendly.

"No," replied the boy.

"Well," said the stranger, as though he had made a decision, "you'd best come over and eat with me. Elk meat'll go pretty good on an empty belly, an' I never yet seen a kid that didn't have an empty belly."

Russell got to his feet without a further word and followed the man. He was no more demonstrative as a boy than he was in later years. He rustled wood for the fire and went to the river for water for coffee. Just a little bit frightened, he tried to size up this stranger. Everything about him strongly indicated a man of the wilderness—an old-time mountain man. He was rather short and stocky, but powerfully built, and moved about with the quiet litheness of an animal. There was a well-worn cartridge pouch fastened to his belt and a large knife scabbard holding two big knives. When traveling he carried a .44 Winchester rifle packed handily across his lap in a saddle-horn sling. Even his horses appeared wiry and accustomed to a strenuous life in the back country of the mountains.

While the elk steaks were being cooked over the fire, the stranger asked some more questions, as if to find out more about the kid and how he came to be camping out all by himself without grub and under such unusual circumstances.

"Son, my name's Jake Hoover . . ." he finally explained. "I'm huntin' and trappin' up on the South Fork of the Judith. Got a nice place up there . . . warm cabin . . . and there's lots of game. You'd better come back with me when I go. You can stay until you get something better to do."

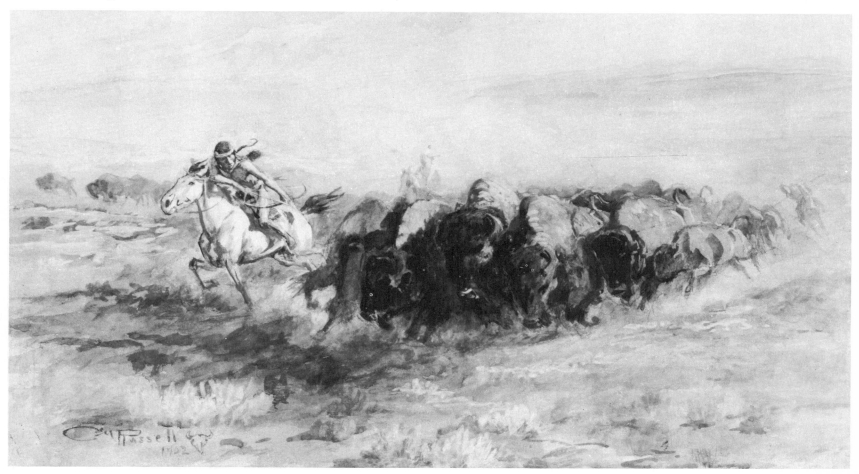

WHEN MEAT WAS PLENTIFUL

Knoedler Galleries, N.Y.C.

Russell quickly accepted. Then to make him feel more at home, Jake introduced the boy to his horses. The one he rode was a sturdy bay with a white stripe across his face which went by the name of "Guts." The pack horses were "Morg," "Sherman," and "Buck." They were all typical western cayuses. Jake had come down out of the mountains with a load of elk and deer meat to sell to the few scattered settlers around Utica. Also he had to buy some tobacco and a few essentials in the way of grub. Then he was going right back.

That night as Charlie lay in his blankets and stared up at the stars, he could not help doing a lot of thinking. But now his thoughts were not unpleasant ones. Peddling elk and deer meat was certainly far more to his liking than herding woollies. The longer he considered his new association the better he liked it and the better he liked this picturesque man of the mountains. Maybe this was just the sort of thing he had been dreaming about. He went to sleep feeling happier than he had been in a long time.

The next morning they went on down to the stage station, and before the day was ended all the meat had been sold, the purchases of tobacco and other things taken care of at the little Utica store, and they were back in camp on the bank of the river. Then, on the following morning, the two set out for Jake Hoover's cabin retreat in the mountains.

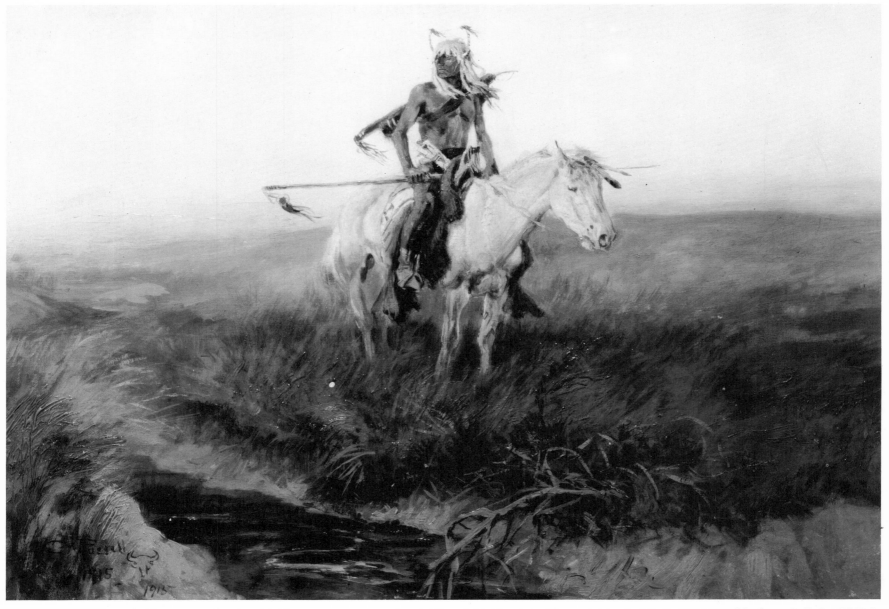

THE SCOUT

Newhouse Galleries, N.Y.C.

FOLLOWING THE FLYING CRANE

CHAPTER V

A Child of the Wild

IT WAS about fifteen miles from the Utica stage station to where the Judith River branched into the Middle Fork and South Fork. There the rolling hills of the prairie basin abruptly gave way to the mountains and timber. Each of the branches flowed down out of a narrow rocky ravine with towering cliffs that reached altitudes of 5,000 to 7,500 feet within a short distance. A little over a mile up the Middle Fork, Yogo Creek flowed down from the northwest. There was a fairly good trail up to the headwaters of the Yogo, which was one of the most recent gold-digging treasure lands in the Territory, and had two little miners' settlements—Yogo City and Hoover. The latter had been named after Jake Hoover, who had been one of the original discoverers only a few years before.

The South Fork made a wide swing southward and westward far back through the high Little Belts. It flowed down through a big valley that was one of the finest game countries in that part of Montana, and still about as wild and primitive as it had been in that spring of 1805 when Lewis and Clark made their historic trip along the Missouri and Captain Lewis named the Judith River after a favorite girl friend back East. When Charlie Russell first went up the South Fork with Jake Hoover there was only a thin thread of a trail, which was even difficult to travel with a good saddle horse. The trail had been made long before by the Indians, who still occasionally made trips into the big valley to get hides for their buckskin clothing and for other uses. It was also one of the most beautiful scenic areas in that part of the Territory; and old Jake, having a good eye for primitive grandeur, had picked the choicest spot to establish his hunting and trapping headquarters. Little did Charlie realize how lucky he was, as he rode Monte up there with the picturesque stranger who had taken him in like an adopted son.

Jake Hoover was a well-known pioneer of early Montana. Even in 1880 he had a wide reputation, not only as one of the country's best-known gold prospectors, but also as one of its best hunters. According to his own testimony, made forty-three years after he picked up Kid Russell and took the boy home with him,[1] Jacob Hoover had also come to Montana as a youngster, at the age of sixteen. He had arrived at historic Fort Benton on June 16, 1866,

49

on the famous old Missouri River boat *St. John*, piloted by Captain La Barge. He first went to the gold diggings at Last Chance Gulch (Helena). That was just two years after gold was discovered, and the camp was enjoying its wildest boom. The year of his arrival Hoover discovered Tenderfoot Bar, one of the richest placer workings of the Gold Creek district—although ironically he profited very little from his remarkable discovery. Then he drifted north to Deer Lodge City; and afterward turned to pioneer cowpunching, becoming foreman of the O. H. Churchill cattle outfit in the Sun River country. He was a rough sort of drifter, who had drunk, gambled, and fought with the most notorious characters of the early days at Virginia City, Bannack, Confederate Gulch, and many other gathering places about which volumes of fact and fiction have since been written. He had shifted from prospector to meat hunter, to mountain trapper, to cowboy, and back again, and had roamed practically every section of the Northwest, from Dakota Territory to the Big Horn Mountains, the Mussel-shell, and up north to the Canadian boundary. He had killed thousands of buffalo, elk and deer, and probably more bear than any other man in Montana. And he was known for discovering more rich mines than any other prospector—without ever reaping a rich reward.[2]

Jake had come to the Judith Basin in 1871, when there were very few white men in the district. He had pushed high up in the Little Belts, where he promptly struck gold and started the stampede to the headwaters of the Yogo. After watching others clean up all around him, he quit his own unproductive claims on the Yogo in 1879 and wound up with the hunting and trapping camp on the South Fork. Few men in Montana Territory had had such diverse experiences or accumulated a more remarkable repertory of first-hand stories.

Jake Hoover's place on the upper South Fork was in keeping with its surroundings. He had built a log shack that squatted in the lap of a grassy parklike bench between the stream and the nearby edge of the mountains. In back of the cabin a big ridge of the Little Belts swung abruptly upward to rugged rimrock and rough broken peaks. There were clumps and large areas of big timber. All around rose an imposing panorama of high mountains. There were really two cabins under a single earth-covered roof, separated by a sheltered open space between. One was the living quarters and the other was a storeroom for hides, meat, and gear. Several unusually large sets of elk and mountain sheep horns had been thrown up on the roof. There was a large, crudely constructed stone chimney at the end of the living cabin and the doorways to both cabins were sheltered by the roof. There was only one small window, made by cutting out a short section of a single log.

The living quarters were as simple and rustic as the exterior. The floor was bare earth. The only furnishings were a bunk made of rough poles and filled with fir boughs; a crude table, of poles hewed flat on the upper side; and a couple of stools of similar construction. The fireplace served for both heating and cooking; and the cooking equipment consisted merely of a couple of large frying pans, a coffee pot, and a camp kettle. This rustic abode was to be Charlie Russell's home for the next two years, as well as his first studio. "Since then I have been in the best hotels in Europe and America," he said a good many years afterward, "but no food they produced could touch that which came from Jake's frying pan . . . He was an all-round mountain man, and he knew more of nature's secrets than any scientist I have ever happened to meet."[3]

Jake and Charlie had a lot in common. Both had a deep love for the Old West. They both

had a natural distaste for the commonplace drudgeries of mere existence—not that they were lazy, but prosaic work they considered an unnecessary evil. So long as there was good grub, a warm place to sleep, and plenty of time to do the things they liked to do, the earth was a fine place.

There was only one phase of that life on South Fork which Kid Russell did not entirely like. Jake loved to hunt. While Charlie thoroughly enjoyed accompanying Hoover on his big-game expeditions, he always had an aversion to killing animals of any kind. But he gained invaluable first-hand knowledge by watching so many varieties of large animals in their native haunts, and became familiar with the details of their anatomy by helping Jake skin and

Historical Society of Montana

JAKE HOOVER'S CABIN

prepare them for market. There was an abundance of deer, elk, mountain sheep, and even grizzly bear in the upper South Fork country.

"Although I was never a hunter, myself," Russell once said, "Jake had no more fear of a bear than I would of a milk cow. On one of our trips he killed four together and the noise they made was not a peaceful song. I had a tree picked out and had spotted the limb I would sit on, but in the midst of the excitement when one bear fell not more than twenty feet away from him, Jake looked about as startled as if he was grinding coffee."[4]

Like most mountain men, Jake Hoover could hold a crippled game animal by the horns, slit its throat, and wait for it to die, without the slightest qualm; and yet he had a deep affection for all the creatures of the wilderness. According to Russell he had many wild pets around the cabin. He would put out salt to attract the deer, some of which became quite friendly. He also had a colony of pet beaver a short distance above the cabin and would frequently go up there in the evening just to sit and watch them. Jake never shot anything in the neighborhood

of the cabin, and these half-wild pets afforded Charlie an exceptional opportunity to practice sketching animals in their natural background.

There could hardly have been a more ideal situation for a young artist of Kid Russell's temperament and interests. He had no worries whatever—he had food, a warm place to sleep, and a minimum of responsibilities. He was realizing to the fullest his most cherished dreams and his heart was free. With such inspiring scenes and Jake's stories to fire his natural interests, he turned more and more seriously to drawing, making little watercolor sketches and modeling small figures in native clay. Jake Hoover knew the wild animals, cattle, men, and country so well that he was a master critic and teacher. He was a stickler for correct detail and could see at a glance when an elk's neck or legs were too long or too short, or when there was something wrong in the portrayal of a cowpuncher on a bucking horse, or of a bunch of Indians

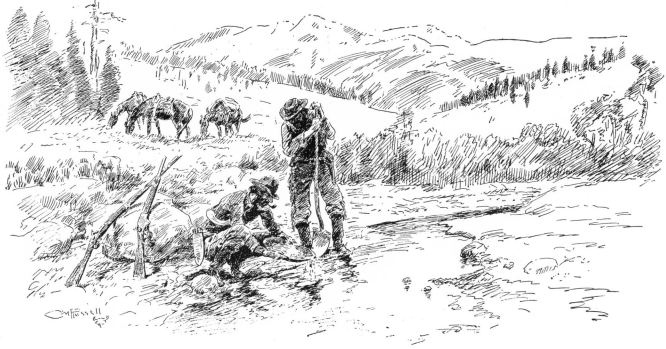

THE PLACER PROSPECTORS

riding into a herd of stampeding buffalo. Then too there was the colorful anthology of stories Jake enjoyed recounting to such an eager listener—stories which Russell never forgot and repeated orally as well as for the printed page to the end of his own life.

There was a good market for meat down in the basin and Hoover had the business pretty much to himself. More people were steadily coming into the Judith country, to establish little ranches and to join the enlarging cattle outfits. Most of them were working too hard to go hunting and were glad to get a quarter or two of fresh elk or deer. Jake was a sharpshooter with his .44, seldom using more than one cartridge per animal, and always a "head-hunter"—aiming for the head to avoid spoiling any of the meat. There were very few expenses to cut into the profits. Charlie helped him do everything but the shooting and Jake divided the money with the Kid. The frequent trips down into the broad basin with the heavily loaded pack horses not only provided a pleasant variety to their life in the mountains, but it afforded Russell an opportunity to become acquainted with all the phases of frontier life. When they

came home to spend a few days just relaxing in their mountain retreat, Charlie would make
a new series of sketches of the scenes and people they had met, using the pieces of paper he
had managed to collect during the trip.

There were occasional visitors at the cabin on the South Fork, for Jake had many friends.
As they wandered in or out of the Yogo, these old-timers sometimes turned their horses up
the lonely trail to pay their friend Jake a visit. Such reunions invariably resulted in a session
of reminiscences about the experiences they had shared in the wild days of booming gold

Hammer Galleries, N.Y.C.

END OF THE PROSPECTOR'S RAINBOW TRAIL

camps, buffalo hunts, vigilante necktie parties, and exciting skirmishes with bands of hostile
Indians. All this was pure nectar to young Russell, who never lost an opportunity to turn an
evening's conversation in the proper direction.

Occasionally a small party of Indians came up the trail to do a bit of hunting in the valley.
They were generally renegades from the reservations, who avoided the white men down in
the Judith Basin like wolves in the night, for they were often on horse-stealing expeditions
or hiding out from posses on their trail. But they could not very well avoid the cabin in the
narrow valley, and according them a friendly welcome there was the essence of good judg-
ment. Whether they were Piegans, Blackfeet, Crows, or Sioux, most of them knew Jake
Hoover; and they knew too that a visit to his cabin was always good for a free meal, as well
as some tobacco, a pouch of salt, or a handful of .44 cartridges. They would sometimes make

Findlay Galleries, N.Y.C.

A DOUBTFUL GUEST

camp near by while they killed a few elk or deer farther up the valley. From the very first, Charlie Russell formed a deep and genuine liking for these primitive people; and they were as promptly and instinctively led to accept him as a real friend. Over the years the Indians in Montana had no more ardent champion of their cause and few white men enjoyed a higher regard among them.

It should be remembered that only a very short time before 1880 the rolling prairie of the Judith Basin and its surrounding mountains belonged entirely to the Indian and the buffalo. The few white men who penetrated the region had been constantly compelled to keep their powder dry and their hair trimmed short, against the possibility of misadventure with redskins. And it was only early that same year that the stopping place on the stage route had been given the name of Utica, so called by its earliest settlers after their home town in upstate New York. The year before, the later famous Granville Stuart, along with Andrew J. Davis, had founded the D-S Company and chosen the Judith Basin in which to establish their cattle industry. After they took in Samuel T. Hauser of Helena, their brand became the DHS. Stuart was manager of the ambitious outfit and had been in favor of the Judith country because the large number of buffalo in the region marked it as a good cattle range. He had established

Knoedler Galleries, N.Y.C.

BATTLE OF THE ELKS

his herd in the eastern part of the large basin, where the terrain was not so broken by hills as it was around Utica and closer to the Little Belt Mountains. Not until the following year did James Fergus, after whom the present county was named, bring his first herd of cattle to the Armell's Creek section, and in that year too the Kohrs and Bielenberg outfit drove their first herd of several thousand head into the basin.[5]

According to the 1880 report of the U.S. Government Agent at the Crow Reservation to the south, the Indians under his charge sold no less than 6,500 buffalo robes at an average of about $4.00 each; and they sold about 10,000 the following year. Most of these were shipped down the Missouri from Fort Benton, about seventy miles to the northwest.

There was no feeling that the Indian wars were over. Despite the success of the then Colonel Miles and his troops, the situation seemed to be building up again in the direction of dire trouble. Sitting Bull had retired north of the Canadian border but threatened to return. The Sioux of the whole northern plains still considered him their leader, and the other tribes seemed just to be waiting for an excuse to go on the warpath. Apprehension in high military places had prompted the sending of an official delegation into Canada to try to reach some amiable agreement with Sitting Bull. This commission was headed by General Terry and Congressman A. G. Lawrence. They had met with the powerful leader of the Sioux on October 17, 1877, but he had refused to accept any of the terms that were offered, hence the situation in central Montana as well as the Dakotas was steadily becoming more serious.[6] It was during this explosive period that Sitting Bull made his classic rebuttal to the overtures of our Assistant Secretary of the Interior, the Hon. B. R. Cowan: "Whenever you have found a white man who will tell the truth, you may return and I shall be glad to see you."[7]

The coming of the cowboy into the Judith did not help the situation so far as Indian troubles were concerned. They brought in a lot of fine saddle horses, along with a steady supply of whiskey—both of which were the greatest temptations known to the Indians. Stealing horses had long been a respected profession among the red riders of the prairies. They would steal horses from any other tribe or even from bands of their own breed, but much preferred to take them from white men—and they were very clever at it. Good saddle horses were the most prized possessions of the cowboys, who had their own ideas as to the proper treatment for any horse thief. Killing an Indian horse thief was considered about as justifiable a use of ammunition as shooting a rattlesnake—and it furnished an interesting possibility for excitement: somebody on **each** side was apt to get shot. The cowboys liked excitement. They also made their own laws and executed them according to the dictates of their own feelings. They disdained the assistance of soldiers, whom they considered only one grade above the Indian. About the only time a buckaroo met a redskin on friendly ground was to trade a bottle of poor whiskey for a good cayuse—which became an accepted basis of exchange. In the crazy exuberance which arose from gulping down the white man's firewater, or in the aftermath of a hangover, an Indian would merely ride out and steal another horse or two to trade for more of the same stuff. All this added up to a few more varieties of trouble for a country that was already well supplied with strife and mayhem.

Charlie Russell had by no means lost his earlier ambition to become a cowboy. The desire was considerably intensified as he came in contact with some of these rugged individualists on the trips down into the basin. There was much to recommend them to a youngster with his ideas. They rode harder on better horses, swore more frequently and in a lingo that had a crisper sting; they even walked differently and dressed differently from other, more ordinary people. But they were as solidly confederated in their insular profession as a pack of road agents; and the carefree life with the romantic mountain man was mighty pleasant for the green lad from St. Louis. He was content for the time to drift along.

The coming of fall brought new inspiration for young Russell the artist: the grass of the rolling prairies turning to gold, the cottonwoods along the streams becoming like golden filigrees against the deep blue sky, and gently shimmering in the balmy breath of Indian summer. Everywhere he looked were pictures beyond his ability to paint. To those who love the western wilderness, this is the most beautiful season of all—a time when there is sheer idle enjoyment just in being alive.

Then, quite suddenly, the snows wrapped the whole country in their white blanket; and Jake Hoover got out his traps. Another new world was now opened to Charlie. Every creature that walks in the snow leaves the story of its eternal struggle for survival, its conquests, successes, and tragedies—which can be read as an open book by those who are wise in the ways of the wilderness. Following Jake along his trap line was like taking a postgraduate course in natural history. The wonders of winter far more than compensated for the bitter cold. The elk and the mule deer came down to yard up in the valley, and even the mountain sheep deserted the high rocky ridges to take up residence on the rimrock within sight of the cabin.

It was all wonderful, but Charlie was restless again and the lure of the roundup camps and the cattle drives was growing beyond resistance. He was soon to seek more exciting pastures.

STAMPEDED

DEADLINE ON THE RANGE

TROUBLE HUNTERS

THE HORSE WRANGLER

CHAPTER VI

A Cowboy Artist in the Making

THE inhabitants of Judith Basin were of all sorts. But good or bad, a surprisingly large number of them became lifelong friends of Charlie Russell's. Among these was the much beloved Rev. W. W. Van Orsdel, who for more than a half century traveled throughout the back country where he became known as "Brother Van." Thirty-eight years after Charlie Russell first came to the basin, a formal celebration was held at old Fort Benton on the Reverend's birthday in recognition of his long service to the country. Unable to attend, Russell wrote him a lengthy letter, under the date of March 20, 1918, which is characteristic of both the writer and the period: [1]

"We first met at Babcocks' ranch in the Pigeye Basin of the Upper Judith. I was living with a hunter and trapper, Jake Hoover, whom you will remember. He and I had come down from the South Fork with three pack horses loaded with deer and elk meat which we sold to the ranchers. We had stopped for the night with Old Bab, a man who was all heart from the belt up, and friends and strangers were welcome to shove their feet under his table . . . His camp a hangout for many homeless mountain and prairie men . . . like a palace to those who lived mostly under the sky.

"The evening you came there was a mixture of bullwhackers, hunters and prospectors who welcomed you with handshakes and rough but friendly greetings. I was the only stranger to you. So after Bab introduced Kid Russell, he took me to one side and whispered, 'Boy,' says he, 'I don't savvy many psalm singers, but Brother Van deals square,' and when we all sat down to our elk meat, beans, coffee and dried apples, under the rays of a bacon grease light, these men who knew little law, and one of them I knew wore notches on his gun, men who had not prayed since they knelt at their mother's knees, bowed their heads while you, Brother Van, gave thanks, and when you finished, some one said, 'Amen.' I am not sure, but I think it was a man who had been a road agent. I was sixteen years old then, Brother Van, but have never forgotten your stay at Old Bab's with men whose talk was generally emphasized with fancy profanity; but while you were with us, although they had to talk slow and careful, there was never a slip. The outlaw at Bab's was a sinner and none of us were saints, but our hearts were

61

clean at least while you gave thanks, and the hold-up said 'Amen.' You brought to the minds of these hardened, homeless men the faces of their mothers; and a man cannot be bad while she is near.

"I have met you many times since that, Brother Van—sometimes in lonely places, but you never were lonesome or alone, for a man with scarred hands and feet stood beside you, and near Him there is no hate, so all you met loved you.

" 'Be good and you will be happy' is an old saying, which many contradict and say goodness is a rough trail over dangerous passes with windfalls and swift, deep rivers to cross. I have never ridden it very far myself, but judging from the looks of you it's a cinch bet that with a hoss called 'Faith' under you it's a smoother flower-grown trail with easy fords, where birds sing and cold, clear streams dance all the way to the pass that crosses the big divide.

"Brother Van, you have ridden that trail a long time and I hope you will ride to many birthdays on this side of the big range . . . "

"I lived with Jake Hoover about two years. In 1882 I returned to St. Louis . . . " Charlie Russell states in the rare and very sketchy autobiographical account of his early days in Montana which was written for the Christmas edition of the Butte *Daily Intermountain* in 1903.[2] Since he had stayed away from home longer than his parents had ever anticipated, the imploring letters of his mother finally induced him to return for a visit. He now had enough money from the sale of meat and furs to make the trip back to St. Louis comfortably. When the bad weather of late February began making life in the Judith Basin miserable for man and beast, Jake took Charlie down to catch the stagecoach for the nearest point on the railroad. His saddle horse Monte was left with the mountain man for safekeeping.

Returning home had its joys, for Charlie was always deeply devoted to his mother. The family hoped he had come back to stay. But Charlie found the prosaic life around Oak Hill even less appealing than before. He was a westerner now, even to the way he talked, the way he walked, and to the battered old broad-brimmed felt hat he persisted in wearing; and he tried to explain to his parents why he had to return to the land he had learned to love. It is beyond doubt that every inducement was offered for him to stay in St. Louis, but there was no swerving his determination, and the visit was a brief one.

Called upon by old friends to relate his experiences in the wild West, Charlie became a very entertaining storyteller. Affecting the western drawl which thereafter became one of his distinctive characteristics, he half apologetically explained that "there warn't much call for speech-makin' out in his country—'cept t' the broncos they rode an' the long-horned critters they wrangled—an' these didn't understand nothin' but profanity." Then he would enthrall his listeners with some of the stories Jake Hoover had told him, garnishing them with colorful bits of cow-country lingo he had picked up.

To those who did not know Charlie Russell well or who fail to understand his unusual nature, he might easily appear uncouth and illiterate. Even in the classic letters and stories he wrote throughout his life, he displayed a total disregard for such conventions as spelling, punctuation and construction. But these attributes were merely the outward evidences of his complete involvement in cowboy life. There might also have been a bit of showmanship in it—for Charlie Russell was *far* from illiterate.

On that first trip back to St. Louis, Charlie made his descriptions and stories of Montana so attractive that a cousin determined to go back with him. This was Jim Fulkerson, an eighteen-year-old high-school senior with only a couple of months to go till graduation. Jim overruled his parents' objection and the two young men set out together in the latter part of March. They returned by way of the Northern Pacific Railroad, the northern route which crossed Dakota Territory and was being extended rapidly westward across Montana. They finally arrived at Billings, Montana, then a booming cow town of about 3,000 inhabitants,

Historical Society of Montana

BUCKING BRONCO

where they planned to obtain saddle horses to continue northward to the Judith Basin. There was still a lot of snow and bad weather, and they were in no particular hurry to get started on the final part of the journey. During this brief respite, however, Jim Fulkerson developed a severe case of mountain fever. At the advice of a doctor, Charlie telegraphed his cousin's parents, who hurried to Billings. They tried to induce Russell to go on alone, but he wouldn't hear of it. After two weeks, sick, anxious young Fulkerson died. He was taken back to St. Louis to be buried, and Russell went on alone.[3]

Charlie had presumably come back to Montana on money made from peddling meat and trapping with Jake Hoover. There is little doubt that his folks would have willingly given him sufficient funds to buy the best ranch in the Judith Basin, but he was as determined to make his own way as he was to live the life he had chosen. There were plenty of opportunities in Billings for a husky young fellow to spend money as fast as he made it, and Russell was rapidly developing strong cowboy tastes. He liked the atmosphere of the cow-town saloons, as well as the honky-tonk music in the places where the lady gold diggers plied their ancient trade. By the time he got away for the Judith, about all he had left was the horse he rode.

"When I pulled out I had four-bits in my pocket and two hundred miles between me and Hoover," he later attested.[4] "Things looked mighty rocky. There was still quite a little snow, as it was in April, but after riding about fifteen miles I struck a cow outfit coming in to receive 1,000 dogies [cattle] for the 12 z & v outfit up in the basin. The boss, John Colter, hired me to night-wrangle horses."

Once again Charlie Russell seems to have been guided in a remarkably providential way. He never gave much evidence of making straightforward plans or even of having serious intentions, yet the right things always seem to have come to him in the most unanticipated manner.

Taking care of the saddle horses through the night was the lowest form of cowboy life and was a task generally assigned to an apprentice, though one who had considerable savvy. The job hardly entitled its incumbent to the distinction of being called a "wrangler"; he was usually referred to as a "nighthawk." The responsibilities were nevertheless important: keeping the horses intact while they filled their bellies with grass during the night, and returning them safely to their riders in the morning. A cowboy without his horse was a helpless creature, particularly in a traveling outfit; and to let a bronc wander away in the darkness was an unpardonable sin. The lowly nighthawk was also sometimes expected to help the cook gather wood and wash the dishes, as well as hook up and drive the "hoodlum wagon" which carried all the bed rolls, gear, and grub; thus he was sometimes called a "hood." But Kid Russell was mighty happy to be traveling in even a menial capacity with the men of his most cherished dreams, and he put heart and soul into making good.

Driving a thousand head of cattle to the Judith Basin was hardly as notable an experience as the big drives north from Texas, although this first one in which Russell participated had many similar features. There was a lot of rough country to push the herd through; the lingering winter weather was at its worst; and there was very little feed for the animals along the way. Cattle with half-filled bellies can be mean to handle, and it took almost a month to make the trip.

Indoctrination into cowboy life under such circumstances might easily have turned a less determined young tyro against the whole idea and sent him hurrying back to the placidity of Jake Hoover's retreat in the mountains. Across the icy rimrocks, ridges, and rivers of central Montana, through snow and sleet, there was no time for a greenhorn scissor-bill nighthawk to find sympathy or tolerance among seasoned old rawhides of the range. The Judith Basin cowboys had already gained a reputation for being about as rough a bunch of men-with-guts-an'-a-hoss as any saddle-pounders in the trade. There is little doubt that

Charlie was a pretty poor night-wrangler. But what he lacked in savvy was more than made up for by his captivating personality—which was forever gaining the warm friendship of all those with whom he came in contact. In those early days, the rougher they were the better they seemed to like him. Kid Russell was their kind of folks—strange sort of maverick though he was.

Charlie managed to hold the job as nighthawk until the herd was brought into the big basin and turned loose on Ross Fork between Lewistown and Utica. Then he returned to Jake Hoover's cabin on the South Fork. His initiation into the exciting life of the cowboys, however, had so deeply affected him that the quiet mountain retreat now seemed much too tame. It was common information that there would be a big spring roundup of all the Judith cattle at Utica, and Charlie could harldy wait for the time when he might join the ranks of the cowpokes. His efforts at sketching were now devoted almost entirely to rawhides on bucking broncos and the re-creations of scenes in which he had played a part during the recent cattle drive. He had brought back from St. Louis a new stock of watercolors and other simple artist's materials, and the compositions he attempted now were more ambitious than

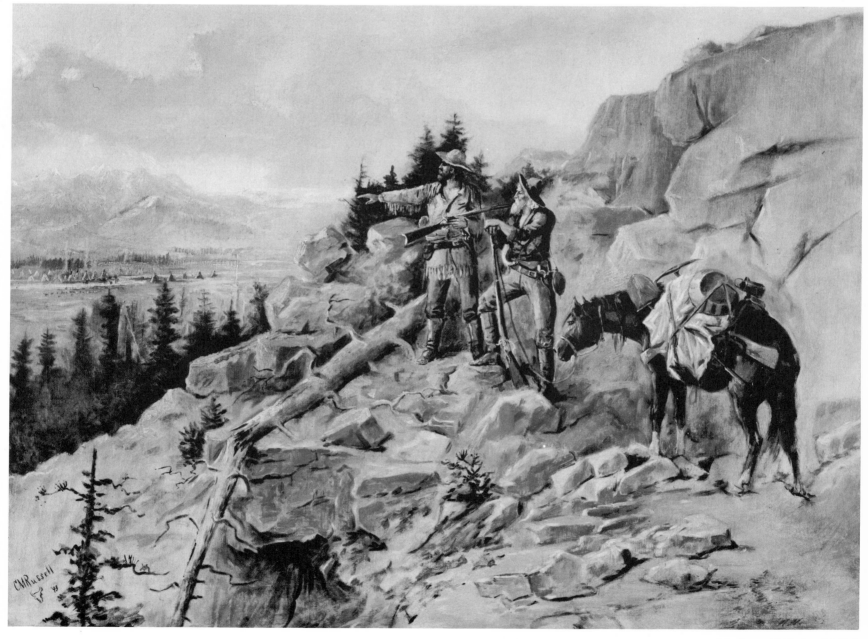

Newhouse Galleries, N.Y.C.

DANGEROUS TERRITORY

those he had done before. Some of the people with homes down in the basin had heard about Kid Russell's ability to draw pictures of the things he saw, and they asked him to make sketches of their little ranches to send back East to relatives. One of these was S. S. Hobson, who became a well-known figure of the district.

In those early days of free grass and the wide open expanses of fenceless range, everybody's stock was permitted to roam at will and forage for themselves through the winter. The cattle were owned by a considerable number of individual ranchers and small outfits. By springtime the animals were widely scattered and pretty badly mixed up. As a matter of practical economy the various ranches and their cowboys would pool together for a community roundup to separate their respective herds and put the proper and legitimate brands on the new crop of calves. Then there was the added complication of several thousand head of new cattle which had been driven into the basin and turned loose during the previous months. These had a variety of brands that were unknown in the district. Under a community roundup arrangement, all these important matters could be worked out in a manner that would forestall serious difficulties among the owners.

The time for the spring roundup, or "calf roundup," was decided by the state of the season. It took place when the grass began to green up. The cattle owners gathered together at a convenient meeting place to organize the project. They selected the most experienced man among them to be the roundup boss, or foreman, who then had absolute power to hire and fire, say when and how. He would divide the cowboys into groups, as he saw fit, and send them out into designated sections of the surrounding country to spread out and gather together all the cattle and drive them back to the designated "holding place." There the separating and new branding would be carried out under official supervision. The cutting out of individual animals, holding them in their proper groups, roping and throwing for branding, required the best of roughriding on the best of horses. It was the most exciting part of cowboy life, and every man took the greatest pride in his individual skill and daring.

Charlie Russell put in an early appearance and applied to Horis Cruster, the roundup boss, for a job. Pike Miller, his former sheep-raising friend, had continued to give Charlie a bad name throughout the district. Pike always referred to him as "that ornery, good-for-nothing Kid Russell"— and Charlie certainly looked the part of vagabond, with his ragged clothes, uncut hair, and awkward appearance. Even his infectious grin and drawled friendliness seemed hardly enough to offset the manner in which he sat in the saddle and handled his horse. But the cattlemen held all sheep raisers like Pike Miller in disdain; and when John Cabler put in a good word for the Kid, on the strength of his previous work as nighthawk on the recent cattle drive, Charlie was hired for the spring roundup in the same capacity.

The Judith roundup of 1882, one of the biggest events of its kind in the then brief history of the cattle industry in central Montana, gave Russell his real introduction to cowboy life. The basin, almost completely surrounded by mountains, sprawled for about fifty miles from north to south and forty miles east to west. It was rather irregular in contour and had many thicket-fringed streams and adjoining valleys; thus a lot of good riders were required to gather up all the cattle. The Granville Stuart outfit alone had well over 12,000 head. When they were all assembled at the holding spot near Utica it made quite a show. There were

nearly a hundred of the best cowboys in the Northwest and they had almost four hundred of the finest cattle-country saddle horses. Here was an old-time cowpuncher extravaganza at its roughest best.

When Charlie left Jake Hoover's cabin that spring of 1882 he took along all his personal belongings—which were little more than a bed roll and the dowdy clothes he wore, plus his precious poke of watercolors and other simple artist's materials. Ill qualified as he was to perform any of the skills which led to acceptance into the fraternity of the rawhides, he had made up his mind once and for all to follow the life of a cowboy from then on.

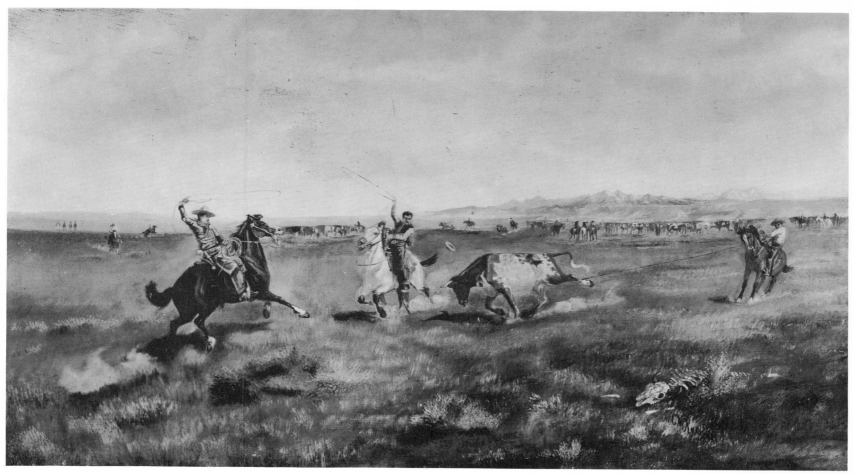

Newhouse Galleries, N.Y.C.

ROPING A WILD ONE

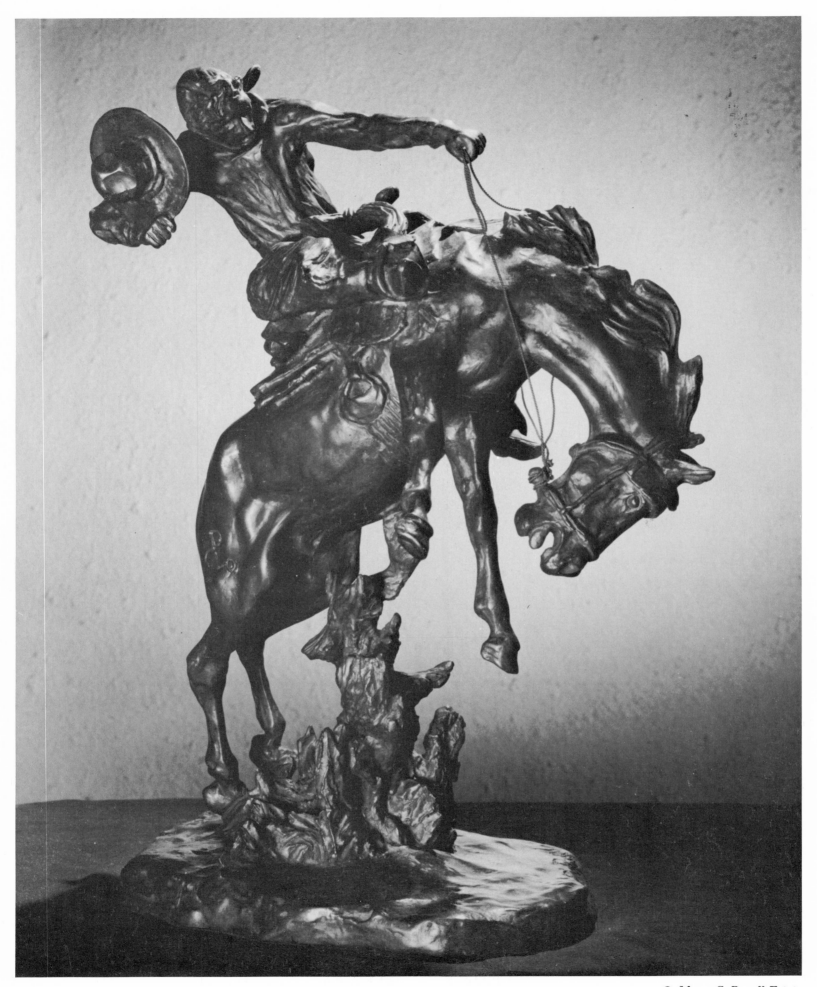

THE BRONC TWISTER (*bronze*)

AN OLD TIME COW DOG

CHAPTER VII

A Jester among Rawhides

ANIGHTHAWK had to be completely dry behind the ears to handle four hundred saddle horses—with only one other man assigned to the task. Fortunately Charlie Russell had the aid of a seasoned hand, and from the start he got along fine with Charlie Contway. In fact they became the best of friends.

In some of the big roundups each saddle-pounder might have half a dozen or more horses at his disposal— a couple of "morning horses," a couple of "afternoon horses," and maybe some more for special duties. This was particularly true of the important outfits that raised their own riding stock. But on that Judith pool of 1882 a lot of the cattle were owned by small ranchers just getting started, who didn't have more than one or two good cow ponies. Many of the riders were itinerant one-horse cowpunchers who had been hired for the job. Some of the horses were roughridden all day. But most of them were high-spirited animals— too tough to stay tired and too mean to be peaceful under any circumstances. When turned loose without a boss on their back and herded out to feed through the night, they sometimes got ornery ideas or decided to take off for the home ranch or some other undisclosed rendezvous of peace and quiet. The nighthawks were often required to ride through the darkness at breakneck speed—which was apt to mean exactly that. The difficulties were compounded when the night was dirty with chilling rain or wind-whipped sleet, and the long hours in the saddle often became a miserable chore. But Charlie and his faithful Monte saw the nights through without serious mishap to themselves or to their charges.

It was during the spring roundup of 1882 that Kid Russell became a character around the cattle country. He had an unusual amount of youthful energy and enthusiasm for all aspects of cowboy life, including the roughest of its rigors. He would ride all night in the worst of weather and come into the miserable muddy roundup camp in such a state of good humor that the other cowboys began to look forward to his arrival as a pleasant, amusing beginning to their day. Wet and disreputable-looking, the Kid would stand grinning by the chuck wagon and drawl some yarn that was sure to bring forth chuckles or hearty laughter. Frequently he would find a piece of paper on which to draw an illustration of something that

had happened during the night or the previous day. He could make a good story out of incidents which might otherwise have passed unnoticed, and had the happy faculty of giving it a rare touch of humor. He was a natural-born storyteller; and he was also rough and occasionally ribald enough to suit the taste of any rawhide. Thus began the Charlie Russell legend that is still alive in what was once the Montana cattle country.

Many of the incidents of that first roundup provided the inspiration and subject matter for some of the most ambitious of Charlie's early efforts, as well as for important paintings done later after he had gained stature as an artist. One of the first large oil canvases he attempted was "The Judith Roundup" (below), or "Utica" as he chose to entitle it for the copyright. This picture (47 inches x 23½ inches) was presumably done in 1885. It eventually came into the possession of Sid Willis and for a good many years was displayed in his famous collection in the Mint Saloon in Great Falls. In 1952 the collection was acquired by the late Amon Carter of Fort Worth, Texas. There were actually two of these early Utica pictures, both of which were first reproduced in the *Seventh Report of the Bureau of Agriculture, Labor and Industry* of the State of Montana for the year 1900. The companion picture was "Turning Out in the Morning." Among the numerous other pictures which in later years were inspired by that early experience in the Judith Basin, bad weather and all, is "A Rainy Morning," dated 1909 (page 71).

When the spring roundup was completed and all the new stock properly branded, the cattle were again turned loose to fatten up on the free grass of the open range. After the long days of strenuous riding, cutting out, and branding, in all sorts of weather, the cowboys were generally ready to hit for the nearest town and paint it red—then drag-it-for-home. The various herds, large and small, had to be driven to their own part of the range, and an

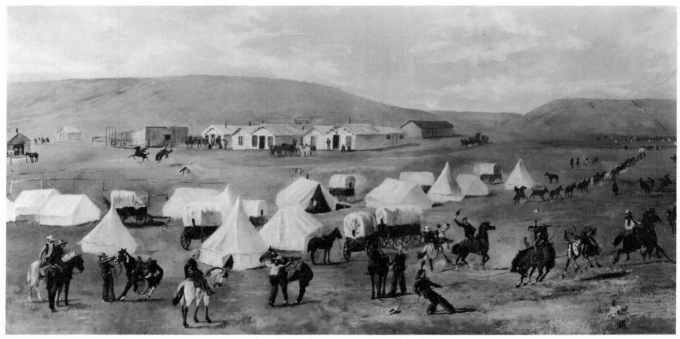

Amon G. Carter Foundation

THE JUDITH ROUNDUP (*c. 1885*)

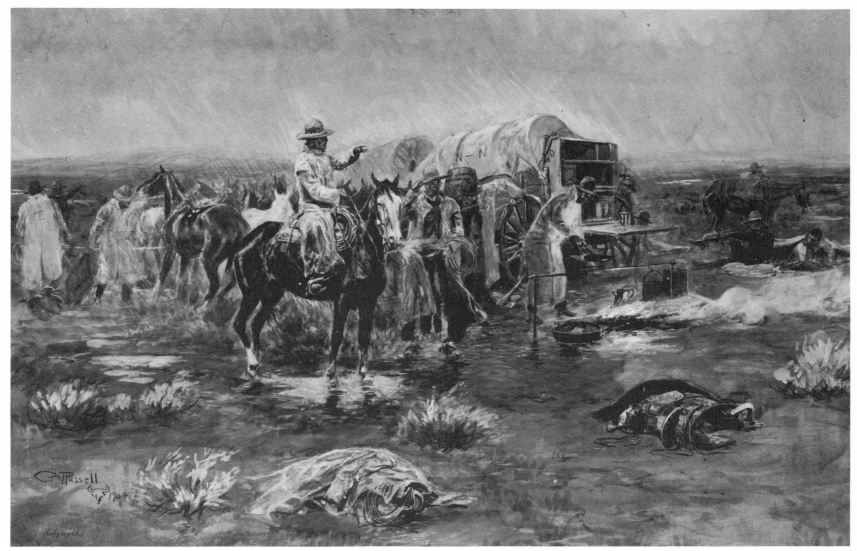

Knoedler Galleries, N.Y.C.

RAINY MORNING

effort made to keep them there until the fall roundup. The latter was sometimes referred to as the "beef roundup"; it was the all-important time when the cattle owners "harvested" the beef that were to be driven and shipped to market. Here were the profits on which the industry depended. Those who had cattle in sufficient number, and could afford it, employed cowboys to ride herd for them through the summer. Keeping the herd together not only simplified the fall roundup, but the cattle could be kept in good grass as well as watched over and protected against the various dangers which beset them.

But Charlie Russell was something more than a mere camp jester. He was hired as a night herder by Nelson True, one of the pioneer cattle barons of central Montana. This was something of a promotion for the Kid, as "Old Man" True was by no means a sentimentalist or any sort of philanthropist when it came to the serious business of handling and safeguarding his cattle. In fact, it seems more than possible that Russell was a considerably better cowboy than his modesty of later years would allow him to admit, and better than he was ever given credit for being by the rawhides with whom he associated during those early days.

Riding night herd on the beef cattle was as serious a responsibility as nighthawking,

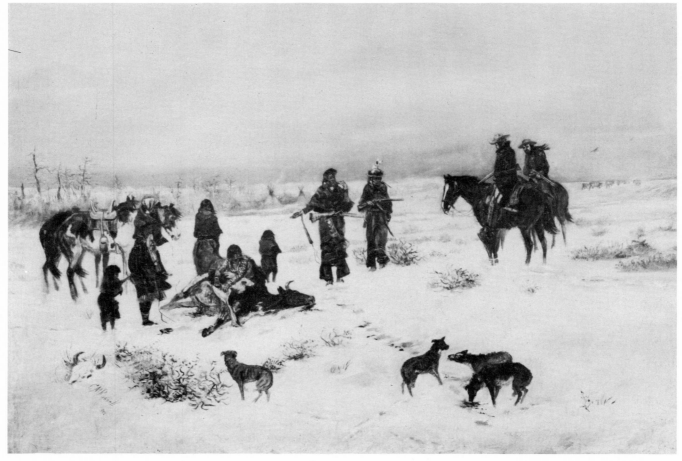

Historical Society of Montana

CAUGHT IN THE ACT (*c. 1885*)

and it was a tougher job as a steady diet. Just to be a saddle warmer from dusk to dawn, night after night, required a lot of stamina—but that was the least of it. The cattle were often restless and spooky, particularly when the nights were black and the weather bad, and they were apt to stampede on the slightest provocation. A blast of lightning or even the striking of a match for a cigarette could start them into a thundering mass. On such occasions it was the imperative duty of their herders to bring them under control as quickly as posible. This required desperate riding to get in front of the herd and turn it. Every racing stride of the cowboy's saddle horse in the darkness might mean a step into an unseen hole, or a stumble over a rimrock or into a cut-bank, that would send both horse and rider tumbling and could result in their being trampled to death by hundreds of sharp heavy hoofs. Night herding was not only strenuous but dangerous work.

When the night was clear and balmy, however, a man had a lot of time to think and dream—particularly one with the temperament of Charlie Russell. It became a custom among the night herders to sing to the cattle, for it was believed that this helped to keep them quiet and contented. Thus the expression "singin' to 'em" became synonymous with night herding. Many of the early-day cowboys made up their own ditties, some of which came into popular use and have been handed down through the years; and some of the songs, however ribald, were chanted to the tunes of religious hymns remembered from childhood.

Not the least of the hazards of those early days were surreptitious visits of Indians. The Judith Basin had long been considered the private hunting ground of the Piegans, one of the warlike tribes of the Blackfoot confederacy. Although they had been officially confined to a reservation some distance farther north, they nursed an increasing feeling of resentment against the cattle and sheep men who were rapidly monopolizing their beautiful prairie hunting ground. This country was also considered a traditional raiding territory for the River Crows, a Siouan tribe from south of the Musselshell. Renegade bands of both tribes still traveled back and forth through the Judith Basin to make raids upon their ancestral enemies, and the white man's beef constituted an irresistible temptation. A dark night was a fine time to steal a fatted steer, hurriedly butcher it, and then get a running start to escape reprisal. A cowboy posse was sure to be on the trail as soon as the unforgivable deed was discovered. Sometimes the red raiders would resort to the bold expedient of sneaking up close to an unprotected side of a herd and putting it into stampede by firing off a gun or cracking a blanket like a pistol shot. In this manner the cattle might be widely scattered and a steer or two could be driven into a thicket to be killed and butchered where it would take longer for the evidence to be found. Occasionally the men on day herd might find telltale pony tracks on the range and taking off on the trail come upon the redskins in the midst of their bloody deed. Many of the rawhides considered it fully justifiable to shoot an Indian on sight under such circumstances.

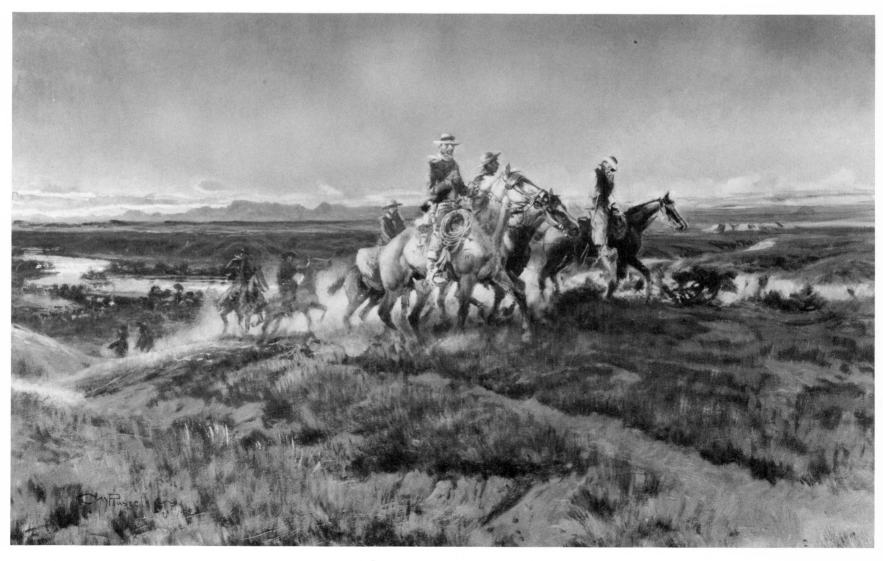

MEN OF THE OPEN RANGE

Indian raids on the white man's cattle were by no means restricted to the summer months. There was generally more urgency during the long winter and less chance of being apprehended when the cattle were widely scattered and less well surveyed. The cattlemen were always suspicious when Indians were in the vicinity, and a look-see ride through the country frequently brought a rawhide upon a scene of the gravest felony in the unwritten law of all cattlemen. Such an incident was portrayed in another of the very early paintings done by Charlie Russell—the first of his pictures to be reproduced. This was "Caught in the Act" (page 72), which appeared in *Harper's Weekly* for May 12, 1888. In the accompanying article, which was obviously written from notes supplied by the artist, Russell declared an unusually strong sympathy for the Indians—another paradox in a man so deeply saturated with the whole ethos of cowboy life. The painting was a rather crude piece of art, yet there is something highly significant in the fact that such a work by an unknown novice was accepted for publication. This is clearly implied in a prophetic postscript which the *Harper's* editor added to the brief article accompanying the picture: "Mr. Russell, the artist, has sketched a subject with which he is entirely familiar. The starving Indians, with savage faces . . . The gaunt, sore-backed horses, humped by the cold . . . The scurvy dogs, snarling as they scent the blood-drops in the snow. Mr. Russell has caught the exact dreariness of it all . . . Anyone acquainted with frontier life will at once appreciate the truthfulness of the picture." Here was something starkly realistic and strangely appealing—qualities far outweighing any academic shortcomings. The original painting of "Caught in the Act" today hangs in the Montana Historical Society's fine museum.

That first year as a cowboy was a full one for Charlie. In the fall he went back to night-hawking for the beef roundup. After that he participated in the overland drive of the market cattle taken down to the Northern Pacific to be shipped to Chicago. It was by far the biggest herd that had ever been moved out of central Montana. Most of the important cattle owners in the Judith Basin combined under the leadership of Nelson True and the project was organized at Utica. When the sprawling herd was finally gotten under way toward Judith Gap and the distant loading station on the railroad, it was accompanied by some of the best cowpunchers in the Northwest—some who never became anything more than roughriding rawhides of the open range, and others who made fortunes from beef on the hoof. The names of all but the teen-age Charlie Russell mean very little today, except to those steeped in the early lore of the cattle country—Stadler and Kaufman, Ensign Sweet, True, Hobson, Hatch, Tuttle, and others. But there was enough rough realism and drama on the drive through Montana to supply a documentary artist with material for a lifetime of work.

The beef cattle had to be driven overland at a leisurely pace so that they could feed along the way and take on weight rather than lose it. It was a four-hundred-mile trip requiring more than two months. Aside from the routine procedures and difficulties occasioned by the rough Montana terrain, the journey was not without its dramatic incidents. They passed where bands of renegade Piegans and Crows had recently fought a bloody battle. And in crossing the Crow reservation the herd was stopped by red warriors who demanded that the traditional toll be paid for each head of cattle. This led to a serious altercation during which the Indians stampeded the big herd. There were fortunately no casualties among the men, although several of the beef were drowned when they went thundering into the nearby

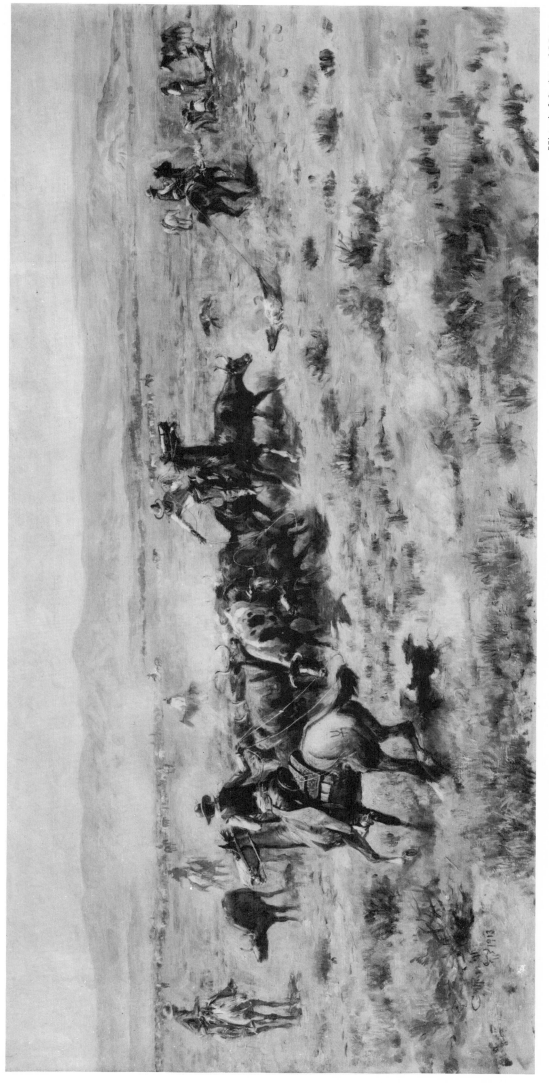

THE ROUNDUP

river. This particular incident provided the subject for one of Charlie Russell's famous paintings. Thirty-one years afterward he recalled that meeting with the Crows on the edge of their reservation and put on canvas "Deadline on the Range" (pp. 58–59), also known as "The Toll Collectors." It was painted in 1913.

The job of nighthawk was particularly advantageous for Charlie Russell. Riding herd through the night gave him an intimate insight into an aspect of cowboy life which he could not otherwise have known so well. It was also a time for quiet contemplation of all the things about him. The days were pretty much his own. The night herders were privileged to sleep when the herd was moved on in the early morning; it was quite easy to catch up with the outfit again before dark. Or, if they wished, they could roam about at will before assuming their duties again. If a strange young maverick of a nighthawk chose to amuse others by telling them stories, or making little sketches of things that had happened, that was nobody's business but his own—so long as he properly took care of the job which was his direct responsibility. But Charlie Russell's experience as a cowboy was only beginning.

Frederic G. Renner

HOSTILES

A BRONC TO BREAKFAST

CARSON'S MEN

AN UNSCHEDULED STOP

RUNNING DOWN A JACK RABBIT

CHAPTER VIII

One Who "Belonged"

RIDING BACK to the Judith after delivering the beef herd for loading on the railroad, Russell decided to become established in a little place of his own. Acquiring a ranch was a simple matter. There was plenty of free land and the government had been urging prospective settlers to take it. About all one had to do was pick out a little area he liked and announce to the neighbors that this was to be his future mail address, if any—just so long as there was plenty of corral and pasture space between the cabin you built and the nearest other squatter. None of the land had been surveyed for the official record, but that wasn't of any great concern. Even if you raised nothing more than sagebrush and buffalo grass and had only one saddle horse, you acquired a less itinerant standing in the community.

The homestead that Russell picked out was in Pigeye Gulch a short distance from Utica, which was rapidly growing into the center of activity for the western part of the basin. The place he selected was handy to timber where logs could be cut for the cabin and snaked in with the aid of Monte, his pinto saddle pony. The project was begun with enthusiasm to get done before winter really set in. But it became quickly apparent that chopping down trees and constructing them into a comfortable home was not Charlie's idea of having a good time. As the struggle progressed, it was plain to his Judith neighbors that the young cowboy was considerably more adept at drawing pictures than he was at building a home, and his cabin became almost as laughable as some of the yarns he told. When the misfitted and rather crooked side walls were hardly half high enough to provide headroom, his enthusiasm collapsed and he decided to put on the simplest roof and let it go at that. The inside furnishings were little better. A circle of stones in one corner of the bare-ground floor provided a place for a fire for cooking and heating. The room was small and there were plenty of cracks in the thatched roof through which smoke could escape. A heap of boughs supplied a place to spread blankets. There was little more. But this crude cabin was not only Charlie's first own home in the West, but also the first studio of his own.

Russell was becoming an integral part of the Montana cow country, and events rapidly increased the aura of legend around him. Folks couldn't understand the young maverick, yet

no one had a feeling that he didn't "belong" among them. It was easy to forgive a lot. Everyone liked Kid Russell, in spite of his shiftlessness and eccentricities. He was always doing something that was easy to talk about and easier to exaggerate. He did not occupy the "homestead" very long, but according to the accounts handed down from those who were in the Judith Basin at the time, this episode provided an amusing subject of local conversation for a long time to come.

The eleven or more years[1] that Charlie followed the life of a cowboy were exciting and colorful, and they were the foundation upon which his future was solidly built. He ran the whole gamut of experiences that the cow country had to offer, including about everything

© The Leader Co.

© The Leader Co.

THE COWBOY BULL WHACKER

that was good and bad. The whole story will never be told, and in some respects maybe it's just as well. Russell never set down or seriously related much of his own story. Many of the yarns with which he entertained his friends in later years and wrote for publication were interwoven with bits of his own past. However, even the accounts of those who knew him best, and those who attempted to gather together the loose ends of fact, are plagued by frequent contradictions and often tinged by the fiction of cow country legends. To follow a calendar of events is relatively unimportant. There were many others who did the same sorts of things—although certainly no other individual ever started as a cowboy and achieved greater renown in a more unusual manner.

After those first two years with Jake Hoover, Charlie consistently followed the calling of the saddle-pounders. It was a rather spotty existence and not a good means of realizing

economic independence. Like most of the other hired cowpokes, when he finished a roundup or hitch at herding, he would draw his pay and go galloping off to see how fast the dollars could be spent at the nearest cow-town dispensary of snake-water and in other places that were rapidly springing up, where a rattlesnake might be ashamed to meet his mother. But this was the life that suited Russell best. He even thrived on the hard times between jobs. There was generally a vacant shack somewhere in the country and other gypsy cowboys with whom to share it. The larger cattle outfits invariably had some sort of batching quarters available for off-season use by their indigent help. No self-respecting saddle-pounder would stoop to work at anything else, just to get a square meal or two. The leisure days that were

© The Leader Co. © The Leader Co.

STAGE DRIVER STAGE ROBBER

forced upon Charlie Russell he spent with ever increasing seriousness at drawing, painting, and modeling, using whatever materials happened to be available. It is clear that he never looked upon art at that time even as an avocation, for he always gave away or destroyed whatever he made—a habit which persisted for a long time.

When the grub became too scarce or the spirit moved him, Charlie would go back to spend a few days or weeks mid the never failing hospitality of his good friend Jake Hoover. There was always plenty of elk meat up at the cabin in the quiet sanctuary on the South Fork. Jake never seemed to care whether Charlie helped with the chores or not and always encouraged his drawing and modeling. In these first few years Charlie also made another trip or two back to St. Louis to see his folks, during which he always purchased a new stock of art supplies, now including the necessary materials for oil painting.

The rapidly developing cattle industry in the Judith Basin during the early 1880s attracted immigrants from all over the West. Newcomers of all sorts, some of pioneer fame and some of questionable background, were continually getting off the stagecoaches that pulled into Utica. Heavily loaded freight wagons drawn by sweating strings of grunting oxen, horses, or mules were periodically coming in to unload supplies of various kinds. Anyone who could handle a saw and hammer could find employment with crews who were putting up the many new buildings that were giving both sides of the muddy yellow road the crude semblance of a street. There were new stores and a variety of saloons; and a respectable distance in back and beyond were appearing the inevitable shacks and tents where the "girls"

© The Leader Co. © The Leader Co.

PROSPECTOR WOOD HAWK

set up business. The lodging places were crowded with newcomers, many of whom carried six-guns cradled conveniently in old holsters hung from their belts. Among them were tinhorn gamblers sizing up the possibilities of staying a while; bearded prospectors from California or maybe Arizona, seeking information about Yogo Creek and other sections of the Little Belts; bullwhackers, mule-skinners, itinerant cowboys, and even a Chinese or two. There was also an occasional greener fresh from the East—usually a half-scared mail-order cowboy, not quite sure he was glad he had come; but now and then a potential buggy-boss with money to invest in raising gilt-edged T-bone steaks.

Buffalo hunting and fur trading were almost a thing of the past. Now there was a growing feud between the cattlemen and the sheep men to dominate the country and its lush grazing prairies. Nor was Utica now the only center of activity in the broad Judith Basin.

Several other tiny settlements were showing signs of development. The principal of these was the rival cow town of Lewistown, about thirty miles in a direct line to the northeast. There were others to the south.

The abundance of the highly nutritious bunch grass provided year-round grazing. In the fall the grass cured itself into natural hay for winter feed on the open range. It was never cut except for the saddle horses that were not turned loose. The winters were bitter cold, and there was an occasional season when the snow became frozen so hard that stock could not paw through the crust to feed and they died by the thousands. But the animals generally came through as fat as stable-fed stock on an Iowa farm. With an average of good weather and

POST TRADER

BUFFALO MAN

good luck it was usual to realize a net income of about 50 per cent per year on an investment. In 1883, with a few thousand dollars in capital, a stock raiser could make a good living and become financially independent in a few years. An investment of $20,000 in a ranch stocked with six hundred heifers could provide an annual income of about $10,000 and at the end of ten years create an established layout worth around $300,000.[2] That was profitable business. The sheep raisers, who sold only the wool of their flocks, were doing equally well. Little wonder that land was so rapidly becoming occupied by cattle—not merely "on a thousand grassy hills," but a thousand to every hill.

As a result, there was probably more money in the Judith area than in any other region of the Northwest. This also attracted all sorts of undesirables, such as crooked saddle-blanket gamblers, gun-fighting desperadoes, and organized bands of horse thieves and cattle rustlers.

SMOKE OF A .45

There was practically no law enforcement, except for the scattered military who were perversely hog-tied by red tape, which led to the organization of the cattlemen's vigilantes—who made their own laws out of lead and hemp.

There were a number of bands of professional outlaws, each organized in units and all more or less bound together in tacit fellowship. These had their own hide-outs and gathering places. Over on the east flank of the Judith Mountains was a little settlement known as Rocky Point, which gained the reputation of being "the worst place in Montana Territory and the resort of outlaws and thieves."[3] At the mouth of the Musselshell, where it flowed into the Missouri, the squaw-man trader Billy Downs had also turned his store into a supply base for questionable characters. Such places were hangouts for notorious individuals like "Rattlesnake Jake" Owen, Charles Fallon, "California Jack" Adams (an escaped criminal with a $10,000 reward on his head, warm or cold), and many others. The gangs to which they belonged were well organized, arrogant, and dangerous. Their principal occupation was horse stealing. They would drive the stolen stock into their hide-outs in the badlands, work over the brands, and then dispose of them along the Missouri River or across the line in Canada. In turn they would bring stolen horses down from Canada to sell in the booming cattle country of central Montana. Drama and conflict were inevitable.

It was in the midst of all this that Charlie Russell passed from his teens to manhood. His greatest pride was a feeling that he "belonged."

AN INTRUDER

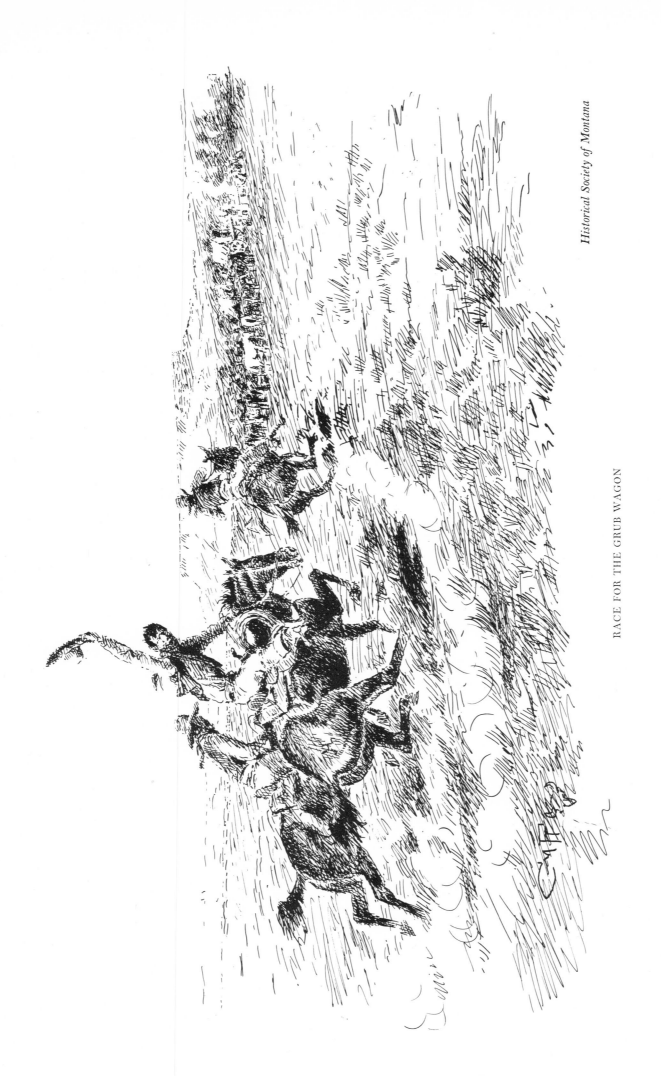

RACE FOR THE GRUB WAGON

CHAPTER IX

The Passing Show

ROUGH RIDING

I N MONTANA'S midland prairies and mountains the transition from the primitive days of the Old West to the era of passive urbanity was most hectic between 1880 and 1890. It was a decade of struggle, for both red men and white, against one another and among themselves. It saw the Indian trade his last war bonnet for a whiskey bottle and become stripped of the final vestiges of his tribal dignity in the concentration camps of the reservations. It saw the white man complete his conquest, trade his buckskins for store clothes, and plant his roots as a serious citizen of the land, amid a violence of final adjustment.

Probably the most influential factor in bringing about the change was the railroad. It was on the afternoon of September 9, 1883, that the golden spike was driven in to mark the completion of the transcontinental Northern Pacific Railroad, which crossed Montana Territory from east to west. The scene took place at Gold Creek, fifty miles west of Helena—just seventy-eight years after Lewis and Clark blazed their trail through the same territory. More than three thousand Americans and some distinguished foreign guests gathered in the grassy meadow for the ceremonies. Special trains had brought the dignitaries—including General U. S. Grant and the British and German ministers to the United States—and about three hundred sightseeing excursionists from the East to participate. There were also several journalists and artists present to give the occasion the widest possible publicity in newspapers and magazines throughout the world. A fine pavilion had been built, and it was gaily decorated with bunting and flags. There were oratorical speeches, with glowing prophecies of the great prosperity which the new railroad would bring to the already rich country through which it passed. The speakers had much to say about "the highest development of civilization," which was now to bless the land.

Among the gala events that had been arranged to impress the visitors was one which took place near the town of Billings. There the excursion trains were stopped to witness an Indian tribal dance. A large group of submissive Crow Indians had been herded from their reservation under an adequate military escort. Against this night glow of large campfires and a background of brightly lighted excursion train windows, the sightseers were entertained by

89

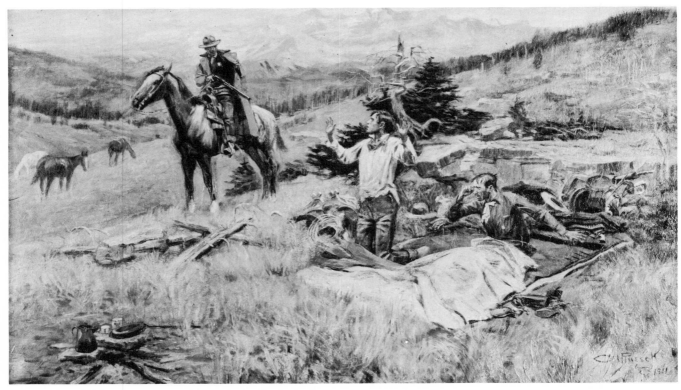

CALL OF THE LAW

the drum beats, jingling bells, and weird chanting of the traditional Grass Dance. For the moment, the Old West became a side show and the tribal dignity of the red man a theatrical sham.

Already the signs of the future were apparent in the form of emigrant families, school-marms, tradesmen, lawyers, preachers, and other symbols of the white man's civilization. Remnants of the old days struggled against the flood tide.

During the winter of 1883-84 it was estimated that about a thousand hunters were engaged in the business of killing buffalo along the Northern Pacific Railroad in Montana and western Dakota.[1] Nature's cattle supplied the principal source of meat and hides for a rapidly dwindling number of the North Plains Indians, although the great herds were entirely a thing of the past throughout most of the areas where they had once been so plentiful. None at all were to be found in many regions. The frontier had moved northward and now the railroad was like a plunging knife in the back of the retreating past. Although the hide of a buffalo bull now brought only $2.00, a cow's $3.25, and that of a two-year-old calf only $1.50, the hunters with their newly developed, long-range rifles seemed intent on carrying out the slaughter of the species.[2]

The year 1884 brought melodrama to the Judith Basin. It was then that Granville Stuart and Andrew Fergus organized and led an armed party of 150 cowboys and cattlemen in destructive warfare against horse thieves and cattle rustlers. It is conservatively claimed that during the first year not less than twenty-one captured suspects cooled their heels from a limb of the nearest tree, although the men who took part in these expeditions of vengeance

were all bound by oath never to recount any of the incidents, and the true story of those vigilantes of 1884 remains one of the untold chapters of Montana history.[3]

It required rough retaliation to cope with the boldness of the bad-men who were operating in the district. The following is an excellent example of real-life melodrama, not recounted from the memory of an old-timer, but quoted directly from an account in the cow-country newspaper that was printed only a short distance from where the episode transpired and written a few hours after it happened. The incident occurred in the budding town of Lewistown, and the newspaper was the *Mineral Argus* of nearby Maiden. The issue was that of July 10, 1884. The headlines read: "PERFORATED THEM! / The Way the Citizens of Lewistown Celebrated on the Fourth / Two Desperate Characters Attempt to Hold Up the Town / Charles Owens and Charles Fallon Will Steal No More Horses / A Lively Fourth That Will Go Down in History as the First in Lewistown and the Most Thrilling in the United States in 1884." Then the story followed. It is worth repeating as an example of the environment in which Charlie Russell found his life's work.

"Last Saturday morning the air was filled with rumors of a desperate battle between two desperadoes and the citizens of Lewistown, on the evening of the Fourth . . . In order to furnish our readers with the facts as well as a complete, unexaggerated statement of the occurrence, we secured a conveyance and drove to the scene of action. At Lewistown we found the various business men pursuing their several vocations, showing by neither action or word that a few hours before they had participated in a bloody affray . . .

"It seems that these desperate characters arrived on the creek some three weeks ago, with a band of horses which they stated they had drove up from Wyoming. They camped in various places, trading or selling off their stock . . . The older of the two was slim built, wore his dark brown hair flowing over his shoulder, his thin lips, peaked nose, sallow complexion and small gray eyes made up a face that seemed to indicate a combination of daring and cruelty. The owner of this illfavored countenance gloried in the sobriquet of 'Rattlesnake Jake'. . . His weapons were two long barreled 45 calibre revolvers and two knives, all in holsters and sheaths attached to a cartridge belt around his waist. His companion was about the same build and makeup, though not quite so hard a looking citizen . . . who went by the name of Charles Fallon and carried a Winchester rifle and knife.

"Friday afternoon these men rode into town. Soon after their arrival a race was gotten up between two scrub horses, and while the crowd was down at the place where the race was about to start, a dispute arose between H. Goodshaw (better known as Dutch Henry) and a half-breed named Bob Jackson. 'Rattlesnake Jake' dropped off his horse and edged up to Jackson, holding his hand on his gun. As the dispute ended without blows . . . Jake struck Jackson across the mouth with his revolver, knocking him down. Jackson scrambled to his feet and run off . . . Jake then remarked to Fallon that he guessed they would TAKE THE TOWN.

"A few minutes later they entered Crowley and Kemp's saloon where they took three drinks apiece, Jake remarking that he would be satisfied if he could only kill that s— of a b—— of a half breed . . . When they stepped out of the saloon, John Doane was standing in the door of T. D. Power & Bros.' store. Jake stepped up to him and whipping out a gun began firing, while Doane threw up his revolver and fired, hitting Jake in the forefinger of the left hand (in which he held his gun). He then took his revolver in his right hand and fired

into the store at Doane. By this time the scramble for guns was general and shooting began in earnest. Fallon was on his horse in the act of discharging his Winchester at anyone within range when he was shot through the abdomen, causing him to fall forward on the horn of his saddle . . . Fallon dismounted, dropped on his knees and taking deliberate aim at a young man by the name of Ben Smith, who was running to get out of the way of the bullets . . . and the ball struck Ben in the left cheek causing instant death.

"By this time citizens from behind saloons, barns and Kemp's ice house were pouring a destructive fire into the doomed pair, who as long as they were able to pull a trigger, kept returning shot for shot. Owens was the first to fall while Fallon bit the dust a few minutes later . . . Nine bullet holes were found in the body of Owens and five in that of Fallon. Saturday morning the bodies of the outlaws were furnished with wooden overcoats ready for burial, but before planting they were photographed as a souvenir of a 'red letter day' in Lewistown." As a postscript it might be added that the rancher on whose land the outlaws were buried, strenuously objected and finally himself dug up the crude caskets. Attaching a lariat rope around the neck of each corpse, he mounted his horse and dragged the bodies across the prairie to a new place of repose.

The vigilantes were continually going into action to make horse stealing and cattle rustling unpopular even among the boldest of desperadoes. A surprisingly large number of culprits were captured and summarily strung up on the nearest tree, or shot on sight, although the fellowship of outlawry persisted and prospered. A further indication of its extent is found in the same local newspaper in the issue of November 5, 1885: "The Buchanan boys returned last week from Fort McLeod, Northwest Territory, where they had been in search of horses

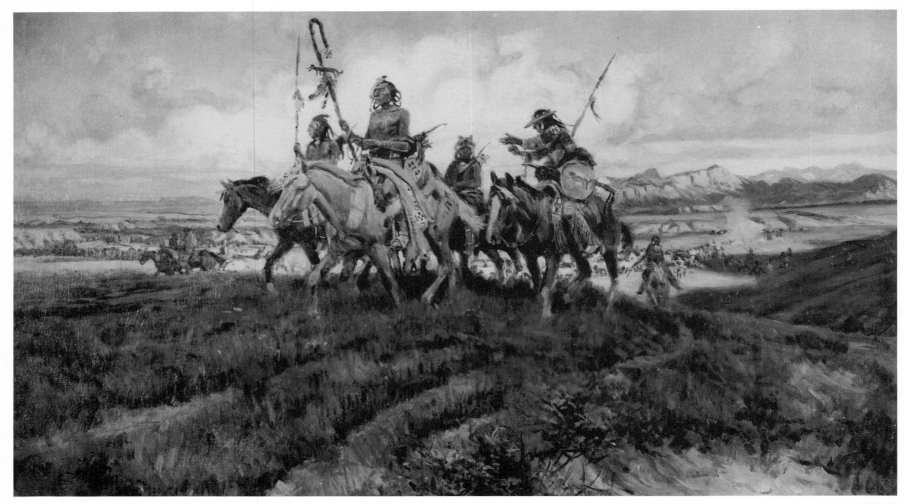

Findlay Galleries, N.Y.C.

WOLF MEN

"A NECKTIE PARTY"

stolen from them last summer. Having learned that their horses were in the possession of the Blood Indians, they started for their reservation about two months ago in the hope of recovering them. Reaching their destination, they secured the aid of a small detachment of the Mounted Police and made a visit to the camp of the Bloods. Their mission was made known through the interpreter, but the Bloods refused to give up a horse or allow any inspection of the stock in their possession. The party was compelled to leave without any satisfaction whatever. The boys say there are fully a thousand head of horses in the hands of the Bloods. Some of the brands are changed, while others are 'skinned' to prevent identification."

Along with the rapid development of the cattle and sheep industries, the difficulties between the white men and the red men intensified. It was only natural for every self-respecting Indian to rebel against the invaders who were gobbling up and growing fat on the red man's ancestral lands. The situation was aggravated by the derisive attitude of the white man. The state of affairs in the Judith country is clearly set forth in an editorial in the *Mineral Argus* for September 10, 1885: "THE RED DEVILS," reads the heading. "During the past summer small lodges of Bloods, Piegans and Crows have been prowling around the

Musselshell, Judith and Missouri valleys, killing stock and stealing horses; in most instances leaving their reservations with permits from the agent having them in charge, which they secured under the false plea of visiting other tribes. The experience of the past summer is all sufficient to settlers and military authorities that the sole object of the Indians in leaving their reserves is to plunder, kill stock and steal horses, the property and belongings of white settlers . . . There should be no further favoritism shown the thieving red devils by military authorities . . . The 'Noble (?) Red Man' will speedily realize that, if he desires to exist on this sphere, he must remain on the grounds set aside for his exclusive occupation. This is as it should be, yet the big-hearted, philanthropical, goggle-eyed, heathen converters and Indian civilizers of Yankedoom cannot understand it and will probably protest."

Even when the roughriding buckaroos went to town for their bits of fun, there was apt to be fireworks. Once again an illustration may be drawn from the contemporary columns of the local newspaper, this time a tongue-in-cheek account of the day's happening:[4] "COWBOYS ON THE RAMPAGE—After Filling Up with Bad Whiskey They Endeavor to Paint the Town Red," read the headlines, and here is an abbreviated on-the-spot description of what happened: "Friday afternoon five cowboys rode into town from the LS roundup camp . . . They were good riders and mounted on firey steeds. Their conduct upon arrival was such to occasion no suspicion of what they might do when surcharged with the amber-colored liquid . . . But they must have stored up a stock of cussedness for their departure in the morning . . . when they treated the citizens to an exhibition of reckless horsemanship, shooting their revolvers in a bold and careless manner, as they rode away. In passing William Pott's saloon, they fired eleven shots into the building, four of which entered the sign over the door and tearing the ceiling within. Charles Archer and A. J. Campbell were sleeping inside at the time of the fusilade, but laid low until the storm was over . . .

"All this would have passed without serious consideration, but prior to their departure in the morning, one of their number had a little difficulty upon leaving a sporting house and

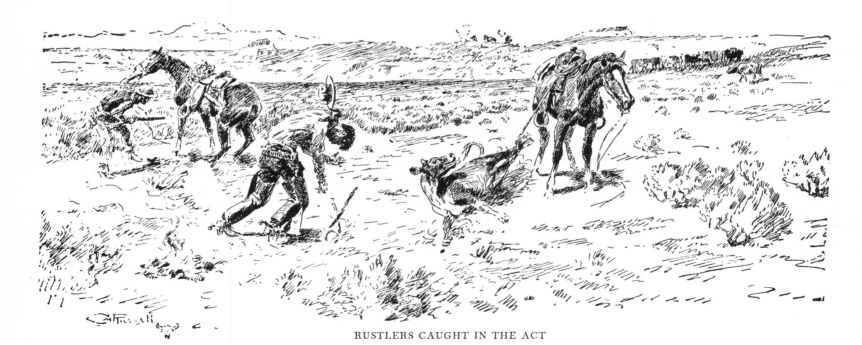

RUSTLERS CAUGHT IN THE ACT

Constable Washburn was called to arrest him. Approaching the cowboy the Constable was about to do his duty when a revolver was suddenly thrust in his face followed by the command: 'Stand back you s-n-of-a-b——,or I'll shoot you!' Mr. Washburn could do nothing better than to retire in good order and wait for reinforcements . . . Mounting his horse the cowboy rode away.'' The article continues in a jocular vein to explain that Constable Washburn, with reinforcements, later visited the roundup camp, where he found the erstwhile boisterous cowboys in a much less pugnacious frame of mind, though nevertheless solidly protected by their companions against anything more serious than verbal reprimand. When faced by the constable they explained that they ''were merely having a good time, but their horses' feet were sore and they guessed they wouldn't go back again . . .''

Those were exciting days for Charlie Russell. There was little that he missed—for he always rode with the wild ones. More important, he made what was virtually a photographic catalogue in his memory of practically everything that happened—scenes that were drawn upon throughout his life to supply the subject matter for many a documentary picture of those times. Among these is ''A Quiet Day in Utica''—or ''Tincanning a Dog'' (page 96), painted in 1907 for Walter Lehman, who had requested something suitable for use as a calendar in his Utica store. When it arrived the scene was found to show not only the early-day Lehman store but a lifelike portrait of its bewhiskered proprietor standing in the doorway. The other individuals were also painted from memory with such accuracy that they were immediately recognizable. Charlie Russell himself can be seen leaning against the hitching rail in front and a little to the left of the store. In back of him is standing Jake Hoover; and between Hoover and Lehman is a character who was known as Millie Ringgold, a Negro woman of Yogo. Stooped over, in front, is Teddy Blue Abbott, with Breathitt Gray who ran the hotel and saloon farther down the street. The three riders, from right to left, are Frank Hartzell, Bull Nose Sullivan, and Bill Quigley.

Historical Society of Montana

JOE SLADE—KILLER

A QUIET DAY IN UTICA

AT CLOSE QUARTERS

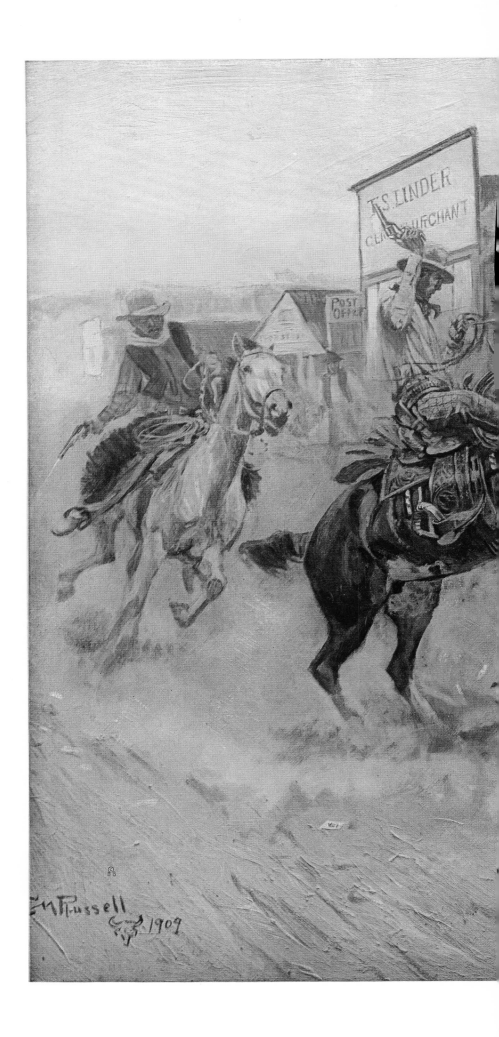

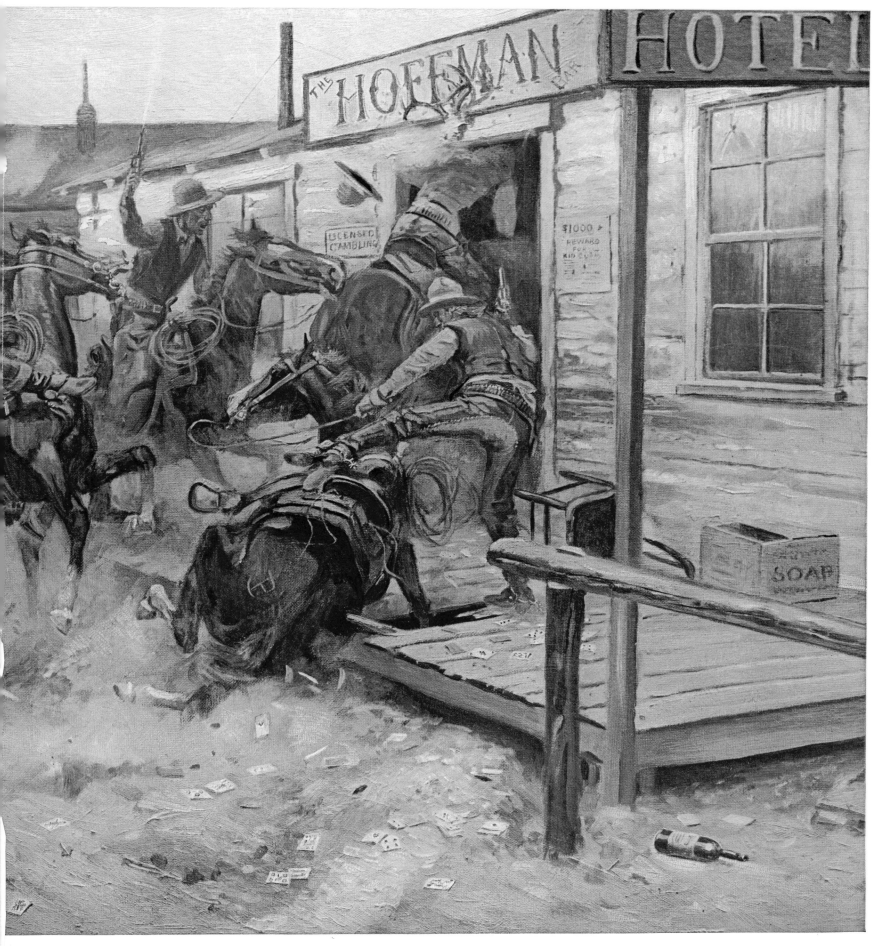

IN WITHOUT KNOCKING

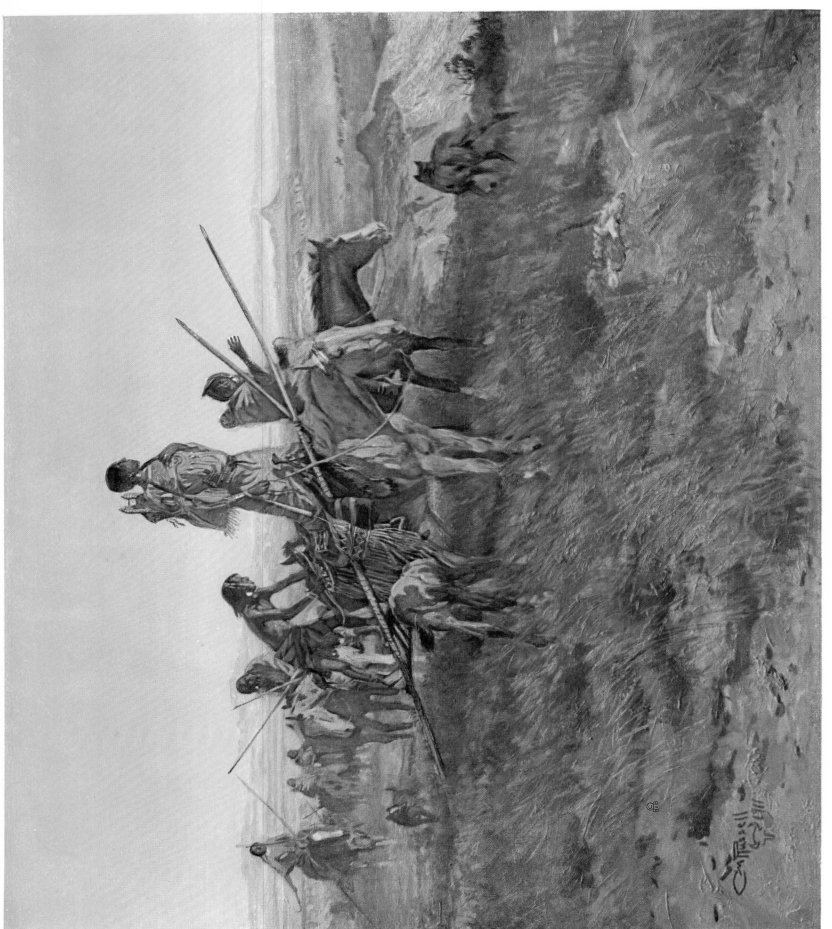

IN THE WAKE OF THE BUFFALO RUNNERS

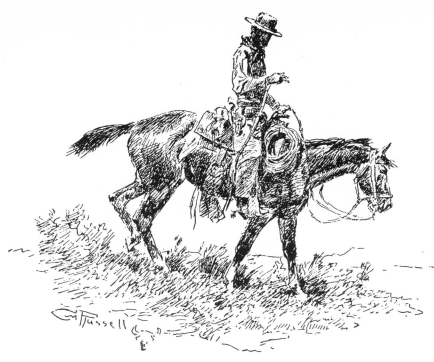

RIM—FIRE DOUBLE CINCH RIG

CHAPTER X

"Last of the 5,000"

DURING THE first six years that Charlie Russell made the Judith his home and earned his meager living in the saddle, he gained a broadening reputation as an artist. But the recognition he achieved was mostly local, and the time he spent at painting was considered strictly as the hobby of an eccentric young maverick of a cowboy. His pictures had enough realism to have a strong appeal, although their greatest attraction lay in the fact that they portrayed cattle-country scenes with which their admirers were familiar. Some of the drawings had been carried back to Helena and other places in the pockets of itinerant cowpokes, and a few of the more pretentious paintings had gotten into the hands of visiting cattle nabobs and taken home to be hung in their offices. Occasionally one was nailed up in a local saloon or store, until someone carried it away. Although Charlie had made considerable progress in his art he still made no effort to convert his talents into personal gain, and even the oil paintings he produced were readily given to the first passing acquaintance who happened to admire them.

The summer of 1886 was an unfortunate one for the ranchers of central Montana. A long and particularly severe drought turned the green pastures of the prairie into a virtual desert.[1] The parched grass was not only unfit for fattening the market beef, but it provided the tinder for a number of fires that swept over large areas. It was rumored that the Indians indulged in the vengeful satisfaction of starting most of these fires where they would produce the most disastrous results. The stream beds dried up, and cattle became walking skeletons and their carcasses were scattered everywhere. Only the magpies and coyotes got fat. The repercussions of misfortune visited practically every ranch, store, and saloon, and by mid-July there were more people on the stagecoaches leaving the Judith Basin than coming in.

The spring roundup had been a bumper one. The cattle population of central Montana had increased prolifically. The Judith Roundup at Utica amounted to an estimated 25,000 head, principally represented by the True, Hobson, Schaffer, and Kaufman-Stadler outfits. The Flat Willow pool was said to run as high as 56,800, and there were a number of smaller roundups around the country.[2] But the success of the roundup proved to be like drawing an

ace to fill a full house, only to lose eventually to four of a kind; and the discouraging events of the summer were merely a mild prelude to the winter that followed.

The cattle that survived the summer drought were in bad shape when the cottonwoods turned gold, and there was very little winter feed on the range. They faced a tough struggle to survive, under the best of weather conditions. But by mid-November a severe storm swept down from the Canadian Arctic that spread over the whole country from the Rocky Mountains to the eastern states. Thus began one of the worst winters in the history of the West. To quote briefly from the record, on November 17, 1886, a Chicago news service sent out a summary reported as follows by the U.S. Signal Office:[3] "Omaha.—It has been blowing a blizzard since early this morning and every railroad is more or less blocked.

FINDING THE OLD LOG SHACK

Travel is entirely suspended. The storm is general throughout the plains region. . . . Sioux City.—A train with 100 passengers on board is snow-bound eleven miles west of Canton, Dakota. The Milwaukee railroad is lined with engines in drifts. . . . Denver.—The west-bound Kansas Pacific mail train has been snow-bound at Brookville since Monday. The east-bound train, delayed at Hugo, is expected through tomorrow. No Burlington train has arrived since yesterday. . . . Sioux Falls.—More snow has already fallen than during the entire of last winter."

Central Montana, as usual, got the worst of it. Along with the Arctic wind and drifting snow, the thermometer took a nose-dive far down below zero. Many of the stock raisers faced complete ruin. The cowboys were called upon, as they never had been before, to put every last effort into saving the remnants of the herds. This was as severe an ordeal for the men in the saddle as for the starving cattle. It was difficult to find areas where there was even a little feed and to keep the emaciated stock from scattering or drifting before the storm

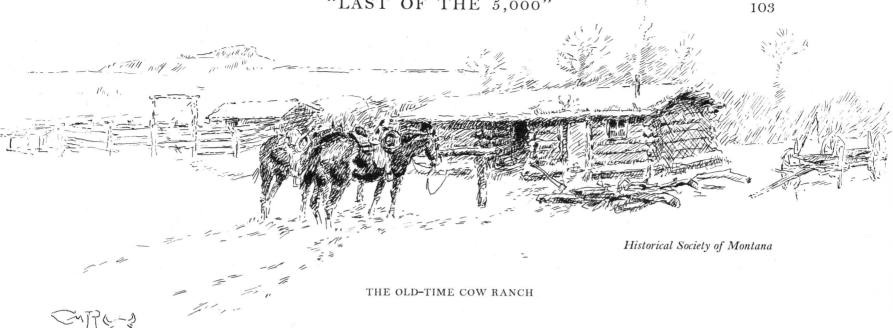

Historical Society of Montana

THE OLD-TIME COW RANCH

and dying standing up. There was no shelter for beast or man. The ground was frozen hard as rock and many a pitfall amid the rimrock lay hidden beneath the drifted snow. Merely riding all day in the saddle, whipped by the icy lash of the storm and cut to the bone by the freezing cold, was an agony almost beyond endurance. The nights were a hundred times worse. More than one night herder failed to return to the bunk-house and his frozen body was found the following spring.

There were no breaks in the bad weather to give at least temporary relief. Fort Benton's little newspaper the *River Press*, in its issue of December 22, included the following comment in its report on the local situation: "Haystacks were overturned, fences were blown down and light articles seemed to be immigrating eastward, and the cattle had to tie their tails to their hind legs to prevent them being blown off." Even the freight wagons failed to get through, which resulted in a serious shortage of food and other necessities of human existence. The same newspaper in the issue of January 19, 1887, had this to say: "There is only about 100 sacks of flour in town and in a few days that will be gone . . . Coal oil is also scarce . . . This community is in a bad fix." And here are some other excerpts from succeeding issues: February 2: "The temperature at 2 o'clock today was 42° below zero, with a gale blowing from the north . . . The result will be immense losses in stock, unless the warm wind of a Chinook should set in to clear the ranges of snow and enable the cattle to feed." February 16: "It was 30° below zero last night by Wackerline's thermometer, which is said to be the best in town." February 23: "The Chinook reported at Helena yesterday was a fraud and delusion . . . P. J. Harvey, who just arrived from Stanford, says the cattle in that section are dying by the wholesale." It was not until the issue of March 2 that the desperately awaited warm winds of a Chinook were finally reported: "The Chinook which has been blowing . . . with the temperature at 42° above zero and the wind attaining an estimated velocity of 30 to 50 miles an hour, has rapidly melted the snow. It has been tardy in coming . . . The points of the hills are bare and the hungry cattle are seeking them . . ." March 9: "Our losses in cattle are simply immense . . . we cannot tell how severe."

During this long period of ordeal and disaster Charlie Russell had been working with Jesse Phelps of the O–H outfit and they were living in the ranch house. They had also been looking after a large bunch of cattle belonging to Kaufman and Stadler, who had their head-quarters in Helena. Along toward the end of that awful winter Phelps received a letter from Louis Kaufman requesting a report on the situation in regard to their herd, which at the beginning of the winter had numbered about 5,000 head. Jesse tried to write a letter in reply, but he didn't have the heart to tell Kaufman the whole truth. Then Russell got an idea. According to Charlie's own version of the story,[4] he found a small piece of paper, about 2″ x 4″, and got out the watercolors that he packed around with him in an old sock during the winter. He quickly sketched a starved-looking steer, showing the Kaufman-Stadler Bar–R brand on its bony flank, standing humped over in the snow about ready to keel over, while some hungry coyotes impatiently waited for the meal that was soon to be theirs. When Charlie finished the little watercolor he signed it and appended the title, "Waiting for a Chinook" (page 107). He tossed the little picture to Jesse Phelps with the remark, "Send 'em that." It was put in an envelope, without any further word or report and mailed to Kaufman.

When the watercolor was received in Kaufman and Stadler's office in Helena it caused considerable excitement. It represented, more impressively than a thousand words might have done, what had happened to the 5,000 head of the Bar–R cattle. Kaufman stuck the picture in his pocket and went across the street to show it to Ben Roberts, who operated a harness and saddle shop—and was later to become one of the artist's best friends. Then the cattleman went down the street to the nearest saloon to show it to others. There wasn't a soul in town who wasn't deeply concerned about the disastrous results of the winter, and every time a stock man looked at the picture he had another drink to drown his feelings of despair. It made the rounds of every bar in town, and everybody who had missed it somehow came to the Kaufman and Stadler office to see it. Someone, probably Kaufman himself, added a subtitle, "Last of the 5,000," by which name the picture became widely known throughout the cattle country.

Stadler and Kaufman treasured the little sketch for a number of years, as a graphic document of the tremendous losses they suffered that disastrous winter. To satisfy a wide-spread demand for copies, they had it photographed and the prints were scattered far and wide. Then it was reproduced as a postcard and hundreds of thousands of these found their way literally to all parts of the earth. Crude though the drawing was, it caught the popular fancy and brought fame to Charles M. Russell, "the cowboy artist." Even now, after well over half a century, the same postcards are widely sold in Montana.

Louis Kaufman finally gave the original to Ben Roberts, who later sold it to Wallis Huidekoper. A good many years afterward it came into the possession of the Montana Stock-growers Association and hung in their offices in Helena. Today this tiny picture hangs in the Russell Gallery of the Historical Society of Montana, in Helena.

Another sign of growing recognition for Russell's work was a brief article in the Fort Benton newspaper the *River Press* for the date January 12, 1887: "While at Utica a River Press representative met Mr. Charles Russell, an artist of no ordinary ability. He had painted several of the most spirited pictures of cowboy life we have ever seen. One of them, painted for Mr. Phelps, represents a cow camp and last winter was exhibited at the St. Louis exposi-

tion. Mr. Russell prides himself on being a cowboy and has been engaged in the business for several years. He is now engaged in painting a picture for James R. Shelton, in which are embraced the buildings which comprise Utica, with a lively cow camp in the foreground. Mr. Russell is a natural artist and we have been informed that he never had any instruction in the art. He is too modest to admit it, if he had."

Of considerably more consequence was an article which appeared in one of Montana's leading papers, the Helena *Weekly Independent* in the issue for May 5, 1887. The headlines

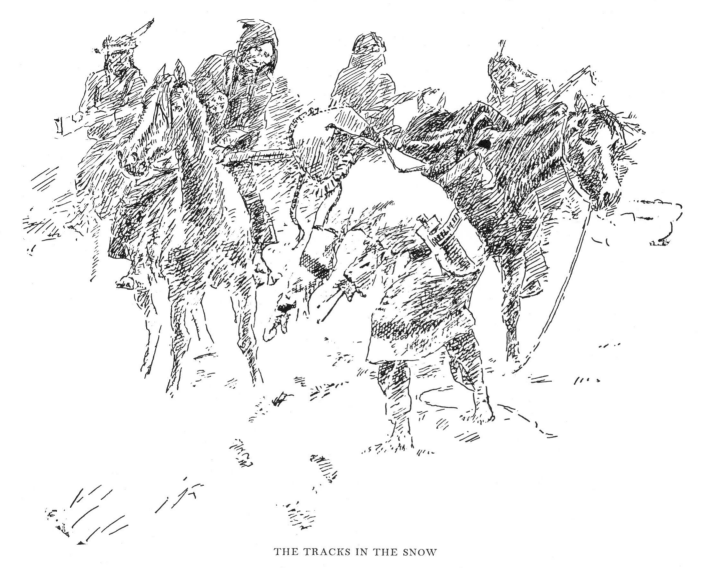

THE TRACKS IN THE SNOW

read: "A COWBOY ARTIST—A Fine Oil Painting by a Range Rider Who Never Studied Drawing in His Life.—On the Wall in Huntley and Pruitt's store hangs a painting with a strange history. It is on canvas, about two by two and a half feet, and, if slightly inartistic in some of its details, is of fine conception and, in the main, finely colored and executed. It was painted in the seclusion of a cow camp on the Judith Range, and by a cowboy. It represents a roundup camp, scattered out on the range after early breakfast—the boys saddling their unruly cayuses, the vicious beasts bucking in every conceivable shape or flying away towards the herds. The foreground shows the camp-fire, tents and mess wagons, and in the background stretches

a range of mountains . . . Altogether it is a wonderfully faithful picture and one that bears much study. The artist is Charles Russell, a cowboy 21 years of age, the son of a well-to-do family of St. Louis. He is a natural artist but never had a day of study in that line . . . The cowboy life suits his eccentric nature, and especially night-herding, at which his time is spent. He will take no money for his pictures, but gives them to his particular friends. This one he gave to Mr. Phelps, the stock partner of Huntley & Pruitt . . . Russell it was who painted the realistic picture of ravage desolation entitled 'Waiting for a Chinook,' which has been extensively photographed."

Three weeks later the Helena *Weekly Herald*, in its issue of May 26, carried the following article: "A DIAMOND IN THE ROUGH.—Within twelve months past the fame of an amateur devotee of the brush and pencil has arisen in Montana, and, nurtured by true genius within the confines of a cattle ranch, has burst its bounds and spread abroad over the Territory.

"Seven years ago a boy of fourteen years left his home in St. Louis and came to Montana, going into the Judith Basin, where he got employment on a cattle ranch and has remained ever since. With the lapse of years and growth to manhood the young fellow developed into an expert cowboy . . . But the spark of artistic genius, implanted in his soul, soon made itself visible and called his energies into the cultivation of talent and ability for sculpture and painting . . . The young cowboy employed his leisure in modeling figures out of plastic materials and in transferring to canvas and paper representations of the rude scenes surrounding his life . . . Never having taken a lesson and with nothing to guide his pencil but the genius within him, C. M. Russell became celebrated in the neighborhood as a painter. His pictures soon found their way to the centers of population, until now his works in oil and water color, evolved amid the rough surroundings of a cattle ranch, adorn the offices and homes of wealthy citizens of Montana's principal towns.

"Mr. Russell's forte lies in depicting animated scenes . . . all drawn from his Montana life on the range and their faithfulness is surprising. One of his well known works is entitled 'Waiting for a Chinook,' and represents a lone steer, 'the last of five thousand'. . . is most realistically done . . .

"His latest work, an oil painting now on exhibition at Calkins and Featherly's represents two Indians about to shoot at a band of antelope. The scene is taken from the bad lands and is an apt representation of that barren district." The article continues with a lengthy and detailed description of the painting and closes with the following comment: "This painting as well as several of the artist's former works, has been purchased by Mr. T. W. Markley, of Washington, father of A. W. Markley, of Helena. Mr. Russell is now in Helena, industriously plying his brush. He has had an offer from Mr. Markley to go to Philadelphia, enter an art school and cultivate his marvelous talent. All who know the young artist and see in his abilities the promise of a bright career, hope he will accept Mr. Markley's proposition and go East to perfect the wonderful faculties with which he is endowed."

After another three weeks the Helena *Weekly Herald* ran a further story about "another painting from the brush of C. M. Russell, the cowboy artist," which was "exhibited in the window of Calkins and Featherly's store and daily attracts the admiring glances of hundreds of people." This one was described as portraying an Indian village in the midst of breaking camp "and the artist has depicted the scene with the fidelity of nature which characterizes

This is the real thing
painted the winter of 1886
at the O H ranch
C M Russell

This picture is Chas.
Russell's reply to my
inquiry as to the
condition of my cattle
in 1886. L E Kaufman

WAITING FOR A CHINOOK

all his sketches from life." The article also stated that "the young man will busy himself a few weeks longer on promised pictures before taking his departure for Philadelphia to commence the study of art under the encouraging patronage of Mr. T. W. Markley."

That Russell was hard at work with his paint brushes is once again indicated by an article in the Helena *Weekly Independent* for July 7, which describes a roundup scene put on display in the Calkins and Featherly window. "As the Independent has said before, every picture of this natural artist is better than the last . . . In the front is the buffalo skull which he puts on all his pictures and which he says is his trade mark. Russell, who is the cowboy in every tone, gesture and movement, is truly the artist of the prairies, the cattle camp and the range. He is a Montana development, and if he ever attains the eminence that the Independent believes him capable after some study, Montana will claim him, and expect to see that buffalo skull crop out once in a while."

We can only conjecture as to what was transpiring in Charlie Russell's mind and heart during that spring and early summer of 1887 which he spent in Helena. It is quite apparent that he was making an ambitious attempt to become a successful artist; that he was being accorded a stimulating amount of encouragement; and that he would soon have to make an important decision. The offer of patronage by a wealthy man, which would permit him to go East and perfect his talents in one of the country's best art schools, was surely foremost in his mind as he labored with brushes and paints in some nondescript excuse for a studio, probably a cheap lodging place in a back by-way of town. The two trails led far apart, into entirely different worlds.

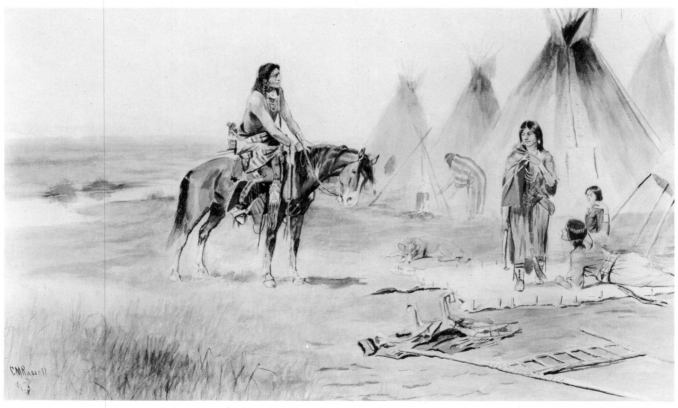

Newhouse Galleries, N.Y.C.

THE BRAVE'S RETURN

HE REACHES FOR THE JEWELED HAND

CHAPTER XI

Brother to the Tribe

CHARLIE RUSSELL went home to his cattle country instead of accepting the philanthropic offer to attend art school in the East. A bit of local news in the Fort Benton *River Press* for August 3, 1887, attests to the fact that he had returned to the Judith Basin after the brief stay in Helena. There is nothing about why he went one way and not the other. That the matter was not entirely settled can be read between the closing lines of that same brief newspaper squib: "His latest picture is now in Chicago, where it will be photographed and thereafter returned here for exhibition. The photographs [photogravures] will be sold for his benefit. With the money he has raised by his paintings, and what he will earn on the roundup this year, he will go east next autumn and attend art school." The picture referred to was a composite of seven scenes of cowboy life. By all reasonable standards it was a pretty crude work of art, although it was made into a photogravure which became what is evidently the first Russell print. The central subject of the composition was entitled "On Day Herd" and other segments carried the titles "On Night Herd," "Roping," and "Bucking Bronco" (page 63).

Russell continued to follow the lines of his old life. All the stock men had taken a severe beating during the previous winter of starvation and disaster, but the effects were quickly disregarded and they went to work with renewed vigor and courage. The only thing that Russell didn't like was that things were becoming too civilized in the Judith Basin to suit his personal taste. As a sign of the changing times, there was even a Widow Oats, who had homesteaded 160 acres about six miles down the road from Utica. Mrs. Oats had come into the country quite destitute and alone, determined to build a future for her three young children. She had a small son and two very pretty little girls whom the local cowboys nicknamed the "Little Swamp Angels," because part of their land was a swamp. About all the Widow Oats had at the beginning was a large washtub and washboard, with which she promptly began making out all right by doing laundry for the local cowpunchers and the town folks in Utica. At the rate of two bits for two pairs of socks or a shirt, she was not only feeding her three youngsters, but managing to buy a few chickens now and then, or a sow

pig or milk cow. The eggs and the milk that she sold added considerably to the intake. There wasn't a cowboy or even a horse thief in the whole basin who didn't have a warm spot of admiration for the little woman, and some of the old rawhides hadn't had so many clean socks and shirts since they left home. About the only bachelor in the district who didn't make frequent trips to do trade with the Widow Oats was Charlie Russell.

It should be stated as part of the record that Russell was in those days far from a prim and fastidious individual. A particularly pertinent insight into this side of his personality was obtained by the present writer from a nice little old lady who now lives in Missoula and whose recollections go back very clearly to the days when she was one of the "Little Swamp Angels" of the Widow Oats.

COWBOY FUN

"We used to see Charlie Russell frequently," she reminisced, with a twinkle in her gray eyes. "He was always nice to me. But mother had no use for him. He was notoriously dirty and untidy in his habits, by all of mother's standards. He would wear a shirt until it became so dirty and greasy that it would almost stand by itself, then instead of taking it off he would put a new one over it—and keep that up all winter. By spring he might have on half a dozen shirts. When the weather started warming up he'd start taking them off one by one. He would be down to bed rock when it got hot. The few times that mother did any of his washing she made him boil the whole works before she would touch them.

"I remember one time that he came and after turning over his small bundle of washing to mother he kept standing near the back door and talking to me in a rather peculiar way. He had his hat off and his hands were fumbling around underneath it. I tried to go inside but he made me stand there. The way he kept looking at me, grinning and talking, made me feel very uneasy. But in a few moments he put his hat back on and with an even bigger grin he handed me a piece of clay, which he had been modeling out of sight into a funny little girl in a sunbonnet. I wish now that I had kept that little piece of sculpture.

"Once I was delivering eggs with my brother, to a roundup camp. It was the year after the 'hard winter.' They were camped on a creek that didn't have a name. When I arrived most of the cowboys were in camp and a number of them were down by the creek, rinsing their shirts and pounding them between rocks. That's the way they got rid of the lice. Russell and another puncher, Frank Plunkett, were merely standing by and watching. They were two of a kind. They got into an animated argument as to which of them was the most lousy and which one had the biggest and fiercest lice on his body. It was all horseplay, of course, but you'd think they were in dead earnest. Finally they made a wager and decided to prove their claims. It was all very formal. They put up the money and a referee was selected. A short piece of wood was found, to serve as a field of battle. Then each of them pulled open

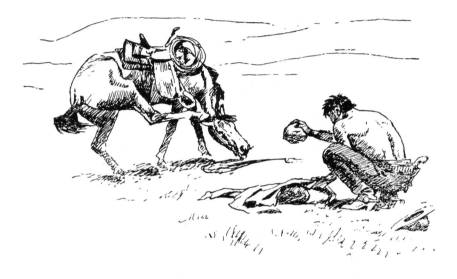

HOW LOUSE CREEK GOT ITS NAME

his shirt and started searching for the biggest and fiercest parasite that could be found. With all the other cowboys crowding around and laughing, the diminutive gladiators were supposedly placed in a 'ring' that had been marked out on the board, and with much shouting and laughing they were urged into battle. When everybody was all tired out, each owner pretended to pick up his own louse and carefully put it back inside the shirt from whence it had been taken. I never knew which one was supposed to be the winner, but I will never forget standing goggle-eyed and watching that incident. Many years later I read Russell's story 'How Louse Creek Was Named,' in his book *Trails Plowed Under*—and he no doubt got the idea from that little affair I witnessed as a girl. But it is really no particular reflection upon Russell, for nearly everyone got lousy now and then, in those days.

"During the winter, when Russell would ride the grub line in search of free meals and lodging, as many of his kind were in the habit of doing when they were out of work, he was sometimes even a little too much for the other cowboys—when they gathered around the hot stove in a small bunk-house. There was a story that went the rounds, that on one such occasion the boys heated up the washtub of water and the whole crew ganged up on Charlie. Stripping off everything he wore they held him in the tub until he got a right thorough scrub-

bing. They said the place was almost wrecked in the process, but that was at least one time that Charlie Russell had a bath, while he was cowpunching in the Judith Basin."

In the fall of 1888 Russell rode his saddle horse Monte back to Helena. The *Weekly Herald* in the issue of September 27 gives a possible clue as to why he made the trip: "C. M. Russell, the cowboy artist, has returned to Helena after several months absence on the range, where he no doubt secured subjects for more of his characteristic paintings. Mr. Russell, we understand, is seriously considering the propriety of going to Europe to perfect his talents in the noted art schools of the old world. It is said his friends have perfected arrangements to give him the best of advantages under the best masters of Italy, and that he may soon leave for that artistic land."

But Russell did not go to Italy to study under the great masters, nor did he go to any other art school, in Europe or anywhere else. Instead he chose a completely different course. He went to live with the Indians—not just as a casual visitor, but to live in their skin lodges as one of them. He rode Monte over the long trail that led north, beyond the Canadian border and into the land of the Bloods, a primitive band of the Blackfeet. These tribesmen had not yet been crushed under the white man's heel of subjugation, as had their brothers on the reservations below the border.

Previously about the only real contact that Russell had had with the Indians was on the few occasions when furtive red hunters had visited the upper South Fork, when he was living with Jake Hoover. Otherwise the bitter antagonism of the cowboys with whom he always traveled had virtually prohibited even the most casual friendly relations. It would seem more natural for him to have acquired an uncompromising contempt for all red men, rather than to have become one of the most earnest and articulate champions of the Indians' cause.

It has been implied that Russell's trip up into Canada was the result of a drunken spree in Helena.[1] He may well have been on a spree just before he started out, and it may have taken quite a number of drinks to induce the two other cowboys to go along with him on such an unreasonable venture. The old human urge to find out what is on the other side of the mountains may have played a part too. But the trip seems to have been motivated by something deeper. One of Russell's saddle companions on that long journey northward took a job on an Alberta ranch and remained permanently in Canada. The other one promptly drifted back into Montana. Charlie went to stay with the Bloods.

"My Indian study came from observing and by living with the Blackfeet in Alberta for about six months," he told A. J. Noyes, the grass-roots historian of Montana's Blaine County.[2] During those months that Russell lived in the primitive lodges of the Bloods, he enjoyed their genuine friendship and had every possible opportunity to become intimately familiar with their every custom and characteristic. He was able to make an even more complete study by learning their language, and he became proficient also in the sign language by which all the red men carried on their intertribal conversations.

The Indians had a faculty of looking deep into the motives of white men who came to visit them, with a clarity of instinctive understanding that is beyond the comprehension of their paleface cousins. The Bloods accepted Russell into their lodges and he quickly became a brother of the tribe. His wornout cowboy clothing was supplemented with Indian buckskins, and he let his hair grow. Hospitality led to real friendship. He enjoyed the privilege of being

THE WATER GIRL

Knoedler Galleries, N.Y.C.

welcome to sit for long storytelling sessions in the big tepee of Sleeping Thunder, the principal chief of the tribe; and in that of Nat-o-wap-e-sti-pis-e mach-is, or Medicine Whip, the patriarchal warrior hero of his people. From both these men Russell absorbed a wealth of tribal lore and information about the Indians. His photographic mind acquired a catalogue of details which a more ordinary man could not have been expected to remember. Sleeping Thunder gave Russell the Indian name Ah-Wah-Cous, or Antelope, a brotherly approbation which Charlie proudly cherished.

It was not Russell's nature merely to skim around the edges of a situation rather than get deeply involved, and the time he spent with the Bloods was no exception. It has been stated that he considered becoming a squaw man, under the encouragement and tribal blessing of his good friend Sleeping Thunder, and there is evidence that his contemplation of the matter was fairly serious. That there was at least one maiden who occupied a more than casual interest in his life is strongly suggested by the attractive individual who is repeatedly portrayed in his pictures with more than ordinary clarity (pp. 113, 122).

Russell would have made a good squaw man. He had the right philosophy. "Most folks

don't bank much on squaw-men," he later wrote, in one of his early literary compositions, "How Lindsay Turned Indian."[3] . . . "but I've seen some mighty good ones doubled up with she Injuns . . . I told you my short experience with that Blood woman; I wasn't a successful Injun, but the comin' of white women to the country's made big changes; men's got finicky about matin'. I guess if I'd come to the country earlier, squaws would 'a looked good enough . . ." Russell attributed these remarks to a fictitious character, but they are much too poignant to have been born of pure imagination. "In early times when white men mixed with

Newhouse Galleries, N.Y.C.

CONTEMPLATION

Injuns away from their own kind, these wild women in their paint 'n' beads looked mighty enticin'. But to stand in with a squaw you had to turn Injun. She'd ask you were your relations all dead, that you cut your hair? or was you afraid the enemy'd get a-hold 'n' lift it?—at the same time givin' you the sign of raisin' the scalp. The white man, if he liked the squaw, wouldn't stand this joshin' long till he threw the shears away, 'n' by the time the hair reached his shoulders, he could live without salt. He ain't long forgettin' civilization. Livin' with nature 'n' her people this way, he goes backward till he's a raw man, without any flavorin'. In grade, he's a notch or two above the wolf, follerin' the herds for his meat the same as his

wild dog brother. But, boy, I started to tell you about myself, 'n' this is about the way he strings it out on me. He's born in St. Louis . . . ''

Through the years that followed, Russell had but very little to say which specifically related to the months he spent in the lodges of the Bloods. But the experience undoubtedly had a deep and lasting influence upon his attitude toward the Indians and their subjugation by the white man. Some of his finest pictures were drawn from the recollections of that experience. Among these is "Counting Coup," or "When Sioux and Blackfeet Meet" as the print

Newhouse Galleries, N.Y.C.

THE PROPOSAL

reproduction of it is entitled (page 37). It was sold in 1902 to a gentleman in St. Louis. When the original painting was delivered, the artist sent along an illustrated five-page holograph letter describing the actual incident which it portrayed. There is a beautiful little watercolor self-portrait of Russell as he sat and listened to the story in the lodge of his friend Medicine Whip, the aged warrior of the Bloods (page 116).[4] The explanation was also made that to "count coup" is to be the first to strike an enemy, with your whip or any article, and this entitles you to the scalp, though the enemy may have been killed by others.

Here is the part of Russell's letter which described the story as it was told to him and

from which the picture was painted: "My Son, he said, fifty snows behind me the Sioux were very bad . . . At last in the moon of painted leaves a scout came in with a Sioux arrow . . . It was not long till many Bloods were on their war ponies in the tracks of the Sioux. The sun was not yet in the middle when we sighted them. It was a running fight . . . until our arrows were nearly gone . . . Now every time a Sioux bow string spoke a Blood brave was wounded or sent to shadow land . . . They had killed our Chief and our hearts were on the ground. The Sioux now called us many bad names . . . One young man called to me saying 'you with the pretty pony, that is not a squaw pony, see he hangs his head in shame. He has the coup paint on his hip, but no man is on his back' . . . His words were like hot irons in my heart . . . Throwing down my bow and empty quiver I shouted 'Come brothers we will show them how the Bloods kill lice . . . ' My pony was strong and I was soon among them. He with the bad tongue ran in front of their Medicine Man. I made a false thrust at his throat and as he raised his shield drove under stopping his heart crying . . . Then quickly changing my shield to the string hand I struck the Medicine Man across the face with my quirt. Then the Sioux crowded about me and left their war pictures on me as you see today. This scar on my face was from the tomahawk which stunned and blinged [sic] me. I remember twisting my fingers in my pony mane. Then it was night very dark. When I awoke my people were about me. The Sioux were dead. All still their hearts slept. They were all scalped, except Bad Tongue and the Medicine Man, which were left for me. The scars on my leg are where the arrows went under my shield. That was long ago, My Son . . . "

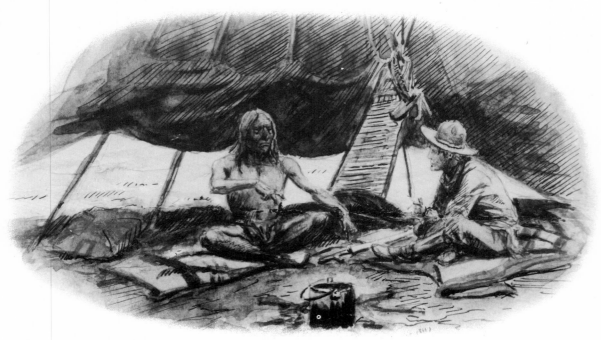

Knoedler Galleries, N.Y.C.

RUSSELL IN THE LODGE OF MEDICINE WHIP

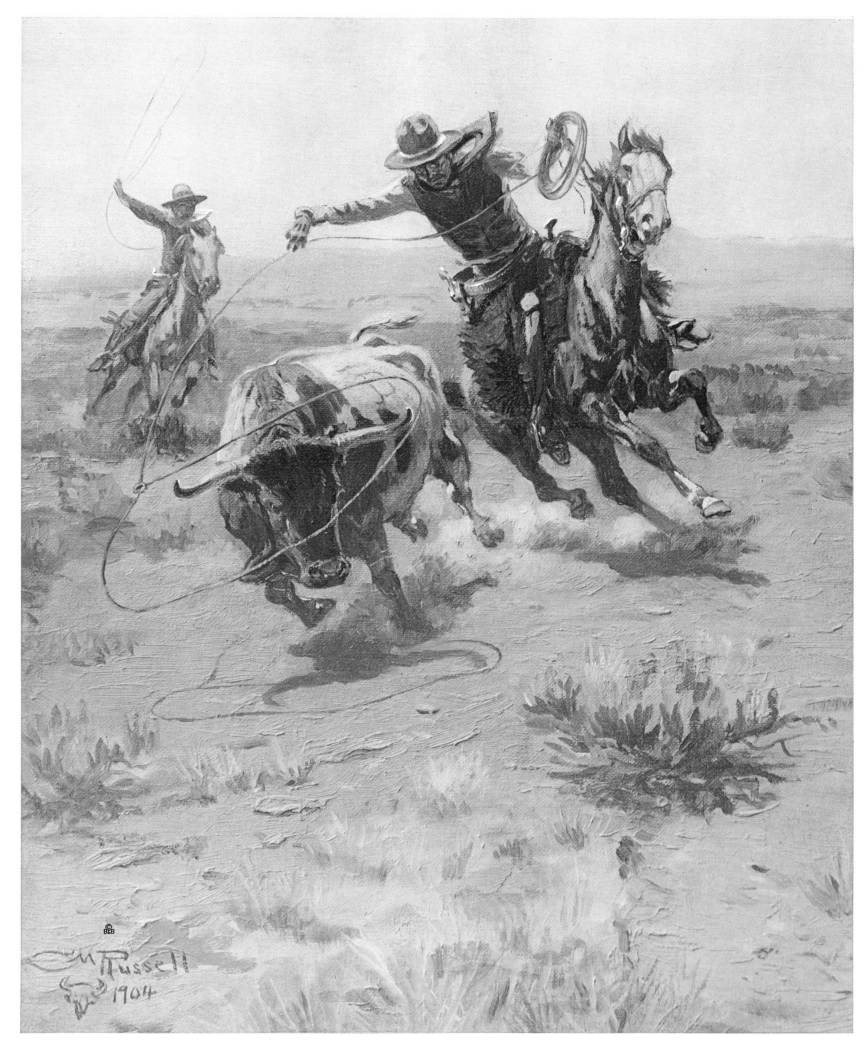

THE BOLTER

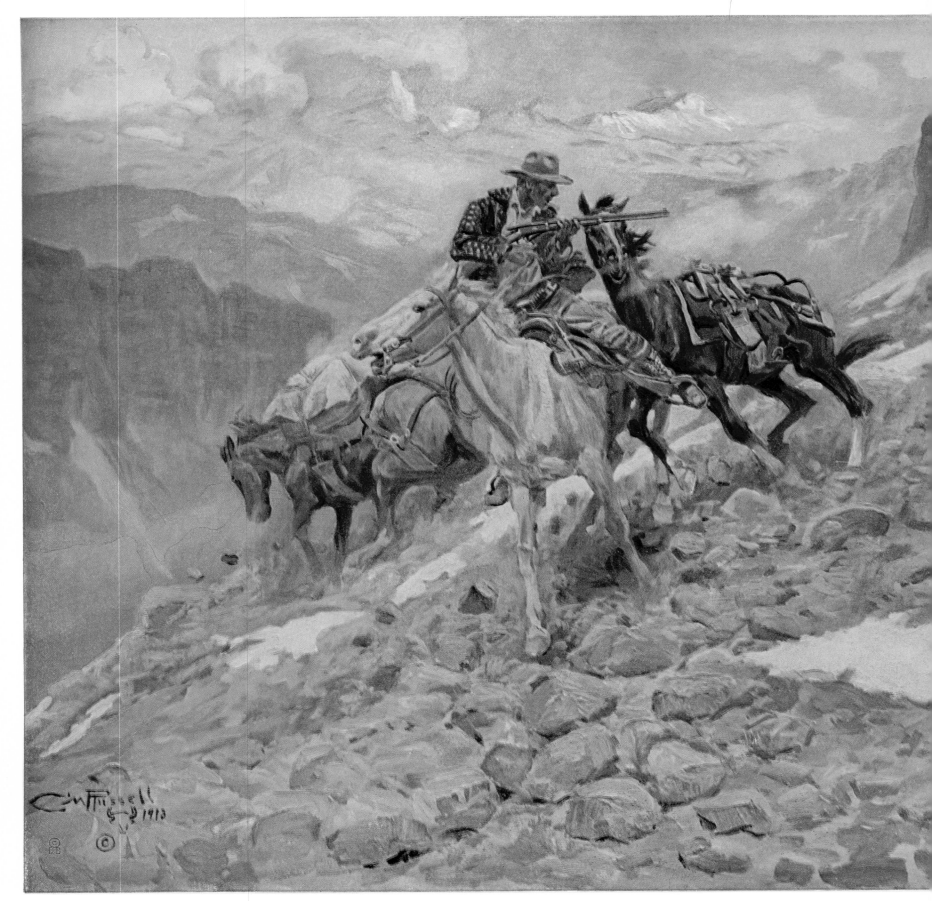

A DANGEROUS CRIPPLE

THE BUFFALO HUNT

THE LOOKOUT

CHAPTER XII

A Fugitive
from Civilization

RUSSELL had been virtually destitute of funds when he rode Monte into the tepee camp of the Canadian Bloods. It is doubtful whether he had a dollar to his name, and the clothes he wore were invariably in a sad state. Winter in the north country was close at hand; there was little if anything he might do for a living; he was a long way from his home range; and he had come to stay an indefinite length of time as a self-invited guest of the Indians. He had very little to offer in return for winter-long hospitality. Cowboys weren't particularly welcome around Indian camps, anyhow. He was not a good hunter and even had a strong aversion to killing game. Drawing pictures and telling stories were hardly a valid basis of exchange. But the Bloods took him in, literally as one of their own. The Indians were like that, particularly in the earlier days and in the remote regions where bitter experience had not taught them to distrust and hate the white man. Once upon a time there had been nothing extraordinary in a white man's taking up residence in the lodges of the red men. Those who were so inclined and received proper treatment, however, generally wound up as moccasin wearers. There was something about tepee life that got under the skin of a paleface, and he was not easily weaned away. It was a long long way back to his former life, and even those who did return never forgot the smoky smell of that earthy experience.

While he was living among the Bloods, Russell unquestionably did as much sketching and painting as circumstances permitted, although he probably never had greater difficulty procuring the necessary materials with which to work. Wherever he went, he generally managed to carry a small assortment of watercolors and a few tubes of oil paint. But he had been in the habit of making sketches on odd pieces of paper, and paper was mighty hard to find around the skin tepees and there weren't any towns near by. It is more than likely that he resorted to depicting the scenes around him on pieces of finely tanned buckskin. The materials he improvised to work with were sometimes as ingenious as his creations. He is known to have painted on pieces of wood, tin, and all sorts of other unusual materials. There are also reports—handed down by intimate friends of those days—that he sometimes made paintbrushes by chewing the ends of wooden matchsticks or green twigs cut from trees.

121

That Russell had a limited supply of oil paints with him on that trip is evidenced by a canvas which was apparently painted during his sojourn north of the border. This is a 36″ x 18″ early work of "Canadian Mounted Police with Indian Prisoners" (page 126). It is signed with the entwined initials which Charles M. Russell frequently used at that period. There is also a date in which the first three numerals 188– can still be identified, although the last digit has been lost in a remounting of the canvas. Not more than four or five colors were used, and an examination of the work indicates that it may have been done with crudely improvised brushes. It is reliably reported that this picture was done for D. M. Blunt, who had a frontier "shack" at High River, not far from the present city of Calgary, Alberta. It may have been given to Blunt in exchange for shelter and hospitality, or disposed of for the price of a few drinks of rum.

In later years Russell painted a number of fine Canadian subjects. Among these is the large and beautifully executed painting, "When Law Dulls the Edge of Chance" (page 128). This is dated 1915 and clearly shows the artist's remarkable progress as a technician. Presented to the Prince of Wales by the town of High River, Alberta, it depicts members of the Royal Northwest Mounted Police of Canada arresting a couple of horse thieves. The police have disarmed one of the outlaws and the six-shooter of the other is being confiscated.

Findlay Galleries, N.Y.C.

KEE-OH-MEE

R. W. Norton Art Foundation

THREE GENERATIONS

Always unorthodox, Russell chose to return to his old cowboy stamping ground at the worst possible season of the year. He seems to have found enjoyment in deliberately doing things the hard way. The month of March usually brings the last and often the hardest winter weather in the far Northwest. He could easily have waited a short time longer and enjoyed a pleasant springtime riding Monte over the long wild trails that led back to the Judith country. There was much more than bad weather ahead of him. He was as usual without funds and otherwise ill equipped for such a long journey alone. His clothes were now a miscellany of worn-out cowboy gear and Indian apparel. In that early spring of 1889 the whole northern part of Montana and the region north of the Canadian border was wild and sparsely settled. To live entirely off the country was no easy matter under the best of circumstances. Traveling and camping in wind-driven snow, sleet, and freezing rain did not make for a pleasant journey.

Before reaching the American border, however, Russell fell in with a large train of overland freight wagons, bound south with a winter shipment of furs destined for St. Louis. They would bring back loads of foodstuffs and other supplies which had been transported up the Missouri River and by rail. To be able to fall in with this big overland outfit was a piece of luck for the vagabond cowboy, for more reasons than one. The wagon boss of the outfit was no doubt glad to have a husky young cowboy along to lend a hand, and Russell was assured of plenty to eat as well as a comfortable sleeping place in one of the partly filled wagons. Traveling a long distance with an overland freight train gave Russell an opportunity to

observe at first hand an important phase of early life on the northwestern prairies. It was
not the only time he rode with such an outfit, but it was certainly his most impressive ex-
perience of the kind.

The men who followed the overland freight trade were as distinctive a pioneer breed as
the old-time cowboys. The top man of every big outfit was the wagon boss. He was the lord
and master, and like the captain of a ship he was in every respect responsible for the safe de-
livery of the cargo. Often he was the owner of the wagons and stock. Russell later portrayed
this rugged type in several pictures, the most notable of which is the famous oil painting
"The Wagon Boss" (page 157).

Then there were the jerk-line men, who were directly responsible for the handling of
the mules or horses that were hitched to each individual unit. Russell's large painting of the
"Jerk Line" (pages 138-139), an inspired example of Western Americana art, was done in
1912 and today hangs in the C. M. Russell Memorial Gallery in Great Falls, Montana. It
shows the jerk-line rein that extended from the left side of the lead animal's bit and ran back
along the line of horses' backs to the hand of the jerk-line man, who rode the nigh wheel
horse and thus directed the movements of the whole string. Sometimes this man rode in the
wagon seat, where he could more easily control the lines to the wagons' brakes when the
train went down hill. In this particular picture the wagon boss is also shown, using his long
bull whip to urge the horses up a hill. It will be noticed that the entire string is at the moment
well off the road, although they will be jerk-lined back at the right time to keep the heavy
wagons in proper position. On the overland freight trains that were hauled by strings of oxen
also hitched in spans, the corresponding driver was known as the bullwhacker. These out-
fits were sometimes referred to as grass trains, because their motive power could be fed en-
tirely on grass, while the mules and horses required a supplementary diet of corn or other
grain when they were engaged in such strenuous draft duty.

The big overland freight outfits that traveled back and forth across the Canadian border,
or had to navigate bad roads through other similarly rugged country, often had as many as
twenty sturdy draft horses, mules, or big oxen hitched to the three heavy wagons which usu-
ally constituted a unit for freighting purposes. When the route was not so mountainous and
over better roads, only four span of draft animals were often used. The first or "lead wagon"
in each unit was always the largest and was known as a "4-inch wagon," because the axles
were four inches in diameter. These were built to carry a load of 6,500 pounds or more. The
second or "swing wagon" was called a "3½-inch wagon," because it had 3½-inch axles and
was capable of carrying about 5,500 pounds of freight; while the "trail wagon" was the
lightest, having 3-inch axles, and could be loaded with a maximum of about 4,500 pounds.
The weight of the total cargo varied according to the difficulties that would be encountered
along the route over which it had to be hauled. The span of horses, mules, or oxen that were
hitched nearest to the lead wagon were called the "wheelers"; the team ahead of these were
known as the "pointers"; the third set were the "sixes"; and those at the head of the line
were the "leaders." They were all connected together with heavy chains called "spreaders,"
which it was important to keep taut in order to obtain the maximum amount of power from
the combined efforts of the entire string.

The tons of valuable cargo that these wagon trains carried made them tempting con-

THE DEFIANT CULPRIT

Knoedler Galleries, N.T.C.

CANADIAN MOUNTED POLICE WITH PRISONERS

quests for the bands of renegade Indians that infested the sort of country through which they traveled. It was for this reason that several units traveled together, and the comparatively small number of men who accompanied the wagons had to be a rugged and capable breed of frontiersmen.

Russell stayed with the overland train until it got down across the wild expanse of northern Montana Territory. But the big lumbering wagons moved much too slowly and clumsily for the spirited young cowboy, and he finally took off on his own again. The Judith Basin had become home and he was anxious to get back among old friends and familiar scenes. Living off the country was now a procedure to which he was well accustomed—a stop now and then at the increasingly frequent ranches along the road, or at a military outpost or even an Indian camp. Most anywhere there was smoke from a chimney or a campfire proved good for a meal and escape from the cold of the night. Sometimes it was a long ride between stops, although the worse the weather and the hungrier one got, the more the crude hospitality was enjoyed when it was found. There was almost never an occasion when a hungry traveler was not made welcome, although sometimes the good samaritans had very little for themselves. But it didn't take much more than a warm shack and a dry bunk to satisfy a man's soul; and it didn't take a great deal more than that to tempt a drifter to spend more than just one night before moving on.

Exactly when Russell got back to the Judith is not recorded. He no doubt rode in as

quietly and unobtrusively as a renegade Indian, and up the South Fork to the never failing welcome of Jake Hoover, or maybe he settled down in some old familiar hangout along the winter grub line. It is pretty certain, wherever he went, that he spent a good share of the time making pictures of one sort or another of Indian life north of the border. From this time forward the red man and everything that he represented was to occupy a new prominence in the scenes and subjects which Charlie portrayed in paints and clay.

With the coming of spring he once again joined the gathering of the paleface tribe of saddle-pounders. "Charlie Russell, the cowboy artist, is once more among the scenes of his earlier triumphs," reported a brief note of local chitchat in the Lewistown newspaper, the *Fergus County Argus*, for May 23, 1889. "Charlie has joined the roundup and will, as of yore, subdue the erratic broncho and chase the nimble and elusive calf." But this was to be the last spring roundup in his beloved Judith Basin in which he would participate.

Findlay Galleries, Chicago

SINGLE HANDED

WHEN LAW DULLS THE EDGE OF CHANCE

THE INDIAN OF THE PLAINS

CHAPTER XIII

Rawhide Arts and Letters

IT IS unfortunate that Charlie Russell did not write a full autobiography, or at least set down a brief but concise account of the events which shaped his unusual career. From the years that he spent on the frontier, living mainly in the saddle, following the cattle camps, he had acquired a deep conviction that the old life was in every respect better than the new way of life which the railroads and the flood of emigrants were bringing to his beloved land. He had also been strongly influenced by the time he spent among the Indians, whose culture and traditions he had come to respect. The result of his wide experience was a rare insight into the human side of those dramatic times and a profound feeling for all the older ideologies of the West, which combined to turn him against the new urban civilization. Unorthodox as he was, the cowboy artist could have written a significant account of that pioneer era of American history.

The letters and the stories that he did write provide some interesting sidelights on the period as well as the man himself. They are interspersed with frontier lore, bits of personal experiences, rawhide philosophy and wit; and they have a distinctive literary style.

Many of Russell's beautifully illustrated letters are gems of Western Americana, and they have become avidly sought by collectors. Their fine miniature watercolor embellishments have caused them to command prices in excess of the amounts currently paid for the large canvases of some other well-known western artists. A collection of Russell's letters was published by Doubleday & Company in 1929 under the title *Good Medicine*. A total of well over 58,000 copies of this book have been printed, which is an indication of the letters' wide appeal. The same publishers two years previously brought out a companion volume of Russell's short stories, *Trails Plowed Under*, which has seen the printing of more than 51,000 copies. Neither of these volumes is by any means a complete compilation of what the cowboy artist wrote. In themselves, however, they have established him as an individual of literary importance as well as a historian of the West.

Although Russell was in some respects half a century ahead of his time, he always preferred to live in the past. "I remember one day we were looking at buffalo carcus," he wrote

129

to his old cowboy friend T. C. Abbott (Teddy Blue), "and you said Russ I wish I was a Sioux Injun a hundred years ago and I said me to Ted thairs a pair of us I have often made that wish since an if the buffalo would come back tomorrow I wouldent be slow shedding to a brich clout and youd trade that three duce ranch for a buffalo hoss and a pair ear rings like many I know, your all Injun under the hide . . ."[1] Expressing his attitude toward the Indian, he wrote in another letter: "The Red man was the true American . . . The history of how they faught for their country is written in blood a stain that time cannot grinde out their God was the sun their Church all out doors their only book was nature and they knew all its pages."[2] He also had this further to say on the subject: ". . . . Our red brother stole his fashion from animals and birds he knew he saw the sage cock dance and spred his tail fethers that's where Mr Injun got his dance bussel he liked the war bonnet that the Canadian jay and the King Fisher wore so he made himself one but the only real American dont use much stile aney more Unkle Sam tells him to play Injun once a year and he dances under the flag that made a farmer out of him once nature gave him everything he wanted. now the agent gives him bib overalls, hookes his hands around plow handles and tell him its a good thing push it along maby it is but thair having a hell

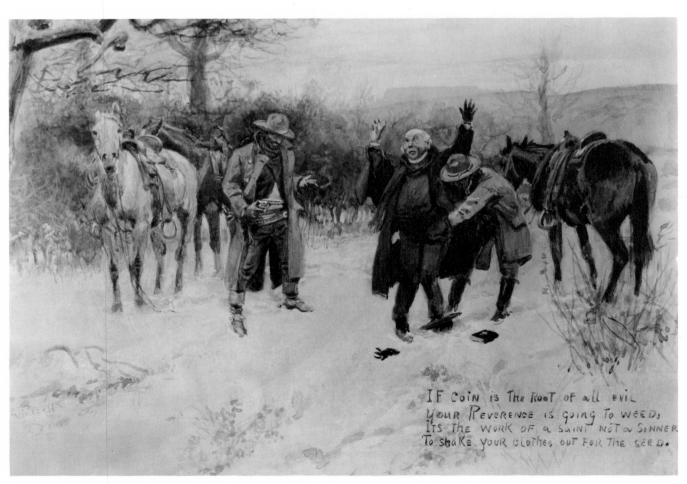

IF COIN IS THE ROOT OF all EVIL
YOUR REVERENCE IS GOING TO WEED,
ITS THE WORK OF a SAINT NOT a SINNER
To SHaKE YOUR CLOTHES OUT FOR THE SEED.

FLEECING THE PRIEST

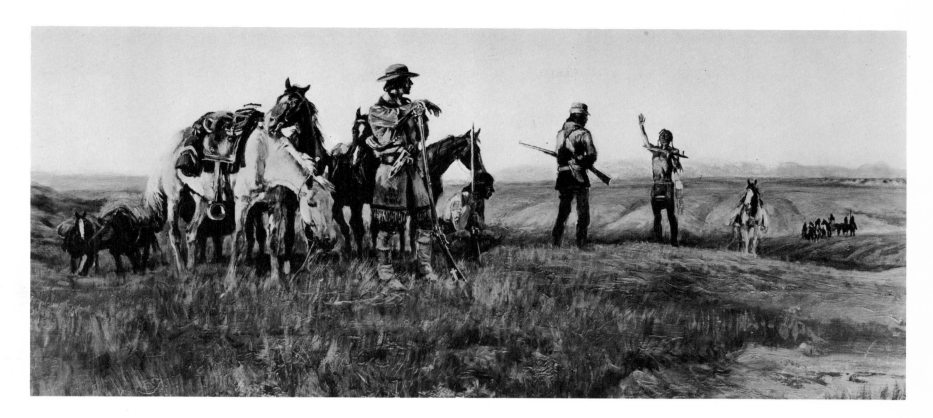

THE PIPE OF PEACE

of a time prooving it." This letter was addressed to Harry Stanford, a Montana pioneer and good friend of Russell's. It was signed "Ah-Wah-Cous."[3] And in an article written for a Montana newspaper, as a eulogy to Edgar S. Paxon, the artist, he stated: "Civilization is Nature's worst enemy. All wild things vanish when she comes. Where great forests once lived nothing now stands but burned stumps—a blackened shroud of death. The iron heel of civilization has stamped out nations of men . . ."[4]

What must have been a bit of personal philosophy is found in the following excerpt from the story of "How Lindsay Turned Indian," as it first appeared in *Outing Magazine* in the issue of December 1907; it was later included in *Trails Plowed Under*.

"I remember one day we're sittin' outside the shack, clear of the eaves. There's a chinook blowin' 'n' the roof's drippin' like it's rainin'. It's mighty pleasant in the sun out of the wind . . . the white Injun's smokin' his mixture of willer bark 'n' tobacco, while I'm sizin' him up . . . He says he's talkin' to the sun; he's thankin' him for the warm wind that melts the snow.

" 'Don't you believe in God?' says I. " 'Yes,' says he. " 'What kind of one?' " I asks.

" 'That one,' says he, pointin' to the Sun. 'The one I can see 'n' have watched work for many years. He gathers the clouds 'n' makes it rain; then warms the ground 'n' the grass turns green. When it's time, he dries it yellow, makin' it good winter feed for the grass-eaters. Again when he's mad, my people says, he drives the rain away, dryin' up the streams 'n' water holes. If it wasn't for him, there couldn't nothin' or nobody live. Do you wonder that we ask him to be good, 'n' thank him when he is? I'm all Injun but my hide; their God's my God, 'n' I don't ask for no better.' "

In those early days Russell seldom traveled much farther than a hundred steps without

climbing into the saddle. He was devoted to his pinto Monte and to all the other horses he owned. It is natural that he should have had some opinions to express on this subject so close to every cowboy and Indian. The following is a mixture of parable and eulogy, and a fine example of how Russell could be earnestly serious in a humorous manner. It is taken from his story "The Horse," which first appeared in the little paper-back publication of *Rawhide Rawlins Stories.*[5]

"Many thousand years ago, when folks was all a-foot, lizards, horned toads an' bull-frogs measured from thirty to a hundred feet in length an' stood from forty to sixty hands. Besides these there was tigers and laffin' hyenas that would eat an elephant for breakfast. From what I've read, in the days I'm talkin' about, man wasn't much, an' he sure lived simple. A good, stout cave was his home. He fed mostly on bugs an' snails, an' a grasshopper that

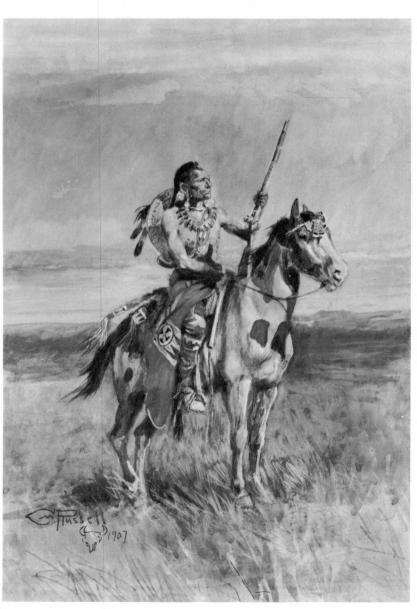

Newhouse Galleries, N.Y.C.

THE SCOUT

happened to 'light anywhere near him or his family was out of luck. Sometimes some real game gent would slip out with his stone tomahawk an' bring back a skunk or two. Then's when they pulled a regular feed, but there wasn't no set date for these feasts, an' they mostly came far apart. With a hyena that weighed seven ton a-laffin' around the door, man loved his home and Maw never worried about where Paw was.

"But one day one of these old home-lovers was sunnin' himself an' layin' for a grasshopper, when he looks down from his ledge to the valley below where all these animals is busy eatin' one another, an' notices one species that don't take no part in this feast, but can out-run an' out-dodge all the others . . . He see's this animal is small compared to the rest, an' ain't got no horns, tusks or claws, eatin' nothin' but grass . . . He remembers when his Maw used to pack him on her back. Bein' a lazy gent he's looking for somethin' easy, an' he figgers that if he could get this hornless animal under him, he

could ride once more like he did in his childhood. Right then is when man starts thinkin' of somethin' besides eatin' . . .

"Mister Man finds that with four legs under him instead of two, he can ride rings around them big lizards, an' there ain't any of them claw-wearin', tusk-bearin' critters can overtake him. The old gent snares more horses, an' it ain't long till the whole family's hossback. When this bunch starts out, armed an' mounted, they sure bring home the bacon. Meat—I'd tell a man. This cave looks an' smells like a packin' plant before the pure food law. It's now that mankind sheds the leaf garments of old Granddad Adam an' starts wearin' new clothes.

"Paw's wearin' head-an'-tail cowskin; the boys has a yearlin' robe apiece. Maw an' the girls wouldn't be in style at all these days. Maybe's it's modesty—it might be the chill in the weather

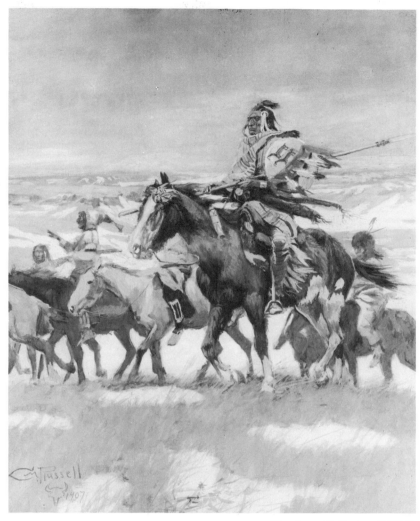

Newhouse Galleries, N.Y.C.

CROW SCOUTS IN WINTER

—but they're sure covered from ears to heels in deer and elk skins, an' from that day to just lately man never knowed whether his sweetheart was knock-kneed or bow-legged.

"Since that old bug-eater snared that first cayuse, his descendants have been climbin', and the hoss has been with him. It was this animal that took 'em out from a cave . . . He has helped build every railroad in the world. Even now he builds the roads for the automobile that has made him nearly useless, an' I'm here to tell these machine-lovers that it will take a million years for the gas wagon to catch up with the hoss in what he's doing for man."

The buffalo earned an ironic eulogy in another of Russell's letters: "this is Thanksgiving day . . . turkey is the emblem of this day and it should be in the east but the west owes nothing to that bird but it owes much to the humped back beef . . . the Rocky mountains would have been hard to reach without him . . . he fed the explorer the great fur trade wagons felt safe when they reached his range he fed the men that layed the first ties across this great west Thair is no day set aside where he is an emblem the nickle wears his picture damn small money for so much meat he was one of natures biggest gifts and this country owes him thanks."[6]

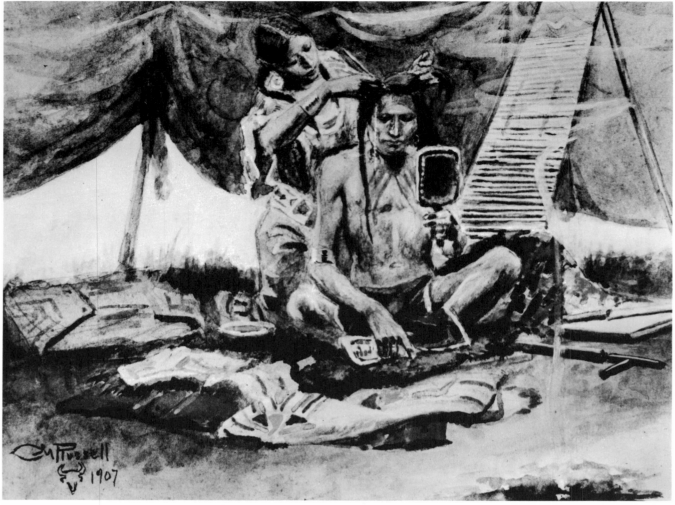

THE BEAUTY PARLOR

Russell learned considerably more from the Indians than the tribal designs on their clothes and their primitive philosophy. Always as frankly critical as children toward those who enjoyed their confidence, the tribesmen often helped him achieve accuracy in his art. They were quick to point out the slightest errors in any picture which portrayed Indian life. "Indians are very observing," Russell told A. J. Noyes.[7] "I recall a picture I painted of Bill Jones. In the braids of his hair he had seven brass tags or buttons, which are used for ornamental purposes. I failed to get in more than five and he soon called my attention to the fact and asked that the others should be put in. When this was done he looked at it and said 'Good.' Not long after this I was called into Bill's lodge as he said he wanted to show me something. He had a package which he began to unwrap and after a time he exhibited the picture which he had tacked to a board. Holding it up he said: 'Bill Jones, Good man, son of a b———.' It seems that Bill's English vocabulary was very limited and wishing to use all that he knew in his conversation, he always wound up with the last phrase. As I never had any acquaintance with Bill's family he may have been telling the truth . . ."

Whether an Indian had five or seven brass buttons tied into the braid of his hair, or none at all, might seem of small importance to a white man. Other items which might seem

unimportant are the sort of headdress that a Blackfoot chieftain wore as he led his warriors into battle against a band of Sioux, or whether there was any relationship between the heraldic sign on his shield and the manner in which his body or his pony were decorated, or the pattern on the moccasins he wore. These are things which Russell could never have been taught in any art school—could never have learned except from intimate association with and keen observation of the Indians. His meticulous attention to details and his unusual memory are the most important factors in Russell's success as a documentary artist. Nor was his fidelity to detail restricted to the paraphernalia and heraldic decorations of the Indians, cowboys, and pioneers that he painted. The physical movements of the men and their respective horses were painted with equal veracity. So too the backgrounds of mountains and prairies— here to such an extent that particular locations in many of Russell's paintings are instantly recognizable to those who are familiar with the country. Even the shades of light and shadow in the early morning, at midday, or when the sun went down, in summer or winter, were painted with exactitude. This is the fundamental precept of Western Americana art.

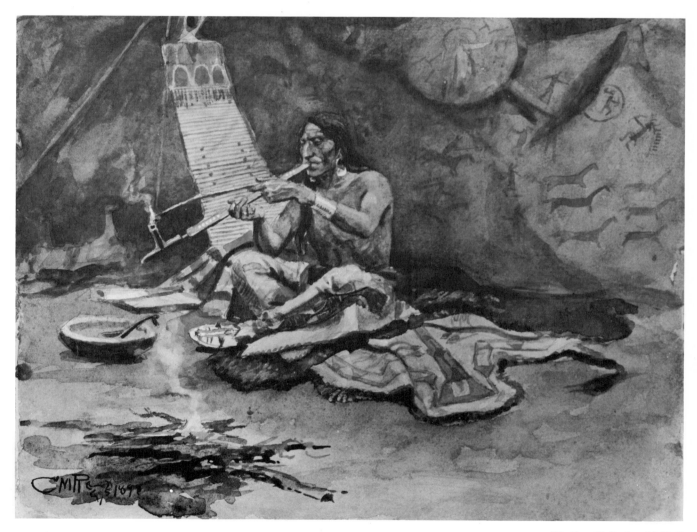

Findlay Galleries, N.Y.C.

THE PEACE PIPE

THE MEDICINE MAN

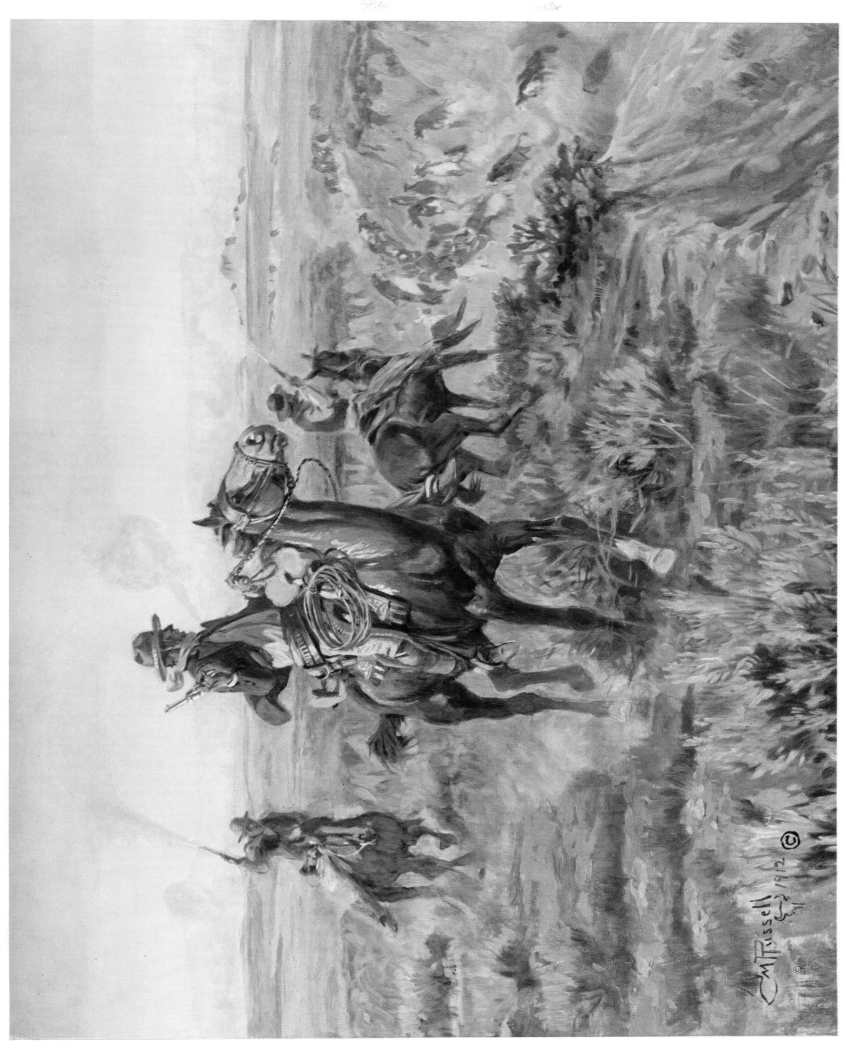

SMOKING THEM OUT

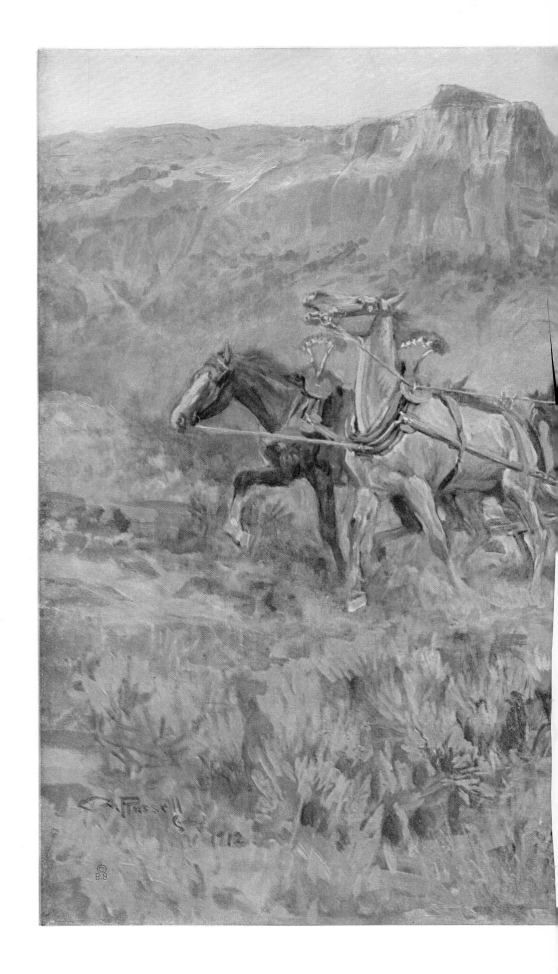

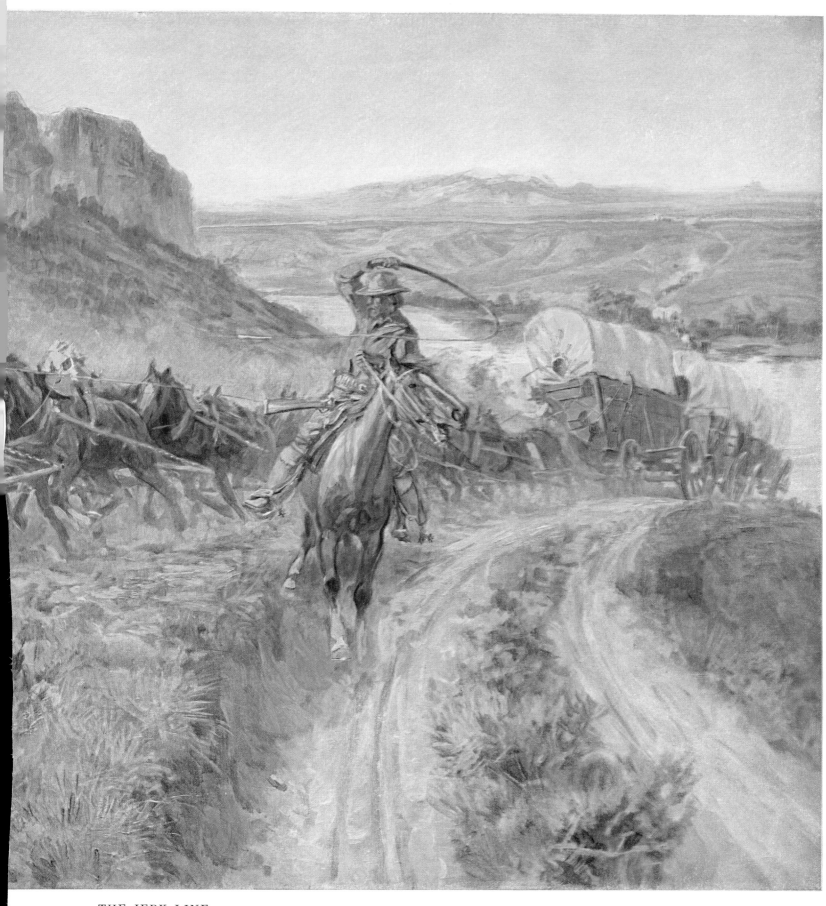

THE JERK LINE

JERKED DOWN

PETE HAD A WINNING WAY WITH CATTLE

CHAPTER XIV

End of the Open Range

"IN THE SPRING of 1889 I went back to the Judith, taking my old place as wrangler," Charlie wrote in the one autobiographical sketch of those early days.[1] "The Judith country was getting pretty well settled, and sheep had the range, so the cowmen decided to move. All that summer and the next we trailed the cattle north to Milk River." That is all he had to say about giving up his beloved home in the Judith Basin. It is a classic of understatement.

The cattlemen had welcomed the coming of the railroads, which provided transportation for their beef herds to the markets of the East and laid the foundations for the rich development of their industry. Ironically, however, the same railroads had poured a rapidly increasing number of new pioneers into the country. In the central prairies of Montana Territory the Judith and Musselshell districts were among the first to be overrun by homesteaders, in spite of the fact that this region did not provide the best of arable land. The 160-acre homesteads, with their damned-barbed-wire fences, were the nemesis of the old-time cattlemen. The successful grazing and handling of large herds was dependent upon an open range. But the cow men held no legal rights to this unobstructed feeding ground, whereas every homesteader had the blessing and backing of the United States government. Indian raids and epidemics of horse thieves and rustlers were a mild menace compared to the invasion of a Widow Oats and her little brood of orphans.

So short a time before, an Indian renegade could be run down and shot, or a questionable character strung up on the slightest circumstantial evidence, and without fear of lawful reprisals. But the homesteaders could not be dealt with in the same way. The cow men resorted at the beginning to threatening and sometimes using the same old drastic tactics. But times had changed. The cow men no longer enjoyed the frontier prerogative of making their own laws. With the homesteaders came urban courts of order and justice. What was worse, the sheep men were at long last getting the upper hand, for their flocks did not require large areas of open range on which to fatten up. And where the woollies grazed, there was nothing left for a respectable range steer to nibble. The cattlemen had no alternative but to look for areas of virgin buffalo prairie.

141

As early as 1878 an effort had been made to establish cattle raising in northern Montana, in the broad expanse of wild and unsettled territory between the Missouri River and the Canadian border. Thomas O'Hanlon and a couple of local associates at the Old Fort Belknap Indian Agency had brought in a small herd from the south. But the Indians got away with so many of the animals that the project was soon abandoned.[2] Another attempt was not made until the summer of 1886, during the extremely dry season prior to the disastrous winter. At that time Granville Stuart, along with some others who had been grazing their herds in the Judith, obtained permission from the United States government to move their cattle northward across the Missouri and run them on the Belknap Reservation.[3] This was done partly in an effort to find water, but it was also prompted by a suspicion that the time was not far distant when they would be compelled to move anyway. The going was slow at first, for the distance to the nearest loading point on a railroad was great and swimming the herds across the big Missouri was a difficult and often costly risk. Sometimes scores of cattle were drowned in the crossing and even an occasional cowboy was lost. There was still little of any brand of law and order in this north country except what the cattlemen made for themselves, just as they had in better days—although the Canadian border was conveniently handy for escaping outlaws. By the summer of 1889 the cattle industry was pretty well established in the Milk River country and was rapidly spreading through the Big Sandy region to the west and northward toward the international line.

Charlie Russell had been a resident of the Judith Basin for nine years. He was now

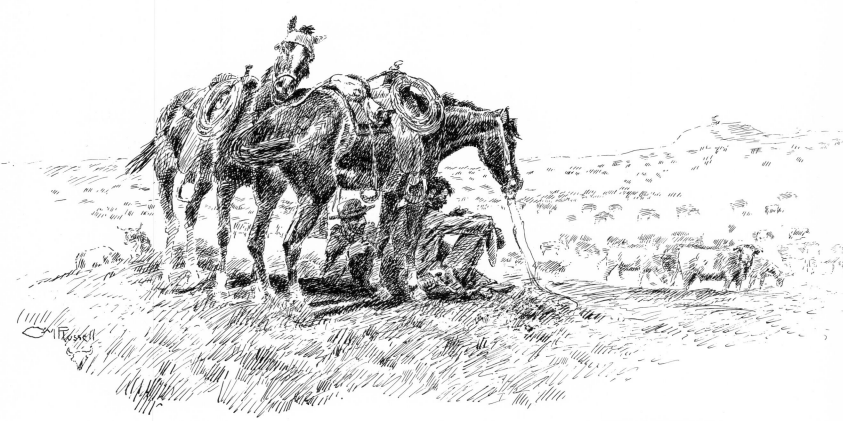

Historical Society of Montana

TIME TO TALK

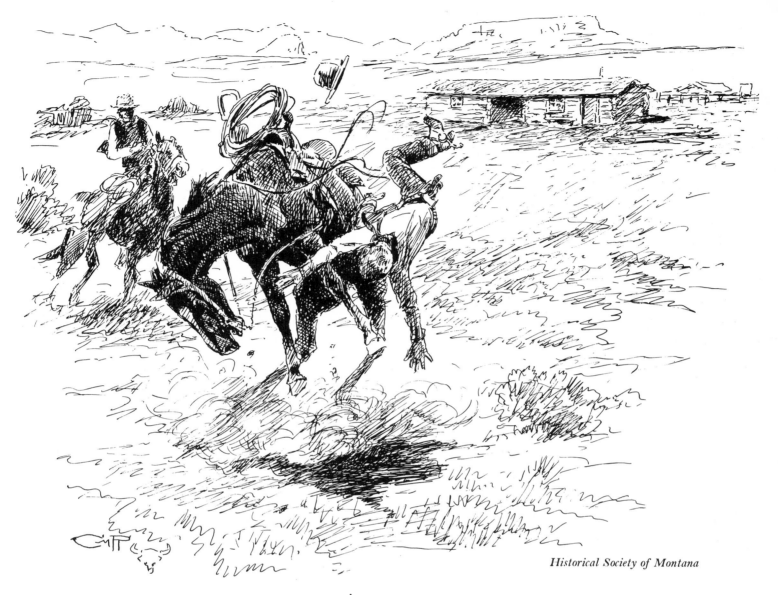

Historical Society of Montana

GRABBIN' FOR GUMBO

twenty-four years old. The Judith had become the nearest thing to a home that he knew. He had watched the cattle trade start and grow to flourishing proportions during that comparatively short period. His trip north and the months he spent living among the Bloods had been his longest period away. But for some time he had been unhappy with the changes that were taking place. His return had convinced him that the old home was not what it used to be. The whole cattle industry was moving out. So the time had come for Russell to move on to somewhere beyond the familiar horizon.

The opinion has been repeatedly expressed, by old-timers who knew Charlie Russell intimately in those years in the Judith, that he had no serious ambition of making art a profession or of becoming the pictorial historian of the Montana frontier. "He was just a crazy cowboy—who liked to draw pictures and tell stories," was the way they generally put it. "Hell, he had no more idea of becoming famous than I did." It was not difficult to form such an opinion from observing the way Russell lived and the attitudes he expressed. If he ever

had any conflict between seeking fame as an artist and living the cowboy life to which he was so devoted, it was the latter which always predominated. If he had any deep hope or desire to become famous it was kept strictly to himself, even through his later years. Nonetheless, there is strong circumstantial evidence that by 1888 Russell was already looking toward a more substantial future as an artist.

It could hardly have been less than a serious motive which prompted Russell to send *Harper's Weekly*, that painting "Caught in the Act" which was reproduced in the early spring of 1888. The text that he sent along and which accompanied the publication of the picture is equally significant. Further evidence is the composite of drawings he sent to Chicago about the same time, with the hope of having it made into a print for public distribution.

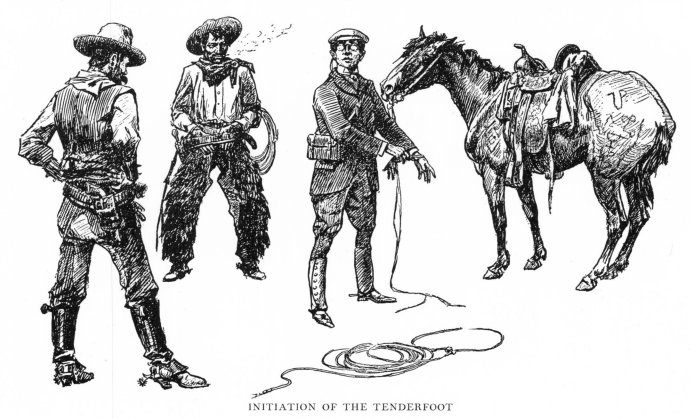

INITIATION OF THE TENDERFOOT

And now again, in *Frank Leslie's Illustrated Newspaper*, in the issue for May 18, 1889, there was a full page of his drawings that was titled, "Ranch Life in the North-West—Bronco Ponies and Their Uses—How They Are Trained and Broken." This carried the signature of C. M. Russell, although the page of sketches also credited another artist by the name of J. H. Smith, to whom the editors had obviously assigned the task of redrawing the pictures to make them more acceptable for use. Russell undoubtedly sent other pictures back East in the hope of getting them published, only to have them returned—to the knowledge of no one but himself. Just how many of these there were will never be known. It must have taken great ambition and undismayed determination to keep trying.

In 1890, the year that he gave up the Judith as his home, Russell had published an attractive tie-bound portfolio of twelve albertype reproductions of scenes of cowboys and Indians, under the title *Studies of Western Life*. There was an accompanying text by Granville

Stuart, who had already become a leading figure in Montana Territory—which in itself indicates that more than casual planning had gone into the publication of this little collection of pictures. The portfolio was printed by the Albertype Company, in New York City, although the project was a local Montana undertaking. The copyright was taken out in the name of Ben R. Roberts, the Helena saddlemaker who acquired the original watercolor of "Waiting for a Chinook." Roberts had since moved to the town of Cascade, a short distance south of Great Falls. It may well be that this gentleman was largely responsible for the whole idea and for carrying it out. It was certainly the most pretentious move that Russell had made toward gaining recognition as a serious artist.

After spending the summer of 1890 driving cattle north to the new range of the Milk

THE SHELL GAME

River and Big Sandy countries, Russell returned to spend his last winter in the Judith Basin.

"That wonderful child of Nature, C. M. Russell, the cowboy artist, has for some time past been with Jake Hoover, on the South Fork of the Judith," reports a paragraph in the *Fergus County Argus*, of nearby Lewistown, in the issue of October 18, 1890. "Charlie has been wonderfully industrious while there and with the marvelous scenery of that grand locality for a background, and poetic fancies untrammeled, he has wrought well with the pencil and the pallet, and several fine specimens of his noted Indian characterizations have been the result."

The same newspaper for Thursday, February 12, 1891, reports the fact that Russell had ridden over to spend some time in the rapidly developing town of Lewistown. That there was a specific purpose to that trip is indicated in the brief bit of published local news: "C. M. Russell, the cowboy artist, was engaged last Saturday in painting a picture on the

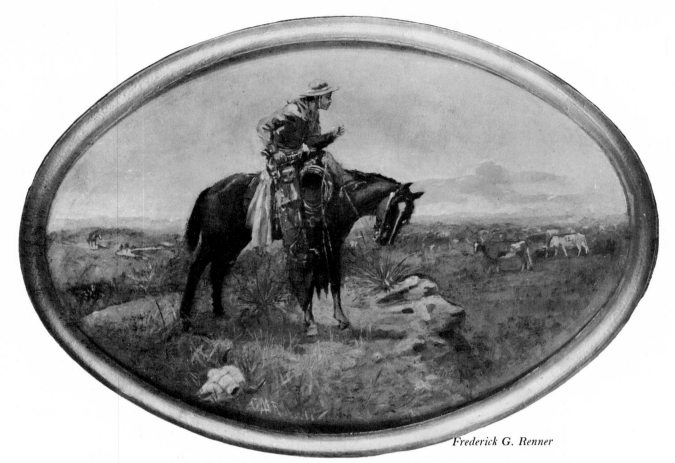

Frederick G. Renner

ON DAY HERD

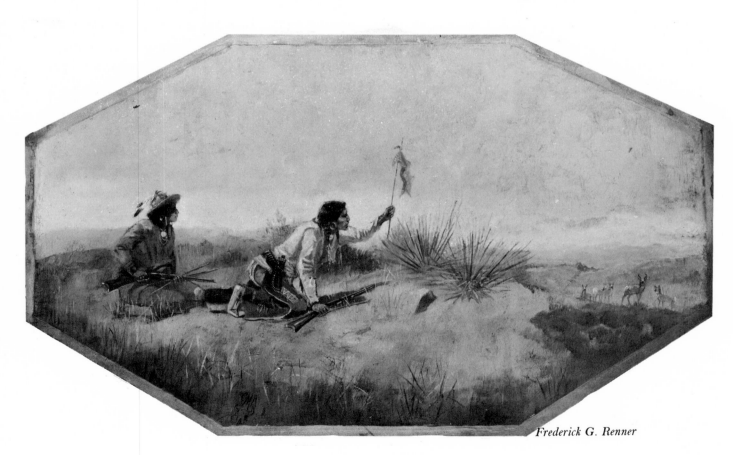

Frederick G. Renner

FLAGGING ANTELOPE

vault door of the bank. He commenced work at 10 A.M. and put on the finishing touches about 4 P.M. In the foreground, on a rocky reef, stands a fine broncho with feet braced to protect himself from going over the precipice in front of him. Seated on the horse, with right leg carelessly thrown over the saddle, is the typical cowboy, smoking a cigarette and gazing at the beef herd a short distance beyond. Attached to rider and horse are the usual trappings—chaps, revolver, cartridge belt, lariat, trapideros, sombrero, spurs, etc. . . . The cattle are branded 12, which is the S. S. Hobson brand . . . It is a fine scene and one of the best productions of this eccentric genius" (page 146). The reported price Russell received for this work was the munificent sum of $25, probably the largest amount he had yet received for a painting. The actual vault door, with the painting, is well preserved and is today in the private collection of Frederick G. Renner of Washington, D. C., one of the foremost authorities on the work of Charles M. Russell. Mr. Renner spent twenty years searching for the door and finally managed to locate it in the possession of the daughter of the man who took over the assets of the bank when it went out of business. A second painting on another heavy iron door (page 146), done by Russell probably shortly afterward, was also acquired for the Renner collection.

Russell lost no time making his way to the most popular saloon in Lewistown to spend the money he had just received for painting the bank vault. Saturday night was a good time to celebrate. If Charlie didn't know every cowboy in a town's social gathering place, it wasn't long before he made their acquaintance. He no doubt bought drinks for everyone in the house and continued the roundelay until the $25 was entirely gone. Among the cowboys with whom he fell in during this imbibing spree was his old friend Bob Stuart, youngest son of the cattle baron Granville Stuart. Kindred spirits, these two decided to finish out the winter together in Lewistown and then ride north to find jobs in one of the spring roundups on the Milk or the Big Sandy. They shared winter hibernation quarters in some cheap shack and Russell set to painting with new zest. The local publicity gained from the picture in the bank, and the recent publication of his portfolio *Studies of Western Life*, had brought his work into popular demand, and as fast as he finished a new subject it was promptly disposed of for $5.00 or $10.00. This kept the two bachelors in more or less sufficient funds for drinks and food, until the time when they rode north together.

THE SURPRISE ATTACK

CHAPTER XV

To "Sing to 'Em" No More

IT WAS a far cry from the saloons of a rough western cow town to the editorial offices of national magazines in the East. Russell had by now turned out a fairly large number of pictures and gained a considerable reputation, although this was principally restricted to the Montana cattle country. His own eccentric personality had contributed to his notoriety. But there had been extremely little that was of sufficient importance to recommend him to national recognition as a western artist. However, at about the same time that Charlie was riding north with Bob Stuart to find a job as wrangler in one of the spring round-ups, a very complimentary editorial regarding his work appeared in a New York magazine. It was written by Charles Hallock and published in the April 1891 issue of *Nature's Realm:* "One of the best animal painters in the world is Charles M. Russell, of Montana, who is popularly known as the cowboy artist. His specialties are frontier scenes, wild Indian life, cattle pieces and natural history subjects, all of which are liberal in their similitude and imbued with a truthfulness of character and detail which is possible only for those who are to the manner born."

There was a great deal of interest in the East in the rapid developments going on in the West. The building of the railroads, which were continuing to fan out into new areas, had opened wonderful fields of opportunity for individuals in every walk of life and all this had caught the popular fancy. Charlie Russell was to ride to fame on this strong tide of popular interest, but there was another circumstance in his favor: the cowboy had become the most exciting personality in American life. He had taken the place of the frontier explorer, Indian scout, mountain man, and fur trader. Editors were strongly conscious of the trend and were anxious to find writers and artists to feed the popular imagination. The writings of such literary stalwarts as Bret Harte and Mark Twain were being widely read. In 1888 the *Century Magazine* had featured a series of articles by Theodore Roosevelt, illustrated by Frederic Remington, on ranch life in the Northwest, which met with such success that they were published in book form the same year under the title *Ranch Life and the Hunting Trail.* Other editors followed suit. *Harper's* had quickly discovered that the dynamic western pic-

tures of Frederic Remington were top-drawer material for both their monthly and weekly magazines, and the work of this artist was in great demand by other publishers. A long list of new names was to rise to prominence at this time—including Owen Wister, Alfred Henry Lewis, and Charles A. King. Even men like Longfellow and Parkman benefited by the new interest in the West.

Through the four years that followed Russell's departure from the Judith Basin in 1891, he rode his pony Monte from here to there and back again: from the new cow town of Chinook on the Milk River of the north, to Lewistown and the old retreat of Jake Hoover's cabin, to Great Falls, to Helena, and even, briefly, to Chicago with a trainload of cattle. He became more of a drifter than before, nighthawking, trail driving, and periodically living off the country, so that his face was familiar in practically every cow-town saloon in central Montana. But he never tired in his efforts to improve as an artist, and his progress, if slow, was steadfast. Only outwardly was he little more than an eccentric, maverick cowboy.

"I recall one night when it was raining and we had to go on night herd," recalled his saddle buddy Bob Stuart a good many years afterward.[1] "He [Charlie] put on his slicker and that made the horse nervous and he also got nervous, with the result that he had to crawl on again . . . Then there was one night on the Big Sandy, when Charlie and myself were trying to hold a bunch of beef and it was getting late in the fall and it began to rain, which turned to sleet and our slickers would simply pop every time we moved. The storm was coming from the northeast and the cattle began to drift toward the Coal Banks on the Missouri. Charlie said: 'What are we going to do?' I told him if he would go ahead and try to keep them back I would bring up the drag. He soon came back and said: 'I can't hold them, they are going in every direction. Let 'em go to hell. We'll get 'em next fall.' I replied all right, but you will have to make good with the boss. Later, in speaking to Charlie about this particular night he recalled it very well. He had a bad time finding camp and when he did he got so near the tent in the darkness that he stepped right on the face of 'Missouri Jim,' the boss."

It is not recorded whether Russell got out of the cow camp before the boss had a chance to fire him, or whether the difficulties were somehow ironed out. It is known, however, that he was shortly afterward traveling with the Bay State outfit when it passed through historic old Fort Benton, probably on a trail drive south across the Missouri. This fact is briefly recorded in the Fort Benton newspaper, the *River Press*, for August 18, 1891. The paragraph of local news also contains the following interesting bit: "He tells us that he is fond of the work of painting and the only reason he does not follow it is because there is not enough money in it. We believe, however, that in his particular line he has no equal and that his pictures would, if properly handled, bring him a fortune."

Those pictures were now being sold about as fast as he made them—that is, the ones he didn't give away when he had a few dollars in his pocket. The only trouble was that even the best of the paintings brought only a small amount and that was quickly spent for sociability among his many friends.

It was about this time that a letter caught up with Charlie from a man in Great Falls. In glowing terms it assured him of a substantial monthly income and grub if he would come down there and just paint pictures to his heart's content. Arriving as the offer did so close

to the long hungry period of winter, it sounded to Russell like a much better deal than riding the grub line or holing up with some cowboy buddies. There was also the attraction of spending the off season in the booming town. There were a lot of people there with real money in their pockets.

Russell recounted this incident a good many years later, with his usual brevity: "I received a letter from Charlie Green, better known as 'Pretty Charlie' a bartender who was at Great Falls, saying that if I would come to that camp I would make $75 a month and grub. It looked good, so I saddled my gray and packed Monte my pinto and pulled my freight for that berg."[2]

Arrival at the town which was later to become Russell's home and the scene of his

Historical Society of Montana

THE OPEN RANGE

struggle to success, is entirely passed over in the short autobiographical sketch he prepared for local newspaper publication and which later appeared in *Outing Magazine*. It is, however, described as a sort of addendum to the story he wrote about his pony Monte. A rather idealized piece of factual writing, this first appeared in the Bynum (Montana) *Herald* under the title "The Pinto" and was later included in the book *Trails Plowed Under* as "The Ghost Horse." Here is the way it ends: "The riders, one leading a pack horse, traveled between the Missouri and the Highwood Mountains. One of them pointed to a heavy smoke that showed on the horizon, a little south of west. 'That's where we camp tonight,' he said.

"It was dark when they reached the town which the smoke had led them to, and their ponies, which knew no lights but nature's jumped over the great shadows made by the arc lights at the street crossings. They passed rows of saloons, dance halls and gambling houses, and after inquiring the way of a bystander, rode to the Park stables, where they unsaddled and stripped the pack horse of their bedding and grub. Now, under the overhanging light of the stable, I will describe the riders and their mounts. One rider was rather slender with black hair and eyes. The other was of medium height, with light hair worn rather long. Both

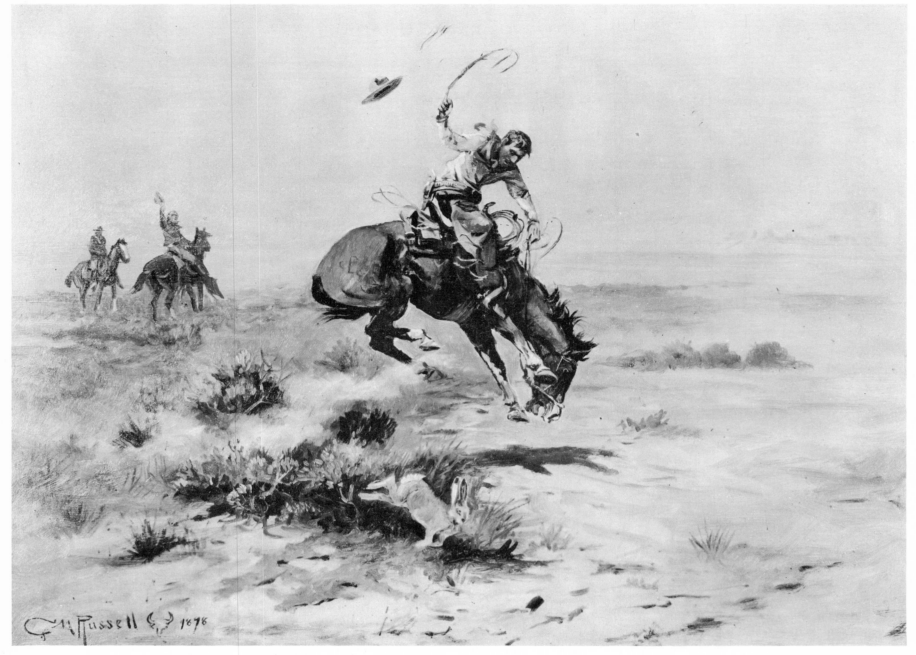

COWBOY LIFE

men were dressed as cow hands, and the only difference in their clothes was a bright colored, French halfbreed sash, worn by the light-haired man. The latter's mount was a rangy gray, branded Diamond-G, one of the Geddis herd. The pack horse which he led was a bay pinto . . . The name of the town was Great Falls. The rider of the brown bronco was Henry Stough. The other, who rode the gray, was the writer of this story. The pinto horse was *Paint,* called Monte by his owner. When Paint died near Great Falls he had been with his master twenty-five years."

One of the first things Russell did the day following his arrival in town was to visit the Brunswick Saloon, to see Pretty Charlie and find out more about the proposition that had brought him south. Russell had more to say about this in his autobiographical sketch: "Mr. G. pulled a contract as long as a rope for me to sign. Everything I drew, modeled or painted

was to be his, and it was for a year. I balked. Then he wanted me to paint from 6 in the morning until 6 at night, but I argued there was some difference in painting and sawing wood, so we split up and I went to work for myself. I put in with a bunch of cowpunchers, a roundup cook and a prize fighter out of work, and we rented a two-by-four on the South side. The feed was very short at times, but we wintered."

The shack in which this motley group were crowded together they called the "Red Onion." There is little doubt that it was a rough and often rowdy living quarters—hardly the environment for an artist to find inspiration or space to pursue a creative urge. But once again Charlie Russell's pictures provided the principal means of procuring drinks and food for himself and his buddies. As fast as a drawing or painting was finished, it was hustled uptown to settle a bar bill or start another one; or, if the residents of the Red Onion were more hungry than thirsty, it would be disposed of for a few dollars in cash to be rushed to a grocery store. In spite of the almost impossible circumstances under which Russell was compelled to work at this time, he turned out some surprisingly good pictures, and they were not merely "quickies."

Up to this time the saloons had been the principal show place for Russell's work. Some of the paintings had been hung in general stores, cattle company offices, and banks, but probably the majority of them had passed through the saloons, in one way or another. Those

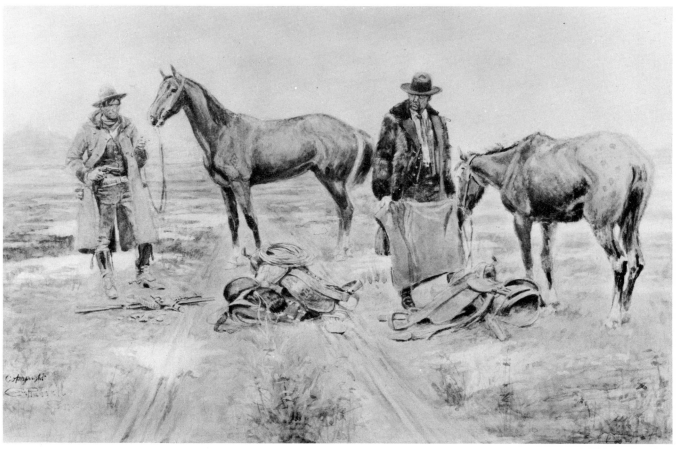

Findlay Galleries, N.Y.C.

HOLDING UP THE SHERIFF

that were taken in to pay bar bills or by outright purchase were generally set up behind the bar, where they could be admired or bought by other customers. It is reported that Charlie occasionally used a back room of some of these places as a makeshift studio. It should be remembered, however, that in that day and territory the saloon was usually the principal if not the only community social center for the local and itinerant populace who built the West. They were more than places where men drank, gambled, and brawled. Many an early-day itinerant man of God used a frontier saloon as a church in which to preach his sermon, amid silence and respect. As the settlements grew, more than one saloonkeeper contributed to the building of a permanent church to serve the community, or underwrote the clergyman's pay while he was becoming established. They were rough places, to be sure, but it was not until the backwash of the white man's civilization from the eastern cities overflowed these western towns that the saloon degenerated into what we think of it today.

Not all of Charlie Russell's friends were cowboys or others who spent all their idle time with an elbow on a bar. He always had the happy faculty of making close and lasting friends among those who walked in high places as well as low. Extremely well informed as he was about every phase of frontier life, he could carry on an erudite conversation with as great facility as he could tell an entertaining story. Among the lifelong friends he made during that first winter in Great Falls was one Albert Trigg, a substantial citizen who took a real interest in the drifting cowboy artist, endeavored to instill in him a more serious attitude toward his painting, and repeatedly carried his pictures around town to find purchasers.

As Russell's work as painter progressed he also spent more and more time at modeling, at which he was equally if not more naturally adept. He could take a piece of wax or any other pliable material and with the greatest of ease quickly mold it into a surprisingly life-like small figure of an animal or person. He would frequently amuse his friends by holding his hands under a table or behind his back and in no time at all producing an attractive little bear, pig, or Indian head. In later life, even after he had mastered the techniques of painting, he would often make wax models of his subjects and stand them up at the side of his canvas as an aid to portraying the figures in a more "round and realistic" manner.

One story of his early days has it that he was entertaining a group at a bar by fashioning various figures out of a handful of wax, when one of the onlookers offered to buy the subject he had just made. "Ten dollars!" said Russell. "I'll give you five!" countered the prospective purchaser. Grabbing up the model he squeezed it in his big hand; separated the wax into two equal parts; then quickly making a similar figure of half the size, set it down on the bar in front of the customer and shouted, "Sold!" Then he bought a round of drinks for all.

Like the birds that flew north in the spring, the cowboys drifted away from the Red Onion to return to the cattle camps of the open range. Russell stayed behind, struggling with the idea of devoting himself entirely to his art. But he soon rode north over the trails that led to his old job as nighthawk and wrangler. Maybe the old urge for the life he loved had something to do with his going back. He had never been much of a success at selling his own pictures; it had generally been someone else who collected cash for them. Russell referred to the purchasers as "suckers." So he rode north in time to join the spring roundup. "Next spring I went back to Milk River and once more took to the range," is how he referred to it.

WHEN SHADOWS HINT DEATH

"Russell the cowboy artist is at present stopping in this city," reports the Fort Benton *River Press* for November 30, 1892. The newspaper praises his work, adding that his pictures "have brought ready customers before the paint was dry on the canvas." The article goes on to recount that "He has with him a collection of Indian relics, collected by himself at different trading posts . . . tomahawks and scalping knives . . . gaily beaded pouches, war clubs and other paraphernalia dear to the wandering tribes that once roamed unmolested through these regions." He was beginning to use such trappings to gain greater accuracy of detail in his Indian subjects, and many of these fine accessories were kept until he finally had an established studio in which to take full advantage of them.

Just where he spent the following winter is a question which elicits contradictory information from his friends and is one of the many discrepancies in the record. After all, Russell stated in his autobiographical sketch that he was born in 1865 instead of the correct date 1864. It is quite apparent, however, that he spent the winter of 1892–93 in the northern cow town of Chinook on another of those hectic hibernation jamborees, this time with six cowboy cronies. In addition to his old friend Bob Stuart, there was "Kid" Price, Tony Crawford, John Thompson, Slim Trumbel, and Al Mallison. They became known locally as the "Hungry Seven" and gained a rather unsavory reputation among the local populace because of strong circumstantial evidence that one of their main sources of sustenance was the result of periodic nocturnal raids into their neighbors' chicken coops.[3] As had become the custom, Russell painted pictures and one of his buddies peddled them as a means of procuring funds for the group. There was also a short-lived business venture in which the artist tried to become the proprietor of a saloon. This last incident is related in a letter he wrote to Kid Price a good many years afterward. It was dated June 1, 1917.[4]

"Friend Kid—It's been some years since I laid on my bellie in the shade of a wagon and built pictures, but I haven't forgotten . . . Well Kid I guess Chinook aint much like it was when I had a saloon there . . . my booze parlor didn't last long, fourteen days I think, it was like the life of a butter fly, short but a very merry one. I remember a stranger asked for a cocktail and I built one. It aught to have been good. I·put everything on the back bar in it, even that piece of lemon skin I had. I guess he wasn't a hard drinker. He only took one swallow and left the house and was never seen after. Maybe he went to Milk River to put the fire out an bogged down in the quick sand . . ."

A more civilized way of life was penetrating rapidly northward even across the last open range to the Canadian border. The Great Northern Railroad had laid its iron trail through the town of Chinook. There was no place farther on to which to retreat. For Charlie Russell the old days had come to an end. "I returned to Great Falls, took up the paint brush and have never 'sung to 'em' since,"[5] was his own literal epitaph to his life as a cowboy.

THE WAGON BOSS

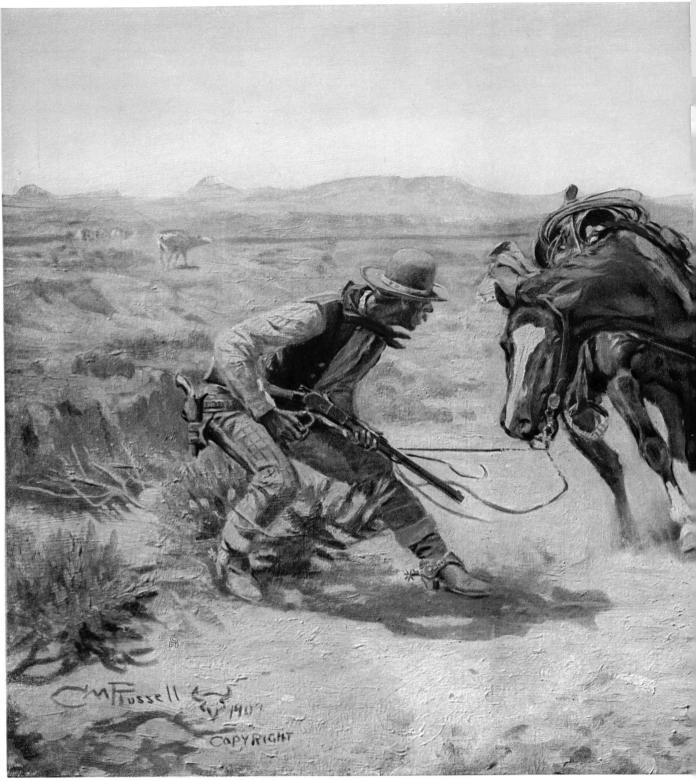

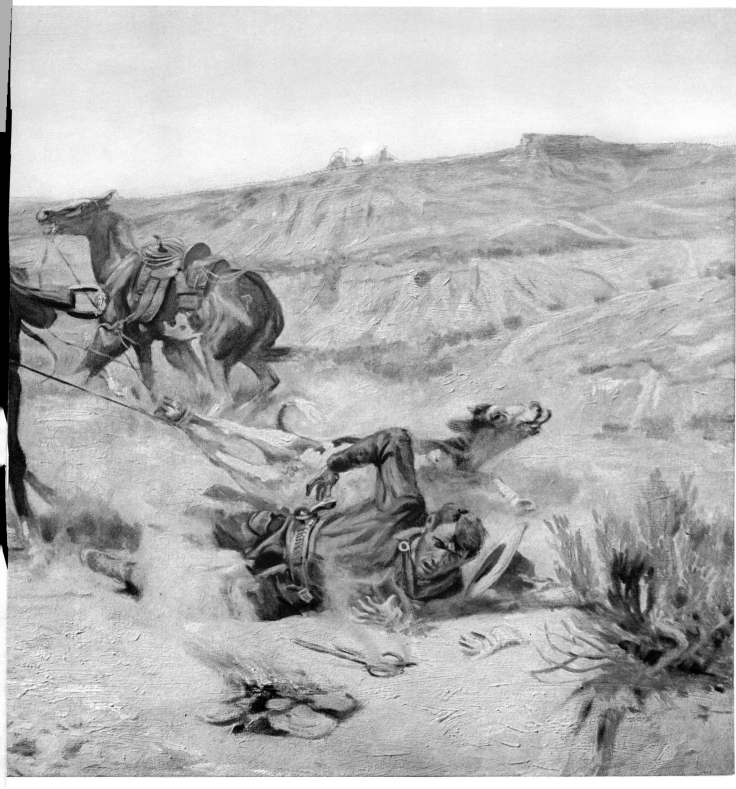

CINCH RING

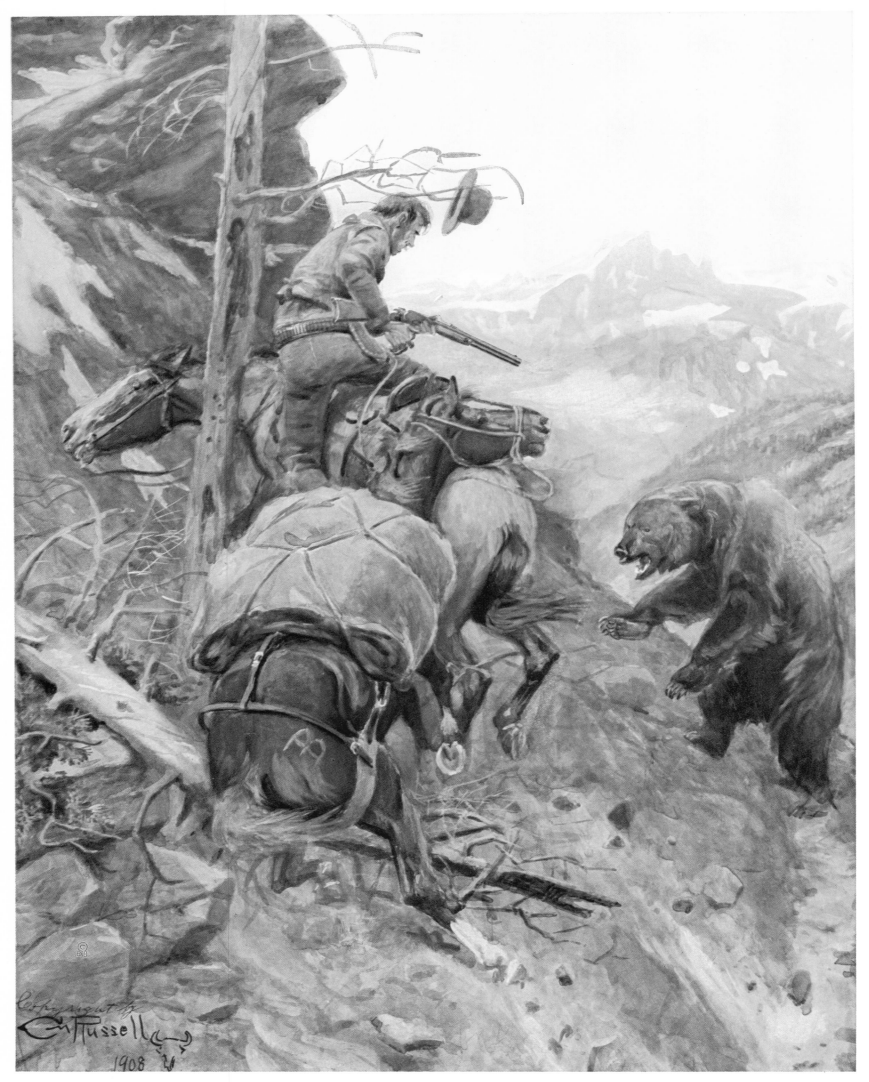

A DISPUTED TRAIL

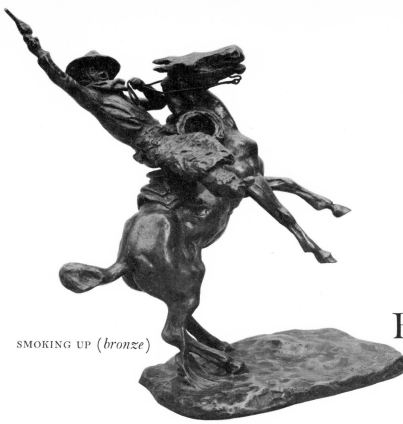

SMOKING UP (*bronze*)

CHAPTER XVI

Roping a Wild 'Un

I T WAS not easy for Charlie Russell to settle down to making a living entirely by painting pictures of cowboys and "Injuns." He loved to draw and paint scenes from his recollection and mold little figures of the living things that were so close to his heart. But his nature rebelled at the necessity for finding "suckers" to pay good American dollars for all the small sketches and canvases the size of windows that he had to turn out to make ends meet. It didn't bother him to live on slim rations, because he had become accustomed to that; and there were always enough friends around to drop in on for an occasional meal. If he was pressed for cash to buy art supplies or other vital necessities, he could easily find credit or borrow a few dollars from almost any bartender in town. He had practically no ties or responsibilities beyond seeing that Monte got a bellyful of feed each day. But thirteen years of wonderfully free vagabond living in the unspoiled back country of Montana's beautiful mountains and prairies were not easily cast aside. Establishing himself amid the hustle and bustle of a big town was a lot rougher than nighthawking a bunch of beef in the worst of weather. However, he stubbornly resisted the urge to ride back to the open range and the roundup camps, and spent the next couple of years working hard at his art—though he still "rode with the wild 'uns" in the big town just as he had in the Judith and the north country.

When life in Great Falls became unbearable and he had a yearning for the solid satisfaction of a saddle on the move and the sweet smell of the open country in his nostrils, he would ride Monte south to the little town of Cascade. Jogging twenty-five miles along the dirt road under the blue sky had the same effect as quenching a thirst in the clear cold water of a mountain spring. Riding through the open country a man could also think and dream. It was mighty good just to be able to gaze off across the rolling prairie to the broken rim of the horizon, where the mule deer and elk roamed in the big timber and bear wandered through the thickets of the deep canyons. Going down there brought back the pleasures of the old life, without the commitments of a roundup camp. Cascade retained much of the atmosphere of a little cow town and many aspects of old Utica. It was situated on the bank of the Missouri

161

River, at the edge of a rugged range of mountains typical of central Montana. A big table-top butte rose just to the west of the village, and to the south the river cascaded down a steep walled valley, through which the road to Helena also wound its way. Spreading out to the north and east were fine grazing lands which retained semblances of the open range. Some of Russell's old rawhide friends were pursuing the only profession they knew around Cascade. There was always a chance of finding a couple of them in either Cornell's or Kraus's saloon; and a bunch of the boys usually holed up in Cascade each winter.

The little town held another attraction for Charlie Russell, and that was probably stronger than all the rest. This was Ben Roberts—the man who acquired the little watercolor of "Waiting for a Chinook," and who had in 1890 promoted the publication of Russell's first portfolio of pictures, *Studies of Western Life*. Ben Roberts, it will be recalled, was a saddle-maker in Helena before the family moved to Cascade and opened a men's clothing and general store there. He had for a long time exerted an important influence on Charlie Russell.

Ben R. Roberts was not only a substantial citizen and a very respectable family man, but like Russell he was extremely interested in the Old West. In 1863, at the age of two, he had been brought to Virginia City in Montana Territory from Denver, Colorado; the three-month trip was made in a covered wagon drawn by oxen. After a year in Alder Gulch the family moved on to Last Chance Gulch, arriving there the same year that gold was discovered and the future city of Helena was founded. Ben's father, W. K. Roberts, became the first sheriff of Lewis and Clark County, then known as Edgerton County—a job that required a man of no mean courage. A young nephew, Joseph K. Toole, also lived with the Roberts family for some time. Toole later became the first governor of the state of Montana. It was in Helena that Ben Roberts grew to manhood and established a family of his own. One of his daughters, Mrs. Charles L. Sheridan, wife of one of Montana's greatest World War I heroes, has supplied the present writer with much information regarding her father's associ-

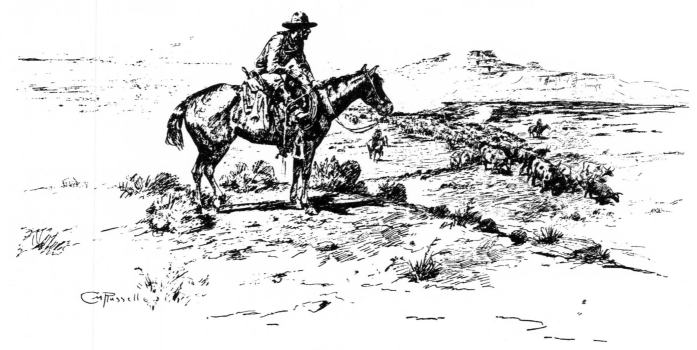

THE TRAIL BOSS

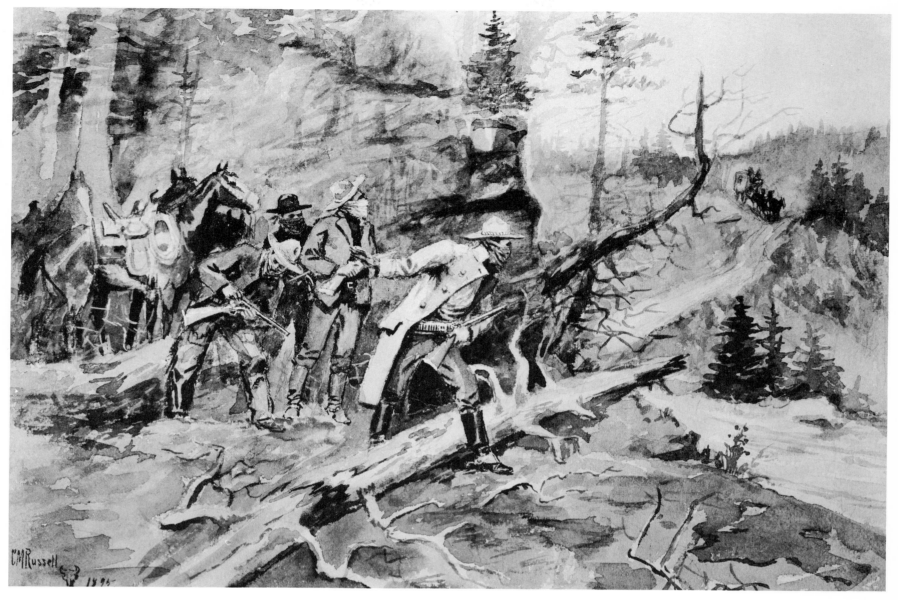

BIG NOSE GEORGE

ation with Charlie Russell. The scene of our conversation was Mrs. Sheridan's present home, which stands on the same site as did her grandfather's log cabin, which was erected in the days when Helena was known as Last Chance Gulch.

"Some of my father's most pleasant memories were of his long friendship with Charlie Russell," Ben Roberts's daughter reminisced, as she sat with her gray head relaxed against the back of a large Victorian chair. "Their close friendship began in the early 1880s, when Dad was making fine saddles for such famous western characters as Buffalo Bill Cody and the more prosperous of the cattle men. Russell was just starting to become known as the cowboy artist, when Dad wrote to him about painting a roundup picture for his saddle shop. Then one day Russell rode up to our barn, on his beautiful pinto pony Monte. 'Hello, Ben,' said Russell—although they had never seen each other before. 'How in blankety blank did you know I was Ben and who in blankety blank are you?' chuckled Dad. 'Well—my name's Charlie Russell,' he drawled, 'an' I was told if I found a fellow that was homelier than I am, it would be Ben Roberts.' They were the best of friends from that time on.

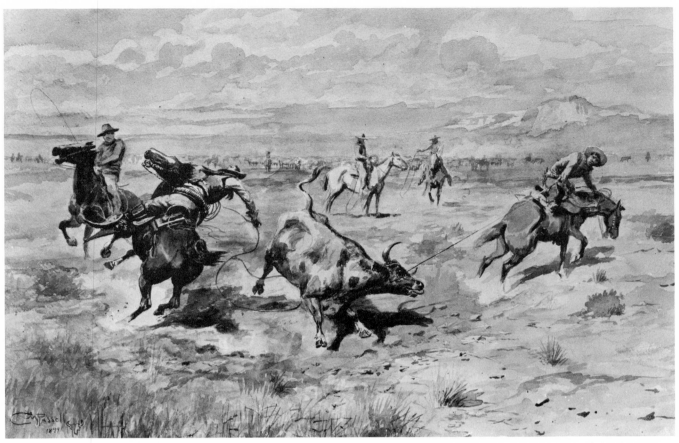

Carlton Palmer

HEELING A BAD ONE

"From the very beginning, Father encouraged Charlie in his painting. He helped him get the use of a stone barn that once stood in back of the old Christian Science Church on Sixth Avenue. That was Russell's first studio in Helena. And he often lived with us from time to time through many years. After we moved to Cascade he came to stay with us more frequently. It was sort of out in the country and there was a small frame building on the place that Dad let Charlie fix up as a studio and place to sleep—the same little shack where Charlie first set up housekeeping when he was married. We never knew when he was coming or how long he was going to stay. But he was always welcome and almost like one of the family. He was always broke—and very frank about it. He'd tell us how he borrowed enough money to get to Helena, or maybe it would be Great Falls, where he'd borrow some more, or paint a picture or two to stay there a while—then he'd come on to our place. He'd say: 'When I get to Ben Roberts's at Cascade, I know I'm good for all winter.' But we loved to have him around. He was always so wonderful to us children. He loved children. The first thing he'd do was pick each of us up in his arms and make a big fuss over us. He'd spend hours amusing us. We'd go down to Dad's store and collect the white tops of cardboard boxes for him to paint pictures on. Sometimes when he was short of paintbrushes, he'd chew the end of wooden matchsticks to use. And he'd always insist on helping Mother—at every- thing from carrying water to peeling potatoes or hanging up the clothes. Sometimes he'd

get in her way—and she'd shoo him away. 'Go draw pictures for the children,' she'd insist. I know that Charlie Russell was a pretty rough character, when he was with the other cowboys—but around our house he never so much as said an off-color word. I can remember nothing but gentleness and kindness about Charlie Russell.''

For a good many years Ben Roberts's home was Russell's principal mail address in Montana—the place where he had his mother send her letters from back in St. Louis. Several months might pass before he came riding along to pick up the mail, but it was about the surest place to reach him. He wasn't much on answering letters and his mother would write to Mrs. Roberts to obtain news about her son. In fact, the women carried on the correspondence through the years until Mrs. Russell's death.

Russell spent the winter of 1893–94 in Cascade. As usual, he joined several cowpunchers who set up bachelor quarters there. There were not many people in the small town to buy sketches or paintings, but the local saloons and a couple of the stores took pictures in exchange for due-bills and Charlie got most of his "square meals" at the Roberts home. In the spring he went back to Great Falls.

In 1894 he had three of his pictures reproduced in a book called *The Cattle Queen of Montana*, a sizeable volume compiled by Charles Wallace and published in St. James, Minnesota. Charlie was given no title-page credit but it was a step in the right direction. More important was the publication the same year of an attractive portfolio of the cowboy artist's pictures illustrating a text by John H. Beacom and entitled *How the Buffalo Lost His Crown*. The story was based on an old Indian legend as told to an army officer by the aged Nis-su-kai-yo,

THE RANGE RIDER'S CONQUEST

a celebrated orator of his tribe. The volume not only featured the work of Charles M. Russell, but also included a photograph of the artist. Published by the Forest and Stream Company in New York City, it was printed on fine plate paper, "handsomely bound," as stated by the advertisement, which also gave its price as $1.75. This little portfolio seems to have been well received in the East, for it was reprinted in 1898 by the R. H. Russell (no relation) Publishing Company in New York City, one of the foremost class publishing houses of the day. The Russell Company published the fine art books of such notables as Charles Dana Gibson, Frederic Remington, Edward Penfield, and E. W. Kemble, and elaborately illustrated editions of the works of Alfred Tennyson and other literary lights of the period.

Eighteen ninety-five was a year of two major events in Russell's life—one sad, the other probably the most fortunate thing that ever happened to him. Charlie's mother had not been well. He was very devoted to her, and at the beginning of February decided to go back to St. Louis to see her. "Many friends of Charlie Russell . . . gathered at the Great Falls depot recently to bid him good-bye previous to his departure to St. Louis on a visit with his relatives . . ." read one newspaper account early in February.[1] The trip was a brief one, although it was fortunate that he went—for his mother died on June 18, at the age of sixty, about three months after he returned to Great Falls.

Early in October he rode down to Cascade on what was intended as a brief trip. He met Ben Roberts on the street and was invited to supper. Later they went out together to the frame house not far from the bank of the Missouri. Mrs. Roberts had been informed ahead of time and had made arrangements for a special dinner.

About suppertime there was a clank of cowboy spur-rowels on the back steps and Ben led the way into the kitchen. Charlie stopped abruptly as he noticed that there was a new member of the Roberts household—an extremely attractive young lady, who was briskly helping get the meal ready. "Charlie," said Mrs. Roberts with a smile of welcome, "this is Nancy." Russell was so taken aback by the unexpected meeting that he forgot to pick up the Roberts youngsters who came rushing to greet him. Then he stumbled along after Ben into the living room. As they sat waiting for supper to be put on the table, Mr. Roberts explained briefly that Nancy had recently come out to Helena from Kentucky. Her mother and father were separated and she was pretty much alone in the world and had had a rather difficult time. She had been living in Helena with Mrs. Biggs. The Robertses had offered her a home and brought her up to Cascade, to help with the children and the housework.

As they all sat at the supper table, and afterward, Charlie was unusually talkative and entertained them in his best manner with the nicest stories he knew. No one seemed in a hurry to clear away the dishes. Whether or not Mr. and Mrs. Roberts, individually or together, had been doing a bit of matchmaking is not clear; at any rate it was a case of love at first sight—even though Nancy was only sixteen and Charlie was thirty.

Thirty-four years afterward Nancy described the impression she got of Charlie Russell on that first meeting:[2] "The picture that is engraved on my memory of him is of a man a little above average height and weight, wearing a soft shirt, a Stetson hat on the back of his head, tight trousers, held up by a 'half-breed sash' that clung just above the hip bones, high-heeled riding boots on very small, arched feet. His face was Indian-like, square jaw and chin, large mouth, tightly closed firm lips, the under protruding slightly beyond the short upper,

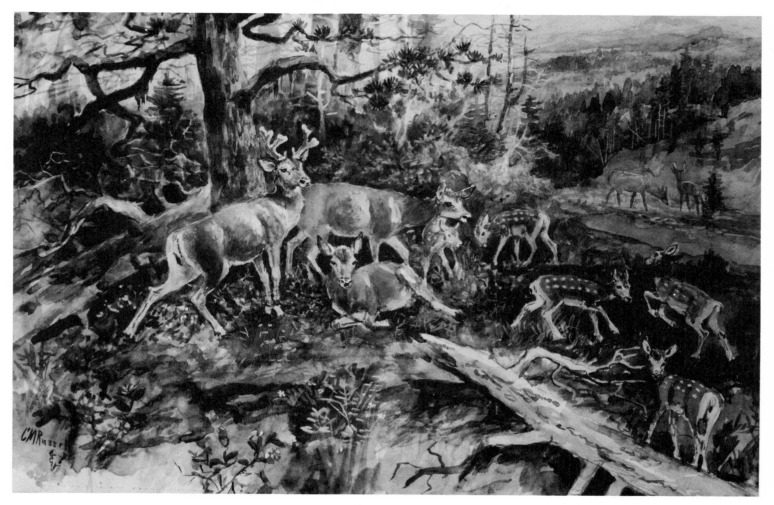

WHITE TAILS

straight nose, high cheek bones, gray-blue deep-set eyes that seemed to see everything, but with an expression of honesty and understanding . . . His hands were good-sized, perfectly shaped, with long slender fingers. He loved jewelry and always wore three or four rings . . . When he talked, he used them a lot to emphasize what he was saying, much as an Indian would do."

Charlie did not hurry back to Great Falls. In fact, he immediately began a serious courtship. In the evenings, after the supper dishes were done, the two would wander along the bank of the Missouri, or out on the bridge across the river, to stand talking or just gazing at the cascading water or the silhouette of the mountains against the sky.

"Mamie [Russell's nickname for Nancy] was well aware of the sort of life that Charlie had led," explained Ben Roberts's daughter long after all of them had lived their lives and passed on. "While Mother thought the world of him she saw to it that Mamie knew all the facts—both good and bad. Young as she was, the girl had been forced to follow a rather rough road herself and she was smart enough to realize what she was getting into. Dad and Mother both had a lot of faith in Charlie Russell—not only in his ability to become a great artist, but that he would make a good husband—and they knew that in both these things he required someone who really loved him and had the courage and the strength of character to sort of rope and tame him. Maybe it was asking too much of any woman—particularly one so young—but that was a decision for Mamie to make."

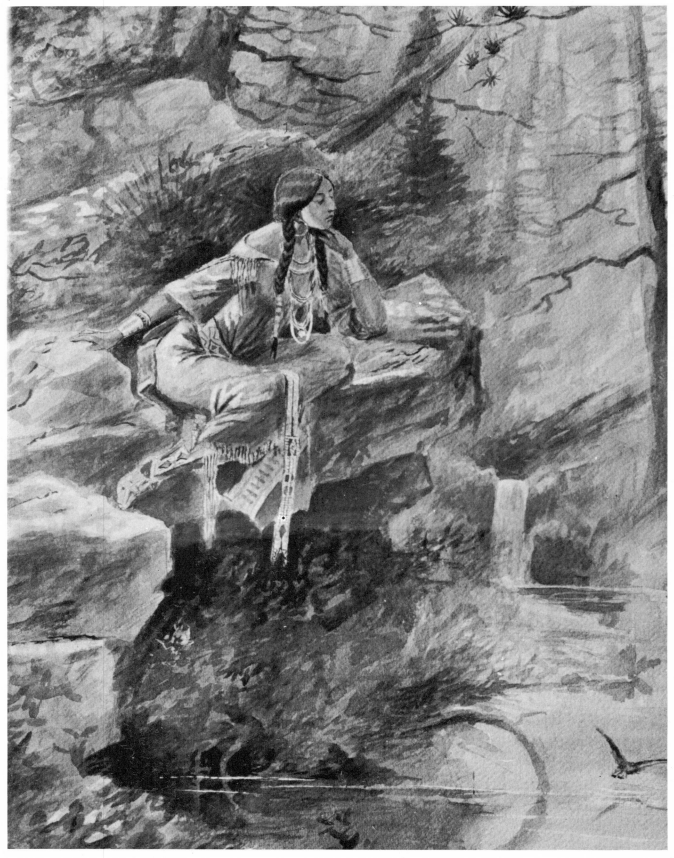

MEDITATION

Frederick G. Renner

CHAPTER XVII

Saddled But Not Tamed

CHARLIE went back to his little makeshift studio in Great Falls and began painting pictures with renewed zest and determination. The new element in his life fired his ambition; and he turned his efforts now to more sizeable oil paintings because they brought more money, and put a far greater amount of serious thought into planning the subjects and the way in which they were to be executed.

Unrestrained and frank as Russell always was in a good many respects, he religiously kept personal matters to himself. But it was not long before the word got around that the cowboy artist had fallen in love. The boys who hung out at the Silver Dollar Saloon and similar places where he spent so much of his time, just couldn't believe it—and they got no evidence from Charlie, one way or the other, despite persistent questioning. For Charlie Russell to become seriously involved with such a "nice" girl—and for such a nice girl to open her heart to the maverick cowboy—seemed just impossible. No doubt Charlie thought as much himself. He realized that this was not a passing fancy, and that he was venturing into a world far removed from everything which had been a part of his life since he had left home more than fifteen years before.

There were circumstances which must have frightened him and upset his thoughts as he sat putting paint on canvas, or lay wide-eyed through long hours of the night. He had not been able even to support himself in a respectable manner. Could he change his ways? He was by now thirty-one years old; and strong-willed as he was, it seemed too late to break a wild cow horse of all his bad habits. But Charlie made increasingly frequent trips to Cascade and continued to court the attractive young lady who had so completely captivated him. He was always welcome at the Roberts home. He helped Nancy and Mrs. Roberts as always. They all sat around the supper table and there was never any hurry to clear away the empty dishes. In the evening the two of them walked out on the bridge to talk about more serious things—and Charlie told Nancy all about himself and the sort of life he had led in the past. He had fully made up his mind to ask Nancy to marry him, but there were not to be any false pretenses.

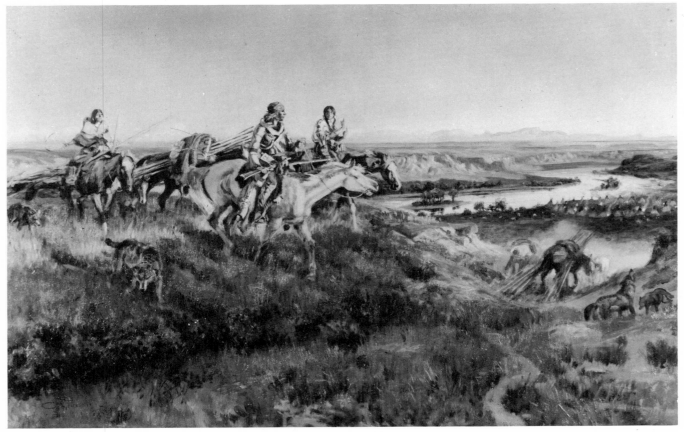

Newhouse Galleries, N.Y.C.

WHEN WHITE MEN TURN RED

The months drifted by—winter and then spring. The word finally got back to the boys around the Silver Dollar that Charlie had given the young lady his beloved pinto pony Monte. That clinched it!

Just when and how they became engaged is one of those personal matters that Charlie always kept to himself. But on September 9, 1896, almost a full year after their first meeting, they were married.

The bride was born Nancy Cooper in Mansville, Kentucky, on May 4, 1878.[1] Her parents were divorced when she was quite young and her mother died shortly after remarrying. Then her stepfather married again and it was not long thereafter that Nancy was shifting for herself. In later years she sometimes used her mother's maiden name of Mann as her own. Charlie Russell nicknamed her "Mamie," although it was by her Christian name of Nancy that she became generally known in later years.

"The wedding was held in our parlor," recalled Mrs. Sheridan. "It was in the evening—about eight o'clock. Mother and Mamie had made the long trip to Helena to purchase material for a blue wedding dress—which my mother made. There was much excitement around our house on the eventful day. Ice cream and cake had been prepared to serve after the ceremony; and Mother helped her get all fixed up long before the appointed time. Charlie didn't have very much money when he came from Great Falls with his bedding and all his other worldly possessions on a pack horse. He spent most of his cash fixing up the little

one-room shack on our place that Dad had let him use as a studio. Practically all of the furniture had been lent from our house. With the help of some of his cowboy friends, Dad, and an Indian, they put in a partition and gave the place a coat of paint. It wasn't much of a home in which to begin their life together, but Mamie was every bit as happy about the whole thing as Charlie was. After he gave his cowboy friends some money as a bribe to stay up town and to have a few drinks to wish him well—and paid the minister ten dollars—there wasn't but very little left.

"When Charlie arrived at the house, he was all slicked up and beaming with happiness. I began to cry. I didn't want him to take Mamie away—for we had all grown to love her like one of the family. I remember he picked me up in his strong arms and kissed me. Then he sat me on the footboard of the bed and looking straight into my eyes he very seriously promised me that he was going to take very good care of Mamie, because he loved her just as much as we did. He kept that promise—although there were times when it seemed almost impossible for them both.

"There were only a few guests at the wedding—mostly our immediate family—my older brother Gorham and my younger sister Vivian Kemp. My Christian name was Hebe. My Aunt Sallie Bet Faust was there—and Mrs. Streeter, the minister's wife. Neither Mamie or Charlie had anyone from their families. After the ceremony, we ate the ice cream and cake —and Charlie and Mamie went on their honeymoon. It was walking hand in hand about three hundred feet to the little frame shack which had been fixed up for their first home."

The readjustment that was necessary for each of these newlyweds was profound, and which of them faced the most difficult obstacles is not easy to say. The fourteen years' difference in their ages was not the least of their problems. They had practically no money, and although they had few expenses beyond the procuring of food, their only source of income was the pictures that Charlie painted and sold—and most of the folks around Cascade who had any interest in purchasing an example of the work of the cowboy artist had already been supplied. Then, too, the severe Montana winter was not far away.

While they lived in such poverty, their marriage might survive for a time, but it could hardly be expected to go on indefinitely under such adverse condi-

Richard W. Norton Foundation

SELF-PORTRAIT (1899)

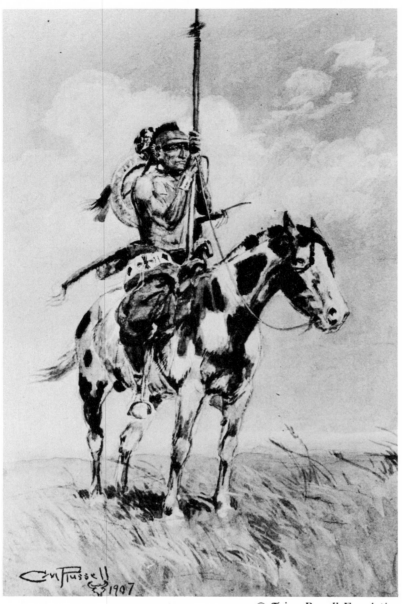

© *Trigg-Russell Foundation*

PAWNEE CHIEF

tions. Charlie was much too sensitive deep down in his rough-shelled heart to permit anyone he loved so honestly to be continuously subject to privation. There were other serious hazards to imperil the union. Charlie Russell had played the itinerant cowboy too long to be expected suddenly to change his ways. The life he had led and in fact his whole temperament were entirely opposed to the idea of settling down to being a dutiful family man. The cards were stacked against the marriage, and if it failed it might even ruin Charlie's chances of becoming a successful artist.

Through the difficult months that followed it is quite evident that the Roberts family had a lot to do with keeping the marriage from falling apart, although the direct responsibility was naturally Nancy and Charlie's. He worked desperately at his painting, and from the beginning she rode herd on him in an effort to keep him from spending too much time in the local saloon. Nancy was an unusually attractive young lady; and although life had already been unkind to her, she

had a lot of determination. The bitter memories of her own parents' wrecked marriage had unquestionably left their mark—and a deep desire to find happiness and security for herself.

In later years Charlie attested to the influence of a woman in a man's life. Although the following lines are from one of his stories, he must have had Nancy and those early days in mind when he wrote: "It's the women that make the men in the world. I heard an educated feller say once, 'n' it's the truth, that a man's goin' to hell or heaven, if you look in the trail ahead of him you'll find a track the same shape as his, only smaller; it's a woman's track. She's always ahead, right or wrong, tollin' him on. In animals, the same as humans, the female leads . . . If you ever run buffalo, you'll notice the cow meat's in the lead. With wild horses, the stallion goes herdin' 'em along, snakin' and bowin' his neck, with his tail fagged; from the looks you'd call him chief, but the mares lead to the water hole they've picked out."[2]

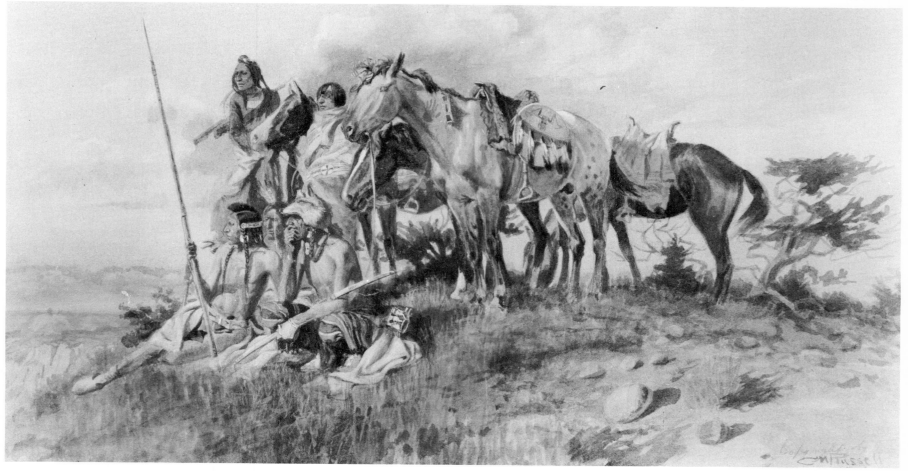

WATCHING FOR THE SMOKE SIGNAL

Newhouse Galleries, N.Y.C.

At another time, with a somewhat different slant, he wrote: "I used to think that men could stand more punishment than women, but I was wrong. In winter a girl wears a fox skin, but her brisket is bared to the weather, and there ain't nothin' on her that's warmer than a straw hat, but she don't pound her feet nor swing her arms. If she's cold nobody knows it. If a man would go out dressed this way, there ain't doctors enough in the world to save him. No sir, a woman can go farther with a lipstick than a man can with a Winchester and a side of bacon."[3]

Faced with the impossibility of disposing of enough of his work in the little town of Cascade to meet even the simplest family needs, Charlie began looking elsewhere. One of his principal outlets was through Charles Schatzlein, who had a store in Butte and who had previously been successful in disposing of several of the artist's pictures. Charlie now sent more of his paintings down there, although there were times when he was so low in cash that the small express charges had to be C.O.D. But Schatzlein never complained. He was aware of the artist's circumstances and tried very diligently to dispose of the pictures as promptly as possible, although the best ones were retailing at a top price of only $25. Charlie could hardly turn out enough work at this rate even to balance their credit at the local grocery store.

Russell had also been eyeing the big publishing houses in the East. For several years they had been featuring the work of several "western" artists, the most successful of whom was Frederic Remington. During the year 1896 this obvious competitor had twenty-two pictures in *Harper's Weekly* and thirty-four in *Harper's Monthly*, as well as four feature articles written by himself. Russell and Remington both had come West in the same year, 1880, although Charlie was three years the younger. They were both entirely self-taught, although Remington had attended Yale University before coming West and had returned East to New York City at the beginning of his serious career as an artist. His rise to fame and success had been both sudden and phenomenal. His elaborately illustrated editions of Parkman's *Oregon Trail* and Longfellow's *Hiawatha* had proved eminently successful; and the bronze castings of his sculptured *Bronco Buster* were selling at a remarkable rate. Rem-

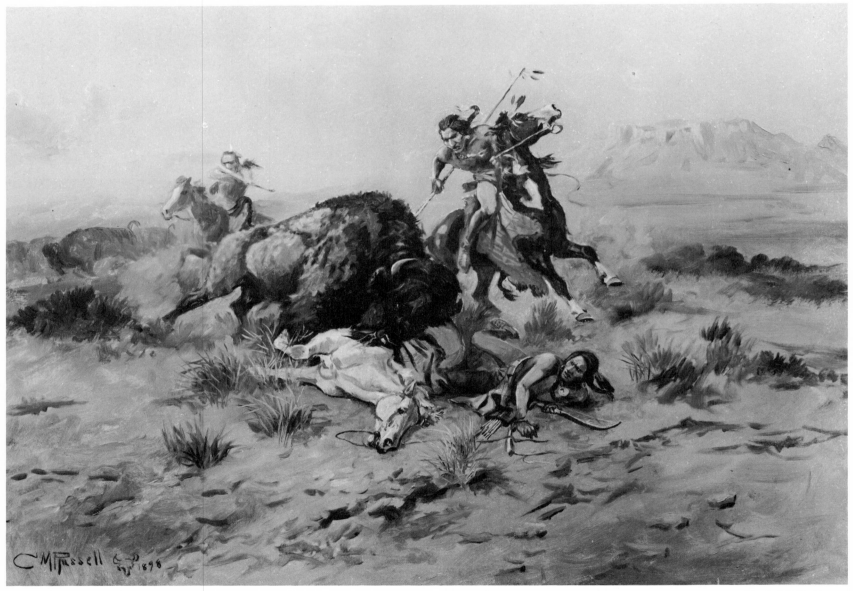

Frederick G. Renner

THE BUFFALO HUNT

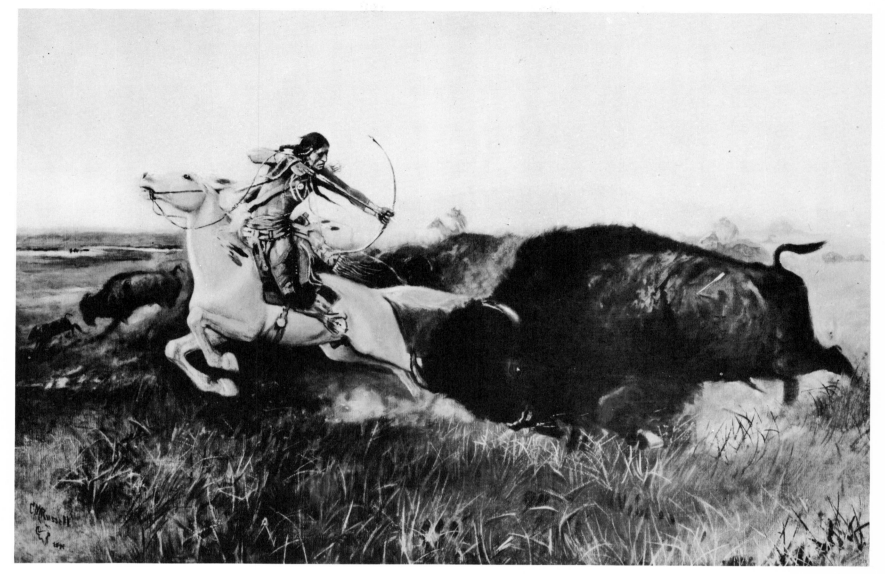

WILD MAN'S MEAT *Frederick G. Renner*

ington was enjoying the rich fruits of national popularity, and unusually high prices were being paid for his work. Publicity articles and stories described him as elegantly established in his gentleman's estate in fashionable New Rochelle, a suburban area just north of New York City. Remington's success was based entirely on the same sort of work that Charlie Russell was doing—although their respective circumstances in 1896 were a contrast in extremes. The Montana cowboy artist, with a young bride, was finding it almost impossible to survive in a little rent-free shack in the tiny cow town on the bank of the Missouri, where he occasionally slipped away to indulge in the expensive luxury of a drink or two with his roughneck friends at a frontier saloon; while Remington lunched with editors and dignitaries at the exclusive Players Club on Manhattan's Gramercy Park. Russell was aware of his rival's success and it would have been only human for him to develop a professional jealousy. But only on rare occasions did Charlie ever say anything critical or derogatory about Remington—or anyone else. The rivalry between the two outstanding artists in the field of Western Americana art has been carried on by their respective admirers far more intensively than it ever existed between themselves.

Russell's efforts to break into the eastern publisher's market had proved discouraging. The letters he wrote were hardly the sort to properly impress a New York editor. And even if his name had meant anything at all, it was preferable, from the editor's standpoint, to deal with someone over a leisurely lunch and to be able to discuss his work with him in person. Russell did manage to get six pictures accepted by D. Appleton & Company for use in a book called *The Story of the Cowboy*, by an up-and-coming writer by the name of Emerson Hough. According to a receipted bill in Charlie's handwriting, made at Cascade, Montana, on March 30, 1897, he received $10 each for three of these paintings.[4] It must have been very disheartening to the two struggling newlyweds.

In the April 1897 issue of *Recreation*, a magazine about hunting and fishing, Charlie Russell had his first article published. It was entitled "Early Days on the Buffalo Range" and was accompanied by two full-page reproductions of his paintings, plus a redrawn title decoration. The article was an attempt at fiction, told in the first person, although it was quite obviously rewritten, leaving nothing of the distinctive style which was later to make Russell famous. One of the pictures was titled "The Bull Charged His Enemy . . ." and the other "The Indians Slid for Their Horses . . ."

By the time of their first married summer together, both Charlie and Nancy had gained a realistic awareness of the many adverse circumstances which threatened their marriage. She knew by now that the road to happiness and security would be rough and uncertain. If she had previously entertained any belief or hope that she could change her husband's wayward ways, it must have required more than ordinary courage to continue. Charlie could have found a more profitable way of making a living. He knew the cattle business and had many friends who would have given him a job of one kind or another. Yet they decided to move to Great Falls, where he would be close to a better market for pictures, although there they would not have the benefit of a rent-free home or the immediate advantages of the benevolent friendship of the Roberts family. All their expenses would be greatly increased. Moreover, he had many more friends in the bigger town who were bartenders and habitués of the places Nancy had been struggling to keep him from frequenting. Nevertheless, in spite of all these potential difficulties, they packed up their meager belongings and started out on the bold venture together.

"They had very little in the way of personal belongings when they left Cascade," explained Mrs. Hebe Sheridan in a joking way. "I think they moved them on a borrowed pack horse."

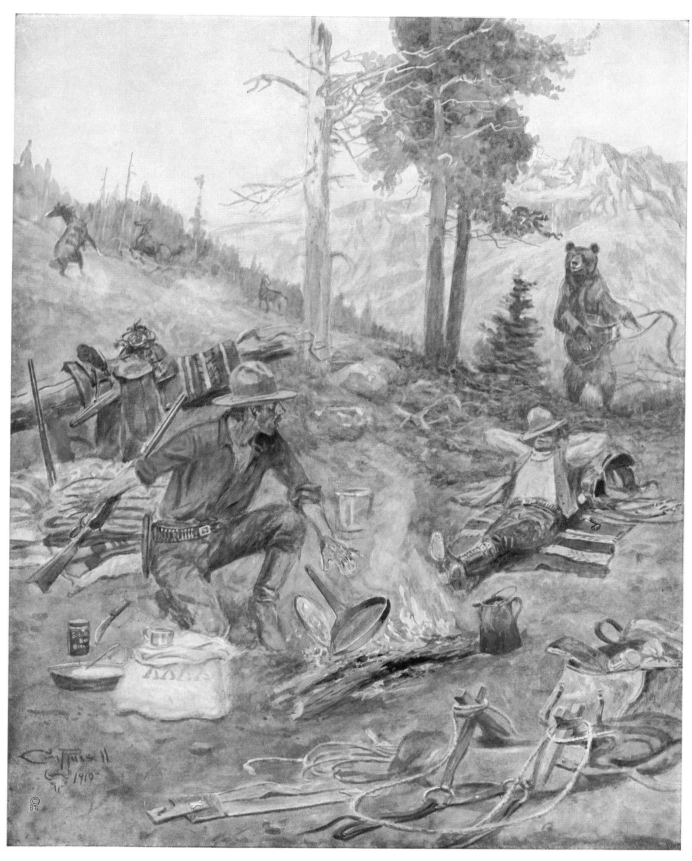

WHEN IGNORANCE IS BLISS

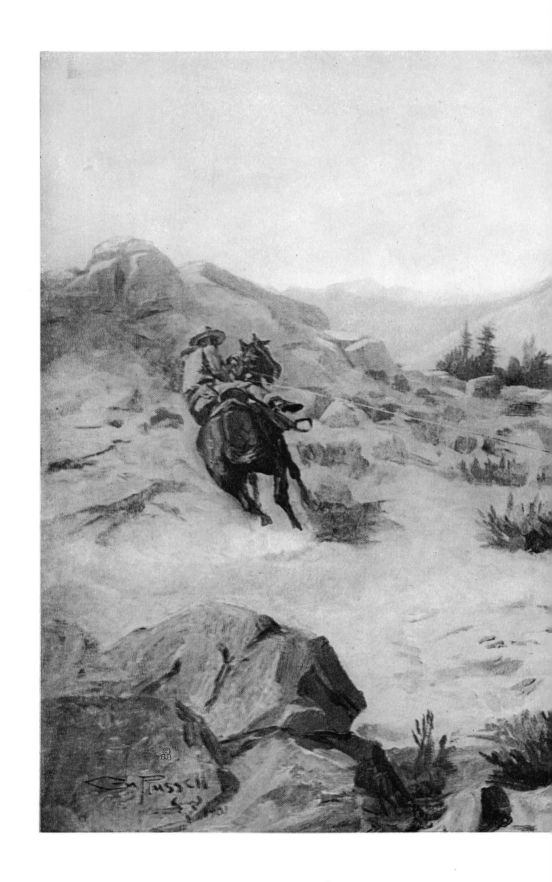

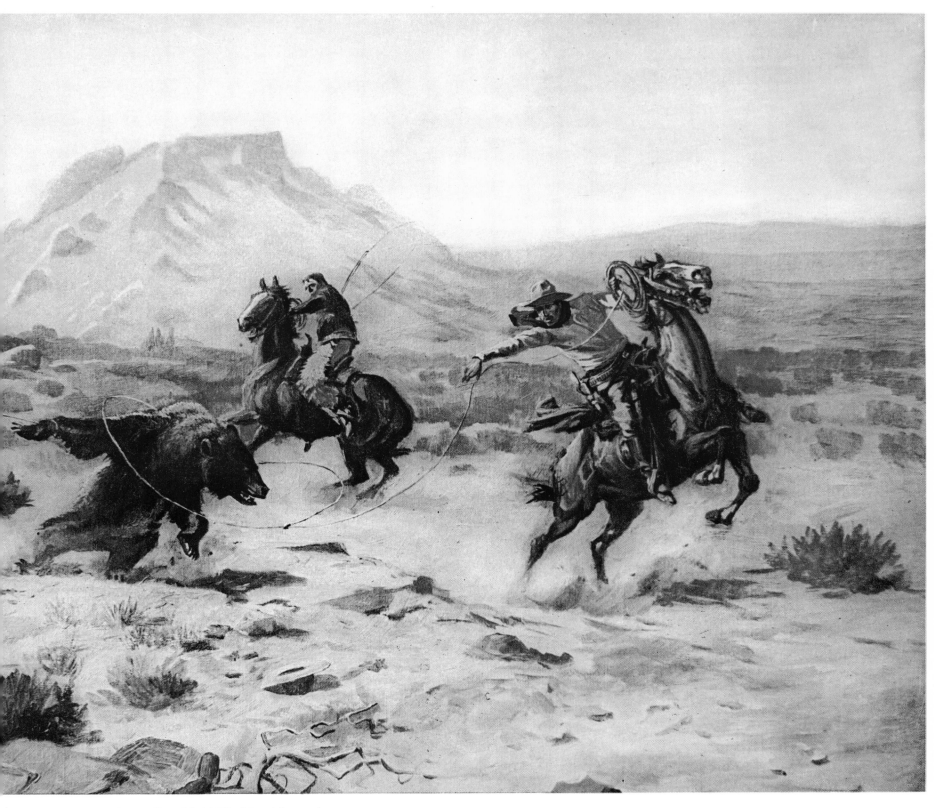

CAPTURING THE GRIZZLY

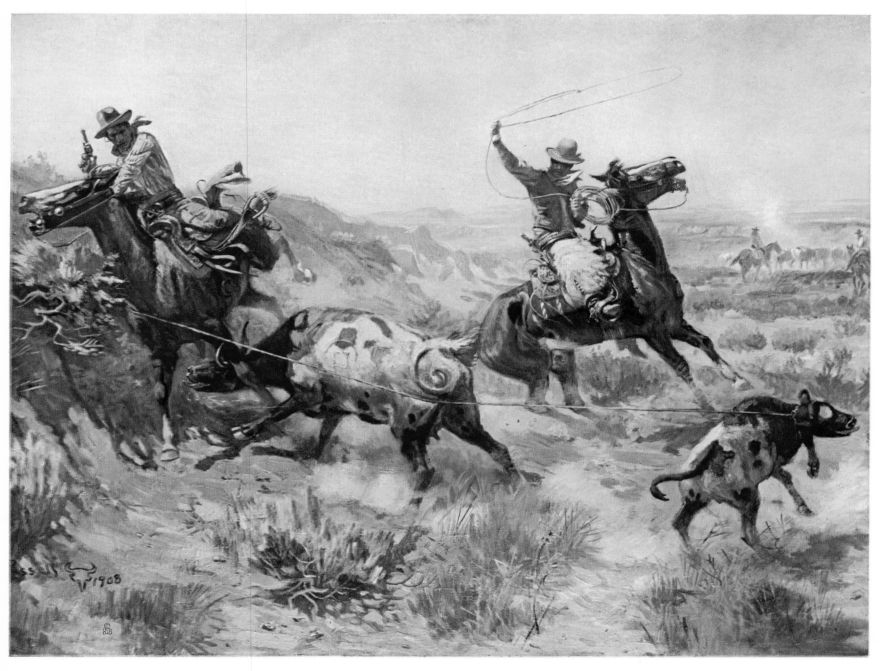

A SERIOUS PREDICAMENT

THERE'S ONLY ONE HOLD SHORTER

CHAPTER XVIII

A New Roundup Boss

COMING to Great Falls with an attractive young wife was a lot different for Charlie Russell from riding from here to there without a care in his heart or a dollar in his pocket. He could not take Nancy to one of the local stables to roll up in a blanket for a night or two until they found a makeshift shack in a cheap part of town. Nor could they throw in with a bunch of roughnecks, to share the rent and draw lots or take turns for the privilege of sleeping in the bunks. But they managed to find a little frame house where the rent was low. It was at least in a respectable part of town. Dark and dingy as the small living room was, it provided a far better studio than most of the places where Charlie had worked in the past. Even though they had very little in the way of food to put on the table, Nancy saw to it that there was always a clean tablecloth and the surroundings were quiet and peaceful. She also persisted in her efforts to keep Charlie from running with the old crowd. When he was working on a picture and some of his former cronies dropped in for a visit or to invite him downtown for one-or-two, she refused to let them into the house or Charlie out. For this determined behavior, Nancy Russell was soon heartily disliked among some of the characters around Great Falls.

Faced with so many responsibilities, Russell turned almost desperately to all the outlets for his work that he could think of. Charles Schatzlein, the Butte dealer, proved to be a good friend and increased his efforts to sell pictures, as did some of the others around Great Falls. The various saloons in town were ordinarily taboo, but the Russells needed the money and Nancy would give her permission for Charlie to deliver a painting for possible sale across the bar, on the condition that he promise faithfully to have "Not more than two!" But Charlie was never a two-drink companion, much as he respected her wishes. They managed to pay the rent and feed—although, as he later put it, "The grass wasn't so good."

That fall Russell signed a "Contract and Agreement" which promised to launch him into the magic field of nationally distributed magazines, books, and art prints. It is herewith reproduced in full.

"Agreement between Charles Marion Russell, of Great Falls, Montana, and William Bleasdell Cameron, of St. Paul, Minnesota, made 30th of September, 1897.

"The said C. M. Russell agrees to make for the said W. B. Cameron twenty black and

white oil paintings, about 24 x 18 inches in size, and twenty pen sketches about 12 x 8 inches each, comprising a pictorial history of western life, the whole to be completed within a reasonable time, or by the first of January, 1898, if possible.

"The said W. B. Cameron agrees to pay to the said C. M. Russell the sum of fifteen dollars for each painting upon delivery and fifty dollars upon delivery of the [20] pen sketches.

"It is further agreed between the parties that the paintings are to be reproduced and advertised from month to month in the Western Field and Stream, published at St. Paul, Minn., and they are also to be published in two books, upon completion, the paintings in one and the sketches in another, such books to be placed for sale upon the market, and that the said C. M. Russell shall have one-third interest in the copyrights of such books and all the profits which may arise from the sale as aforesaid.

"*Witness*: Mamie Russell *Signed*: C. M. RUSSELL

 Signed: W. B. CAMERON

 on behalf of himself and for Western Field and Stream."

William Bleasdell Cameron was the editor of the small outdoor magazine *Western Field and Stream*, the publication of which was moved from St. Paul to New York City in April 1898, whence it has been known as *Field and Stream*. Only about half the contracted number of oil paintings were reproduced, as full-page frontispieces and otherwise, in the monthly issues during the year and a half that followed the signing of the agreement. At least four were made into art prints, 14″ x 18″ in size, with wide margins and suitable for framing. They were advertised at fifty cents each or three for a dollar. The sale of these must not have been too successful, for they are today among the rarest of all Russell prints. Reproductions of two of the originals, "Lewis and Clark Meeting the Mandans" and "Before the White Man Came" are shown on pages 183 and 184, respectively. Another of the paintings was "The Smoke Signal"; and one of the pen sketches that was successful in finding publication was "A Friend in Need . . ." (page 185).

A brief series of articles appeared in *Field and Stream* under the by-line of editor William Bleasdell Cameron, which read so much like the stories of Charlie Russell that it seems safe to assume that the artist supplied the material from which they were written. These were evidently the basis for the contemplated books, which were never published. It is quite obvious that supplying the oil paintings at $15 each and the drawings at $2.50 apiece did not prove profitable for the Russells.

One day shortly after Russell signed the agreement with Cameron, Charles Schatzlein was in Great Falls and came out to have a talk with the artist. They undoubtedly discussed the new contract. Schatzlein had some things to say which made a deep impression upon Nancy, for years later she quoted his comments: "Do you know . . . you don't ask enough for your pictures. That last bunch you sent me, I sold one for enough to pay for six. I am paying you your price, but it's not enough. I think your wife should take hold of that end of the game and help you out."[1] This set Nancy to thinking. There was no doubt that Charlie was doing better work. His pictures were selling about as fast as he could finish them. He could not have been more diligent or have turned out more work; yet in spite of

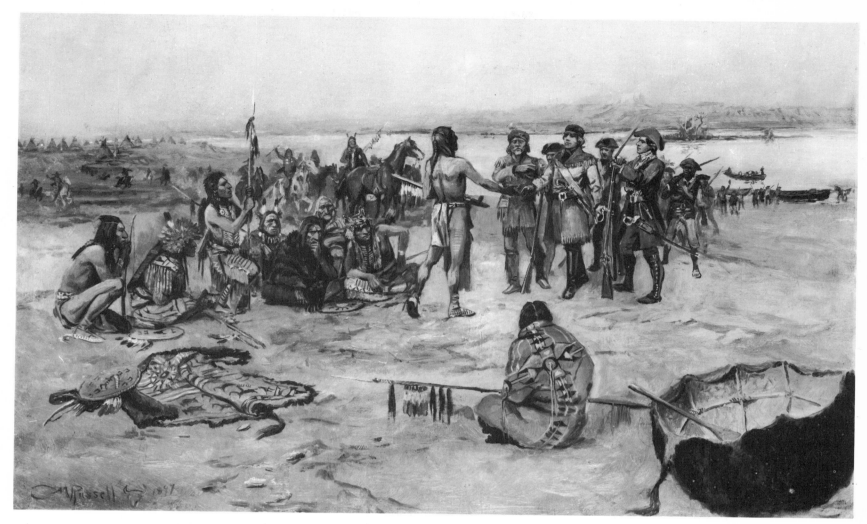

LEWIS AND CLARK MEETING THE MANDANS

this, they had been unable to make ends meet. It seemed that the only solution was to get more money for what he did. Nancy decided to take over the sale of the pictures and determined to boost the prices until they could not only pay their household bills but live more comfortably all around.

It was not long thereafter that Russell finished a painting for a local buyer. But instead of delivering it himself, as he had been accustomed to doing in the past, he yielded to Nancy's insistence that she take the canvas and collect the money. Mindful of their desperate circumstances, and fortified by her deep devotion to her husband and admiration for his work, she approached the prospective customer with all the determination she could possibly muster. She thought very hard about the old stove and the bare shelves in their rather empty little house, and all the nice meals she would like to cook. She made up her mind to ask twice the price Charlie expected—or carry the picture back home. After the potential purchaser had had time to admire the painting, she added her own praise, then told him what it would cost to own the work. Much to her surprise, it was paid for without the strenuous protest she had prepared herself to resist. From that day forward, practically without exception, Nancy handled all the business arrangements on every picture that was sold. She began raising prices, and quickly developed into an aggressive agent. To get larger and larger amounts for her husband's work became something of an obsession with her, so much so that many more people came to dislike her. For her to handle the sales was perfectly all right with

Charlie, for he had never liked that task anyhow—although he frequently admitted to close friends that he was embarrassed by Nancy's boldness and greatly surprised when she was paid the prices she asked.

"The lady I trotted in double harness with," he once said, "was the best booster an' pardner a man ever had. She could convince anybody that I was the greatest artist in the world, an' that makes a feller work harder. Y'u jes' can't disappoint a person like that, so I done my best work for her . . . If it hadn't been for Mamie, I wouldn't have a roof over my head."[2]

But the new policy was far from making them rich quick. The folks around Great Falls and most other places in central Montana were too accustomed to seeing Charlie use his pictures as "bar receipts," or make outright gifts of them to friends, to pay the sort of prices that Nancy Russell was now demanding. He had many ardent admirers, including erstwhile rawhides and others nostalgic for the old days, who would have liked to own one of his paintings, but most of them just didn't have that sort of money. So far as Nancy was concerned, Charlie had no special friends; the prices were the same to all and there was about as little chance of getting a bargain as of getting a discount on a hundred-dollar bill from an unfriendly banker. As a result, unsold paintings began to accumulate in the little rented home where the Russells lived.

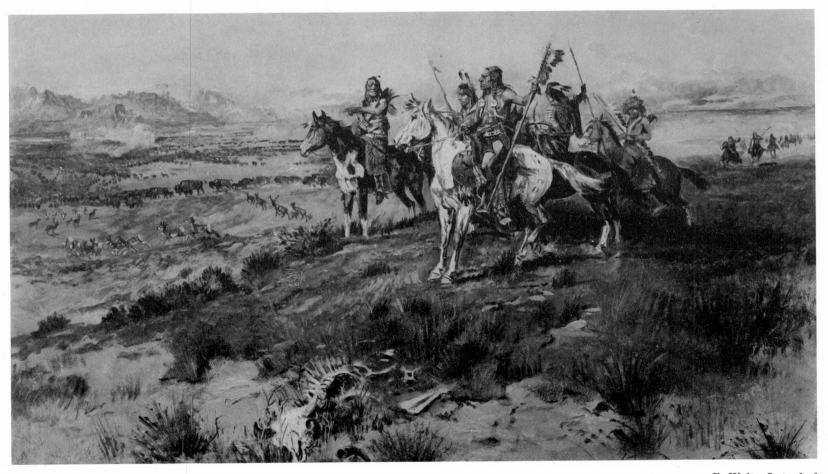

E. Walter Latendorf

BEFORE THE WHITE MAN CAME

Having assumed complete management of the picture sales and all other family business, Nancy still faced other problems. Among these was Charlie's propensity for the sociability found behind the swinging doors. As part of her struggle in this matter, she set up such a blunt and arrogant barrier between her husband and his former cronies that even to this day some of them retain a strong dislike for her. "Aw—she was just a sheepherder's daughter!" was the derisive retort an aged cowboy made to the present writer when he was queried about the wife of his old friend of the Judith Basin. There was, however, a twinkle in his eyes, which seemed to concede, "Maybe she had the right idea, though." Nancy also endeavored to make a "gentleman artist" of her husband—one effort in which she never succeeded.

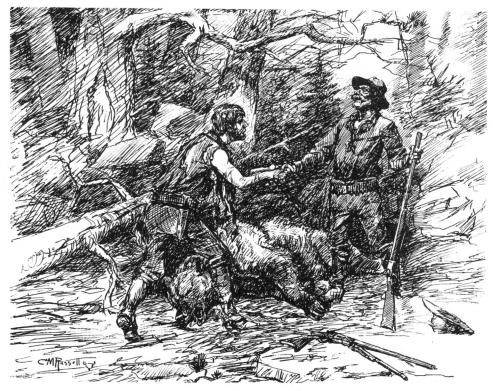

Field and Stream

A FRIEND IN NEED

It was shortly after the move to Great Falls that Charlie's father came from St. Louis to visit. The elder Russell was now president of the Parker–Russell firm, which had continued to expand and brought ever increasing prosperity to the family. It seems not a little incongruous that the gifted son and his ambitious young wife should live in a state of virtual poverty when the father could so easily and would undoubtedly very willingly have given all the financial assistance necessary. From the time that Charlie left his parental roof as a fifteen-year-old boy, however, he had been determined to make his own way in the world, just as he had refused to become a part of the family business so that he might live the sort of life that suited his fancy.

After the death of his mother, and Charlie's marriage and subsequent settling down to the serious purpose of becoming an artist, Charlie and his father drew closer together than they had ever been before. Whatever disappointment or ill feeling there may have been on

the part of the elder Russell gave way to parental satisfaction with his son's choice of a wife and a growing admiration for his artistic ability. It is reported that "Soon after Mr. and Mrs. [Charles M.] Russell were married, Mr. Russell's father visited them and for a wedding gift gave them the house and studio on Fourth Avenue North, where the Russell city home has been ever since."[3] Nancy Russell in her biographical note in *Good Medicine*, gives another version of the facts, however: "In 1900, Charlie got a small legacy from his mother, which was the nest egg that started the home we live in." At any rate they must have had substantial assistance from some outside source, for the location they selected for their permanent home adjoined the residence of Russell's old friend Albert Trigg, in one of the best residential sections of Great Falls. The home that they built was a two-story frame building of more than ordinary proportions and much beyond the means that was being provided by the sale of pictures at the time. Today the C. M. Russell Memorial Gallery and Studio occupy the site of the Trigg and Russell family homesteads.

Russell persisted in his efforts to get his pictures published and widely distributed. His astute wife undoubtedly had a lot to do with this attempt to achieve more than local recognition. It was an unsuccessful attempt, from a financial standpoint at least, but they kept trying. Early in 1899 eight Russell pictures appeared in a privately printed little volume called *Rhymes of a Round-Up Camp*, by Wallace D. Coburn—but the artist's name was not even printed on the title page. About the same time there appeared a portfolio of twelve plates, attractively bound in limp black morocco with stamped gold design and lettering, *Pen Sketches, by Charles M. Russell, The Cowboy Artist*. It proved an immediate success on a small scale, and was reprinted three times before the end of the first year. The publication of this portfolio, as well as the *Rhymes of a Round-Up Camp*, was taken over by the W. T. Ridgeley Company, of which Charlie's old friend Charles Schatzlein became president and Russell himself vice-president. But the progress Charlie made was still local; and the sales of his portfolio and the little book of rhymes were restricted, on the whole, to places where their popularity was stimulated by a more than ordinary interest in the subjects portrayed. It could not have been a very remunerative venture. And even with the sale of paintings at increased prices, the Russells could hardly manage the large house on Fourth Avenue North comfortably.

Russell also looked with some seriousness toward having the little wax and clay figures that he made reproduced for sale. One small medallion (and probably two) was sent to the Roman Bronze Works in New York City to be cast. One of these, *Old-Man Indian* (sic) (4¾" x 4") is signed and dated on the back: "C. M. Russell 1898" (page 187). Britzman gives the date as 1896 and lists a second one. Presumably these were made in 1898 and were Russell's first bronze castings.

In the spring of 1901 Charlie made a trip back to St. Louis to see his father and try to promote the sale of his work. "A few weeks ago Charles M. Russell, the 'Cowboy Artist,' who lives in Great Falls, went to St. Louis to visit relatives . . ." reports the Helena *Daily Independent* on May 13. "All the St. Louis papers have printed more or less about the artist, and some of them have illustrated their stories with reproductions of his pictures . . ." That the trip was not altogether successful, and even to some extent embittered the artist, may be gathered from an interview which appeared in the Anaconda (Montana) *Standard* for

December 15, 1901, in which he is quoted as saying: "There's nothing in the East for me. What do Eastern people care about my pictures? Why, they wouldn't give thirty cents a dozen for them. It is the Western people who understand and want my pictures. I realize and understand that. I was down to St. Louis a while ago and I had a chance to see what Eastern people like. They all are daft on the impressionist school. In one gallery I saw a landscape they were raving about. Color! Why, say, if I ever saw colors like that in a landscape I would never take another drink. A man who would paint such a thing and represent it as a copy of nature must be on the ragged edge."

The interview, which took place in Charlie's improvised studio at his home on Fourth Avenue North, gives an interesting portrayal of the artist at the time: "Indian robes and finery were scattered about . . . On the walls were pen and ink sketches, water colors and oil, all the products of his gifted fingers . . . The first impression of him fitted his title accurately. He is a cowboy artist and looks the part. His manner was unaffectedly hospitable and courteous . . . a heavily built man, thick set and sturdy. He walks with the gait of a cowboy . . . a man who has spent much time in the saddle. He was dressed, as usual, in a soft flannel shirt and gray trousers, held at the waist by a twisted, dark red sash . . . A coat would have seemed out of place . . . One sees but little of the artist in that large, strong, big-jowled face, over the eyes of which hang two straggling locks of tawny hair, half hiding the characteristic corrugations of the brow . . . Modest of his accomplishments, not prone to talk of his work, carefully, almost boyishly, covering up his love of art and longing to accomplish great works . . ."

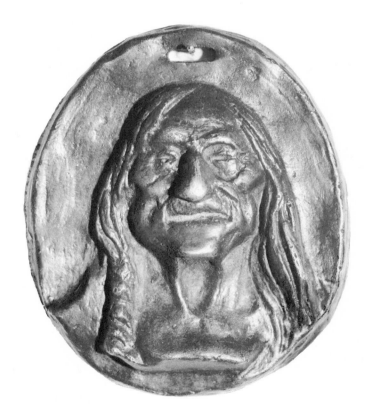

E. Walter Latendorf

OLD-MAN INDIAN (*bronze medallion*)

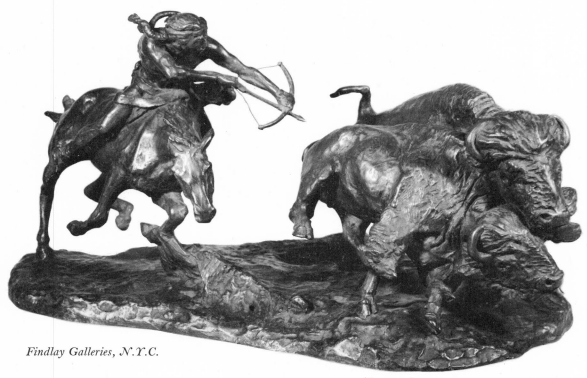

THE BUFFALO HUNT (*bronze*)

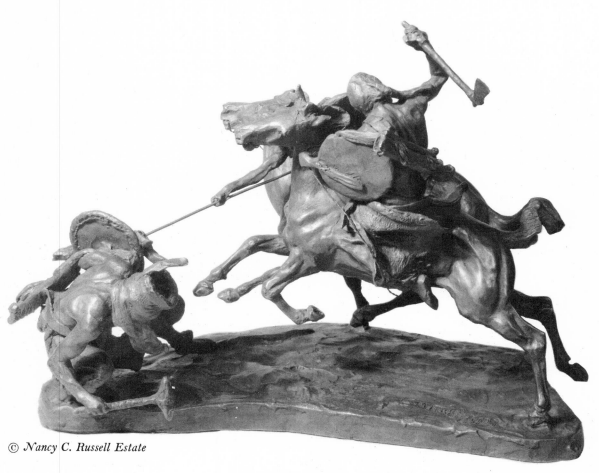

COUNTING COUP (*bronze*)

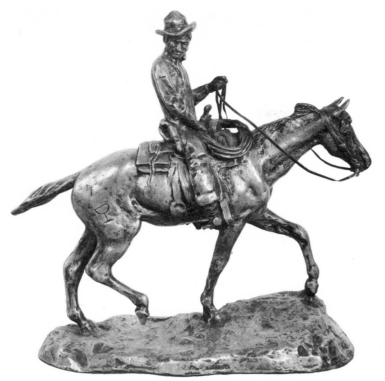

WILL ROGERS (*bronze*)

CHAPTER XIX

A Stranger in "The Big Camp"

A PARLOR was not a natural atmosphere for Charlie Russell to paint in. His wife had had a remarkable influence upon him, although there were some circumstances over which she had little or no control. She had inspired him to take a serious attitude toward his work and to try to make real all the aspirations which he had kept hidden in the past. Nancy had supplied the balance that kept him from drifting off into the old life along the vagabond trail. She had brought about some superficial refinements in his personal appearance and habits. But in his heart he had not forgotten the smoky aroma of the Indian tepees, nor the wonderful freedom of the rough places where he had taught himself the art of drawing and putting colors on paper and canvas in realistic scenes of the life he loved. He longed for the companionship of the people he was now portraying from his recollections. Although there was no returning to those old days, he wanted to work in a place that was more in keeping with the spirit of everything he did and thought—a log cabin studio, with rough walls on which to hang all the Indian paraphernalia, saddles, and guns he had cherished and used in his pictures; and with a big fireplace, in front of which to roll a cigarette and dream, and relax and reminisce with his old cowboy companions and redskin friends who came to see him when they were in town.

Nancy had been pretty hard on him, so far as his manners and morals were concerned, although she now had the situation fairly under control. There was plenty of room on the property adjoining the house, and in 1903 arrangements were made for the building of a log cabin with one large room for a studio. They had to settle for telephone poles as the material, but that was a small matter. Charlie told the contractor what he wanted and then had nothing more to do with the project while it was in progress. Probably he remembered his unfortunate experience trying to build a cabin in Pigeye Basin.

Before the log building was completed, an incident occurred which almost spoiled the whole idea and indicates how sensitive Charlie really was beneath his rough exterior. It is best told in the words of Mrs. Russell:[1] "Then, one day, a neighbor said, 'What are you doing at your place, Russell, building a corral?' That settled it. Charlie thought the neigh-

bors didn't want the cabin mixed in with the civilized dwellings and felt they would get a petition to prevent our building anything so unsightly as a log house in their midst. Way down in his heart, he wanted that studio . . . but he was worried at what he thought the neighbors would say, so said he would have nothing to do with it . . . nor did he go near it until one evening Mr. Trigg, one of our dearest friends, came over and said, 'Say, son, let's go see the new studio. That big stone fireplace looks good to me from the outside. Show me what it's like from inside . . . So Charlie took Mr. Trigg out to see the new studio that he had not been in . . .

"When they came back into the house . . . Charlie was saying, 'That's going to be a good shack for me. The bunch can come visit, talk and smoke, while I paint.' From that day to the end of his life he loved that telephone pole building more than any other place on earth . . .''

Russell decorated the log studio with all his cherished mementos of the past, and there he worked every day from early morning. There his old friends were always welcome—cowboys, bullwhackers, bartenders, retired road agents, Blackfeet, Sioux, and half-breeds. He would often cook meals for them in the big fireplace—and squatting on his heels Indian fashion, roll a cigarette in his long slender fingers, light it, and in the smoke, drift back in his talk to the times when Montana was Nature's country.[2] Or, "his people" would sit by and they would talk quietly while he applied paint to canvas. All this was good for his soul, and his pictures showed it; they improved both in the quality of craftsmanship and in the inspirational values they portrayed. It was also at about the time the log studio was completed that Monte died of old age.

Nancy continued to ride herd over her husband and his guests; she also encouraged Charlie to cultivate new friendships which might help him later on. Among the new people he got to know around this time were John Marchand and Will Crawford, two fairly well-established illustrators of the western scene who were visiting in Montana. They shared a studio in New York City and had good contacts with leading publishing firms in the East. Although neither was particularly prominent as a painter, they had many friends in the best art circles. They were great admirers of Russell's work, so that it was only natural for them to encourage him to go to New York, which was the mecca of the art and publication trade in America. They seemed very confident that Charlie would find ready sales for his paintings and be able to obtain important commissions through personal meetings with editors and publishers. They both offered to help him when he came. In spite of his almost bitter antipathy for every aspect of urban life, and the recent unsuccessful experience he had had in his home town of St. Louis, the idea seemed to Russell a sensible possibility. It is more than probable that Nancy entertained ideas of her own in the matter and had a great deal to do with making the plans for the trip. They did not have very much money to spend either on a trip to New York or to meet the expenses which a suitable length of time there would involve; thus Charlie vacillated for several months. But finally, in the late fall of 1903, they decided to make the plunge.

It was about this time that elaborate preparations were being made for the Louisiana Purchase Exposition at St. Louis, which was scheduled to open May 1, 1904. Russell's father had insisted that Charlie submit some of his best paintings for possible exhibition at the fair.

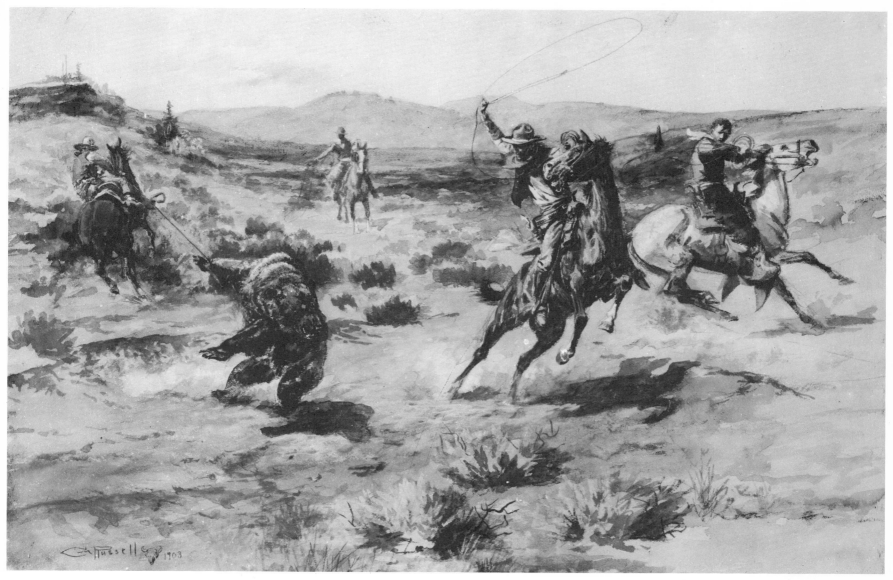

ROPING A GRIZZLY

On December 6, 1903, the St. Louis *Post-Dispatch* carried a story in its Sunday Magazine section, headlined, "Cowboy Artist Who Has Lived Among the Indians for Twenty-Three Years Will Exhibit Studies at the World's Fair." His painting "Pirates of the Plains" and some other pictures were selected to be hung in the Fine Arts Building.

When the Russells were packing for their trip to "the big camp," as Charlie called New York City, they gathered together an assortment of the unsold paintings which still were in the log studio on Fourth Avenue North, to take along. Then, dressed in their best and loaded down like a couple of pack horses, they started out on the long iron trail for Manhattan. On the train Charlie met a kindred spirit, who was to become one of his staunchest friends and most ardent admirers. This traveler was also on his way to New York to try his luck there. His name was Will Rogers.

Depending almost entirely on Will Crawford and John Marchand for guidance and assistance in the big city, the Russells got a cheap room at the modest Park View Hotel, which was about a block away from their friends' studio at 133 West 42 Street, just next

door to Times Square. The Park View's address was 55 West 42 Street, then opposite Bryant Park—once the site of the city's infamous Potter's Field and afterward of the fabulous Crystal Palace. The New York Public Library was in the first stages of construction on the site adjoining the park. "We had a nice little room," explained Russell,[3] "but it didn't have no view of no park." It was a long way from the last roundup camp the cowboy artist had shared.

They lost no time finding a place to display the paintings that Nancy hoped to sell to wealthy New Yorkers. "We didn't have the price to go to any of them fine galleries," as Charlie put it, "so we hung the pictures in a basement studio down the alley."[4] Crawford and Marchand urged all their acquaintances to see the work of the cowboy artist from Montana. Nancy was on hand in the basement showroom from early till late, waiting to take their money. The little lady had on her best dress, her best smile, and had mustered all the

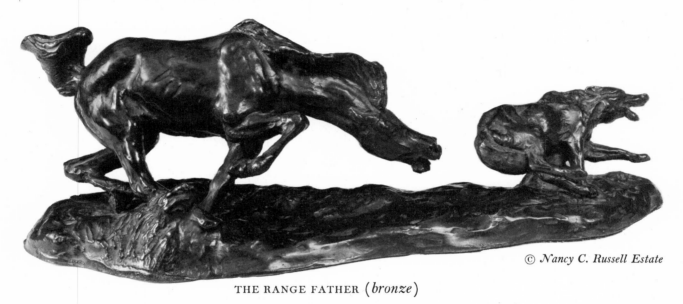

© *Nancy C. Russell Estate*

THE RANGE FATHER (*bronze*)

courage she possessed; while Charlie stood by, rolling one cigarette after another, watching to see what would happen. The visitors came—they said some nice things about the vivid scenes of cowboys and Indians—but they didn't buy pictures. Among the choice examples of Russell's work was a fine 20″ x 30″ watercolor entitled "Roping a Grizzly" (page 191). This picture later became a prized possession of President Taft and hung in the White House. It recently sold in New York City for $35,000. But during that first show in New York City the Russells did not take in enough money to pay their rent.

As the family funds began to dwindle, Nancy took to locking the little basement display room so that she might carry bundles of her husband's pictures around the city from one publishing office to another, and everywhere else she might hope to make a sale. This also proved almost futile. Most of the editors had their own favorite western artists to supply their needs in that field. Remington had just begun to publish a long series of full-page and double-page color plates under a tight contract with *Collier's Weekly* and was riding high on the crest of national popularity; his art prints and bronzes were selling widely. One of his books, *John Ermine of the Yellowstone*, had been produced as a play on Broadway only a few

weeks before the Russells arrived. Thus there were very few places where Nancy was even able to get her small foot inside the door. At *Leslie's Weekly* she managed to promote a story about her husband for the issue of March 3, 1904, with reproductions of some of his pictures. The editor also selected "Navajo Indian Horse-Thieves . . ." for the cover of the April 21 issue. At *Outing Magazine*, editor Caspar Whitney was sufficiently interested to use one of Russell's pictures in his August issue and the autobiographical story, with three pictures, in the December number. That was about all Nancy accomplished—but it was hardly worth their while from the standpoint of remuneration.

From the very beginning, Charlie's dislike for New York increased and he wanted to pack up the pictures and go home. But Nancy refused to give in. They were compelled to

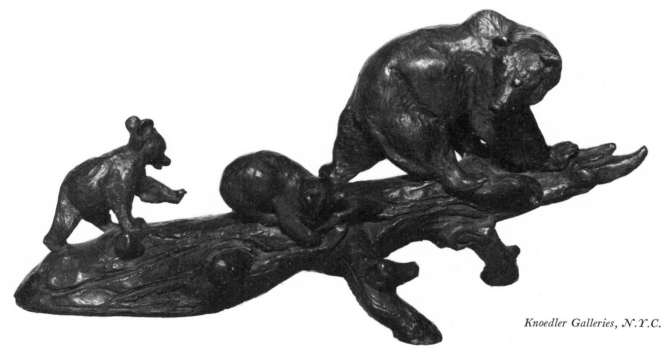

THE MOUNTAIN MOTHER (*bronze*)

abandon the basement salesroom and carry the pictures back to the hotel. At the invitation of Crawford and Marchand, Charlie set up an easel in their studio, while his wife continued her search for new contacts or new friends who might lead to sales or outlets of any kind.

In the January 31, 1904, issue of the New York *Press* there was an elaborate story with the grossly exaggerated heading "SMART SET LIONIZING COWBOY ARTIST." It carried a photograph of Russell on horseback, one of the fireplace in his log studio, and reproductions of his pictures "Roping a Grizzly" and "A Battle on the Plains," as well as of a wax model. The interviewer stated that Russell "doesn't like New York. Taciturn as a Sioux chief, self-contained and impassive, he is hardly the man to care for pink teas. He will remain a Westerner of the old school to the end . . ." There is also a lengthy description of the artist's painting "Massacre of Custer," done from the Indians' viewpoint, and of how the artist obtained the details for this picture directly from one of the red warriors who participated in that historic incident. It is also quite evident that the controversial name of Frederic Remington was brought up in the interview, for the writer records the following comment:

"Russell, however, has none of the jealousy of the artist, and frankly praises Remington as the premier artist in depicting the American soldier." Someone other than Charlie Russell might easily have been less gracious, but the cowboy artist never entertained any outward expression of malice toward anyone.

Russell had heretofore made wax or clay models mostly to amuse his friends or to provide models to aid him in his painting. While sharing the studio of Crawford and Marchand he made an eleven-inch-high figure of a drunken cowpuncher on a rearing horse. The man was shown with his mouth open and his six-shooter held high in the air, in the act of smoking up a cow town. Charlie called it "Smoking Up" (page 161). The model made such a favorable impression upon those who saw it in the studio that someone suggested it be cast in bronze. The reproduction rights were sold to the Co-operative Art Society and six castings were made. One of the castings was presented to President Theodore Roosevelt by a prominent New Yorker.[5] This was the artist's first bronze statue.

After about four extremely discouraging months, however, the Russells packed up their unsold pictures and went home. Charlie wanted to have nothing more to do with the big camp on the island of Manhattan. In an interview published in the Great Falls *Daily Tribune* for February 16, 1904, he is quoted as saying: "New York is all right, but not for me. It's too big and there are too many tepees. I'd rather live in a place where I know somebody and where everybody is somebody. Here everybody is somebody, but down there you've got to be a millionaire to be anybody . . . And the style of those New York saloons. The bartenders won't drink with you even. Now I like to have the bartender drink with me occasionally, out of the same bottle, just to be sure I ain't gettin' poison . . ."

Charlie went back to his work in the log studio. Disheartening as the whole trip had been, Nancy was still determined to break into the big money that came through recognition by the moguls in New York City. Through persistent correspondence she pursued the contacts they made both for the sale of pictures and possible commissions to do illustrating for magazines or books. Russell had made some good friends during his stay and began writing letters to some of those nice folks. Devoted as he was to all his friends, Charlie never liked to write letters and preferred to illustrate them with drawings or beautiful little watercolor pictures. With their unique text in colorful rawhide lingo, their disregard for simple spelling and punctuation, and their spicy bits of wit, Russell's letters became cherished possessions of their recipients. They were such interesting conversation pieces that they were often carried about to be shown to friends. Small and innocent link to success though they were, the letters thus played a role in getting the cowboy artist talked about.

By the time another winter started moving down into Montana, some encouraging prospects had been developed in New York and Nancy prevailed upon her reluctant husband to make a second try in the big city. Once again loaded down with pictures, they boarded the train for the East. They stopped in St. Louis to visit Charlie's father and to see his work on exhibition at the World's Fair. Then once again they checked in at the Park View Hotel on Manhattan's Forty-second Street. Russell retained his strong dislike for the big camp. In a beautifully illustrated letter which he wrote on January 29, 1905, to Albert Trigg, his good friend and next-door neighbor in Great Falls, he included the following comment: "as I am lonsum to night an far from my range I thaught it might help some to write you just

think I am in a camp of four millions an I guess I know about eight it makes me feel small It makes it strong d— small the whits are shure pleantyfull . . . I havent heard from there since I left onely through Nancy an that don't tell me much of the bunch I mix with but we expect to start home in three weeks so Il soon know . . ."[6]

The second trip to New York proved more successful than the previous one. Nancy sold a number of pictures; and Charlie sculptured three of the best miniature groups he had ever produced, with the purpose of having them cast in bronze. Many critics consider these among the finest specimens of their kind. "The Buffalo Hunt," or "The Buffalo Runner" (page 188), approximately ten inches high, depicts an Indian on horseback racing alongside a buffalo bull and cow. The hunter is in the act of shooting a second arrow into the cow, al-

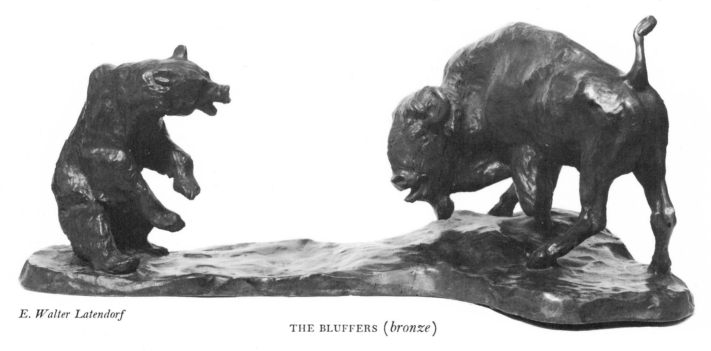

E. Walter Latendorf

THE BLUFFERS (*bronze*)

though in later castings the first arrow is missing. The Indian's pony has only one hind hoof touching the ground, a front leg being supported by a small bunch of grass. The second group, "Counting Coup" (page 188), is twelve and a half inches high and is of three Indian warriors and two horses. A mounted Blackfoot and a Sioux are riding at full gallop. One of the warriors is striking out with his lance at a wounded Indian who is crouching on the ground almost under the horses' hoofs, while the other rider is about to protect his fellow tribesman by striking their enemy with a tomahawk. Although the group is perfectly balanced, only one hoof of each pony is touching the ground. The third group, "The Scalp Dance," or "Blackfoot War Dance" (page 196), depicts two almost nude warriors dancing in celebration of their victorious return from battle. One crouching Indian has a fresh scalp attached to his war shield, while the other holds aloft a rifle to which is tied his own trophy of personal combat. All three groups were cast by the Roman Bronze Works and were displayed for sale in Manhattan's fashionable Tiffany & Company. The first two groups were priced at $450 each, the latter at $180. This must have given Nancy a great deal of satisfaction, for Remington's 24-inch "Bronco Buster" was then priced at only $250 and his 30-inch "Mountain

Man" at $300—although it should be pointed out that the Russell bronzes were somewhat more expensive to cast, because of their complicated detail.

Nancy's perseverance and salesmanship had started to pay off elsewhere too. Russell was commissioned to supply illustrative plates for B. M. Bower's book, *Chip of the Flying U*; W. T. Hamilton's *My Sixty Years on the Plains*; and for some of Stewart Edward White's "Arizona Nights" stories scheduled for *McClure's* Magazine. He was also to begin a series of his own stories with illustrations for *Outing Magazine*. These were the first of the famous Rawhide Rawlins stories which later appeared in book form.

Needless to say, Charlie and Nancy were a lot happier when they went home to Great Falls this time. He had enough work to keep him busy for a long time—and it was not merely on speculation.

THE SCALP DANCE (*bronze*)

THE STRENUOUS LIFE

WHEN HORSEFLESH COMES HIG

A LOOSE CINCH

(*bronze*)

WHERE THE BEST OF RIDERS QUIT

CHAPTER XX

A Rocky Trail to Fame

THE STRUGGLE was by no means over. If they had more fancy steaks for dinner now, that only served to remind the Russells that there was still work to do—and they worked hard. Nancy plugged along doggedly as business manager and never relaxed in her efforts to promote her husband's work. Charlie kept on painting and modeling, and spent longer and more serious hours in the log studio. He filled in his time writing stories and poems, which were similar in tenor to the re-creations he painted on canvas and paper.

Due largely to the influence of the partner in whom he had come to place such faith, Charlie had mellowed and become more restrained. But now and then the spirit of the old Kid Russell busted through. On one such occasion the incident involved a local prize fight. The bout was to take place between one Stanley Ketchel and one Jerry McCarthy. Ketchel was a young and almost unknown maverick who later became the middleweight champion of the world. What reputation he had was based on the fact that he had recently been arrested in Miles City as a vagrant and put in thirty days on the rock pile. His opponent enjoyed wide notoriety as a fistic killer. Everyone expected the fight to be a matter of legalized murder. It was advertised to take place in Great Falls on the evening of December 19, 1905.

The afternoon of the fight Russell had dropped in at one of his favorite saloons, where he happened to get into conversation with "Doc" Flynn, a visiting resident of Butte. When he learned that Doc was going to serve in Ketchel's corner during the pugilistic proceedings, Charlie became very much interested and began buying drinks. Being both ardent devotees of the manly art, the cowboy artist and the corner man quickly became the best of bar buddies. A lot of betting was going on, with high odds in favor of McCarthy. As these two convivialists talked and drank, however, Russell began putting wagers on Ketchel. Before they had that final last one, Charlie had run his bets up to several hundred dollars—far more than he could possibly afford or would ever dare let Nancy know anything about.

After dinner that night Russell got out to attend the fight. By that time he was undoubtedly very regretful of having been so carried away by Doc Flynn's enthusiasm. But according

201

to the record, "Ketchel scored an eleven round knockout over Jerry McCarthy." Just how much Charlie won is not recorded, but he had a little celebration afterward.

Russell gave Doc Flynn a liberal share of the loot and also presented him with one of his paintings, a picture of a cowboy running a buffalo near the edge of a cliff. Five or six years later, Flynn moved to San Francisco, where at one point he found himself in desperate need of a few dollars. The former corner man was working around a fighters' gymnasium, where a French artist by the name of St. Julien was taking nonprofessional exercises. Flynn approached this artistic gentleman about buying a picture that had been painted by a cowboy friend. When he mentioned Russell's name the Frenchman perked up and agreed to see the painting. Flynn took it to St. Julien's studio and immediately had visions of a square meal or two. "I'll give you four fifty," offered the Frenchman. "No," parried Flynn hungrily, "make it five and the picture's yours." The difference between $4.50 and $5.00 was a lot to an old corner man who was flying so low to the ground. He figured he could stand pat for at least a round or two. "O.K.," agreed the Frenchman, quickly producing four twenty-dollar gold pieces, which he handed over. "I give you check for ze balance by five o'clock. O.K.?" Flynn was too astonished to say anything. He had been thinking in terms of dollars and St. Julien had been talking in hundreds. At five o'clock the Frenchman came to the gymnasium with a check for $420 and an impressive bill of sale which had been drawn up by a lawyer. Flynn cashed the check at nearby Tim McGrath's saloon. The fact that the picture was shortly afterward valued at $1,500 did not upset Doc Flynn, who lived well for some time thereafter, before going back to Butte.[1]

Charlie Russell never quite learned the real value of a dollar and never lost his desire to give away his pictures to friends and admirers. Gambling with fate was as natural to him as painting or modeling, and he always seemed blessed with more good luck than good judgment. He worked hard and played hard, and by no means spent all his time in the Great Falls studio; he had too great a love for the wild, unspoiled back country. As soon as the grass began to get green, or the cottonwoods turned golden, he was gripped by an irresistible urge to get out of town. He made trips back to the Judith and up into the Chinook country, to see old friends and gain new inspiration for his artistic efforts. He was a frequent visitor to the Indian reservations, particularly when the white fathers condescended to let the Indians play at their old-time festivals and ceremonial dances. The tribesmen always accorded Charlie Russell a particularly warm welcome—for there was a mutual understanding between them. A tepee was quickly set up for him and the old ones came to pass around the pipe and talk about things which they did not discuss with other white visitors. Russell also took in the cowboy "rodeos," where roping and riding bucking broncos was becoming more of a competitive sport than a day's work.

The region Russell probably loved best of all was the section of the Rocky Mountains in the extreme northwestern part of Montana, which in 1910 was set aside for permanent preservation as Glacier National Park. Shortly after Dimon Apgar homesteaded there in 1895 and founded the town of Apgar, Russell had purchased a small area of land on the shore of beautiful Lake McDonald. He would go there to camp, amid the scenic grandeur of great mountain peaks, glaciers, and the refreshing silence of the virgin forest. He would spend day after day wandering about alone, silently as an Indian, taking great pleasure just in

watching the abundance of nature's wild creatures, large and small, in their rugged paradise. It was into these same mountain fastnesses that the Indians had for centuries come to endure the ordeals of religious penance to the Great Spirit and to "make medicine" for inspiration and success in their own pursuits of life, according to age-old traditions. Charlie understood those ancient legends of the red men and it was for a very similar purpose that he came.

So that he could take Nancy along and have a studio where he might work amid these inspiring surroundings, he had a log cabin built on the shore of the lake. He named it "Bull Head Lodge," after the buffalo skull that he always used as a symbol with the signature on

R. W. Norton Foundation

RUSSELL'S CABIN AT LAKE McDONALD

all his pictures. After the cabin was built, there was hardly a year that the Russells did not spend at least part of the summer in this idyllic retreat. Everything was left as nature had made it. Even the logs for the building were dragged from another section of the property. No animal or bird was permitted to be molested and many of the wild creatures became very friendly under Charlie's sympathetic encouragement. Grouse nested in the nearby tangles of brush and paraded their coveys of fluffy chicks among the berry bushes and open glades without fear of harm. Pine squirrels climbed up on the shake roof, to flick their tails and chatter in neighborly fashion. In the mornings and evenings deer came down off the mountain, to stand and stare with curious confidence, then continue with nimble grace on down to drink and nibble along the nearby shore of the lake.

An early riser, Charlie would get his own breakfast and wander off alone to drink in the freshness of the morning and watch the game before it settled down for the day. There was a colony of beaver in a little meadow a couple of miles down the shore, where he would slip up quietly to sit watching the busy little workmen repairing their dam or dragging limbs of cottonwood to anchor them on the bottom of the pond for winter food. Sometimes it might be a mother bear, even an occasional grizzly, with her cubs that he would stalk close enough to observe intimately. Even such small things as the pattern of a spider's web, sparkling with tiny pearls of morning dew, or the shafts of light filtering down like a veil of lace through the big trees, engaged his attention. Or, he might climb up to the edge of some ledge, where he could leisurely roll a cigarette and daydream as his gaze wandered over the panorama of scenic grandeur across the lake. It was not just with mountains and animals that his thoughts were occupied on these occasions. He would create and plan in his mind the details of pictures far removed from the scenes around him; and when he returned to the cabin he would put on paper or canvas the inspirations which had come during his morning perambulations. Sometimes he set up his easel on the rustic porch, where he could look out across the reflections of the mountains on the lake.

Aside from the rough log buildings among the trees, about the only alterations Charlie made in the natural surroundings were some interesting decorations along a tiny stream that trickled down over its rocky bed in a winding course through the carpet of the forest near the cabin. In the little coves and nooks Charlie arranged groups of miniature figures of Indians, with tiny bows and arrows, horses and tepees; and grotesque little men-of-the-mountains, with beards of moss—all of which he fashioned in clay or carved out of wood.

In the evenings, after the supper dishes were washed and put away, he and Nancy would sit in front of the big open fireplace. Its smooth cement facing was beautifully decorated with pictures of Indians, deer, bear, moose, and other creatures native to this environment which he loved so sincerely and where his peculiar soul was so peacefully at home. It was in front of this same fireplace that in the summers to come he was to entertain many devoted and distinguished guests.

As early as 1903 the Brown & Bigelow Company in St. Paul began using color reproductions of Russell's paintings on large calendars they made for their customers. These became very popular in Montana and the surrounding territory. Everyone liked to display the calendars in prominent places and after the year had run out the pictures were often framed for keeping. Some were made into art prints. The calendars proved to be a source of substantial income for the cowboy artist. He not only got the original paintings back after the color plates were made, but the calendars became one of the principal means of making him widely known and led to the private sale of a good many original pictures thus used. The following relevant incident was related to the present writer in a letter from Walter Lehman of Lewistown, Montana: "Along in 1907 our family was running a store in Lewistown . . . so my father suggested to my brother who was manager, that he write [to his old friend] Russell and get a picture for a calendar. Instead of asking for a small water color job, my brother asked for an oil painting. Mrs. Russell went to relatives of ours in Great Falls and asked if the Lehmans knew what Charlie was getting for his pictures, to which the relatives replied, 'probably not, but they are able to pay whatever he asks'. . . When we got the

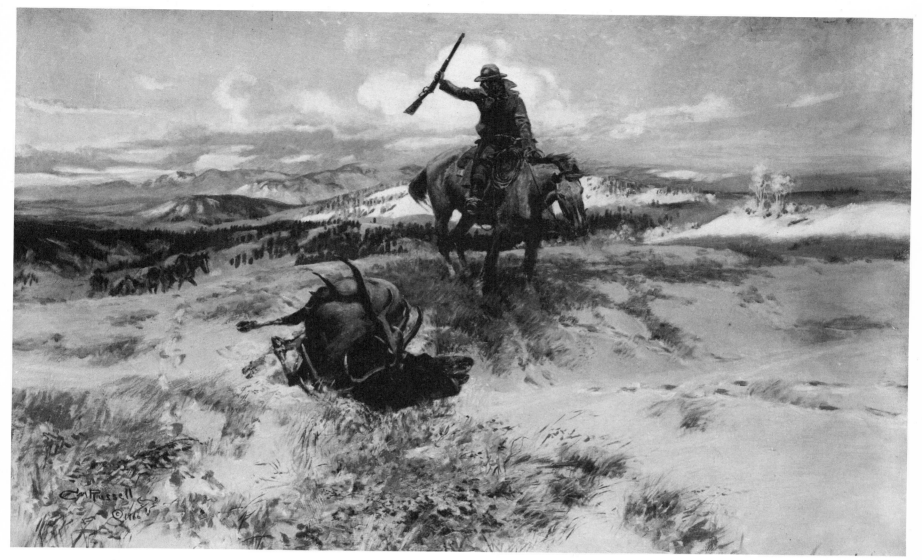

WHEN TRACKS SPELL MEAT

picture about six weeks later, we were afraid to show the bill to my father and had a bank in Moore pay the bill. We held out cash from the sales each week which went to the bank. We told father it cost a hundred dollars. We never did use it as a calendar.'' After paying the purchase price, the recipients discovered that the cost of having the reproduction made was just too high, although the picture was a fine one. It is shown on page 96 and there is more about it there in the accompanying text.

Sales began making news—and news made more sales—not only around Montana but in distant places. The Russells made pilgrimages practically every winter to the big camp on Manhattan, where Nancy continued to struggle to increase the market and boost the prices for Charlie's works. By 1908, incidentally, he had completely given up drinking. They graduated from the little basement showroom to more and more pretentious quarters. They also sent pictures to other cities for display and possible sale. It was a long rocky trail they traveled, with many a disheartening uphill climb, but finally they arrived at the great divide which looked out into the sunny valley of promising success. On Wednesday, April 12, 1911, came Charlie's first official "one-man show," at the Folsom Galleries on Manhattan's Fifth Avenue. In many ways this marked the "arrival" of Charles M. Russell and his wife Nancy.

Two of New York's leading newspapers, the *Times* and the *World*, ran almost full-page illustrated stories about the artist and his work in their Sunday editions in advance of the opening. The New York *Times* of April 9 included the following interesting comments: " 'Cowboy' Russell, or, to be formal, 'Charlie' Russell, or, to be ridiculously formal, Charles M. Russell, cowpuncher that was, painter and sculptor that is, has come from Montana for his first 'one-man exhibition'. He has brought with him a score of paintings and bronze groups of Indians and cowboys and wolves and buffaloes that are making him famous. Also he has brought along plenty of brawn and sinew, and the incredible gift of a man who lives in the saddle, and a weather-beaten face that speaks eloquently of the open range . . . His

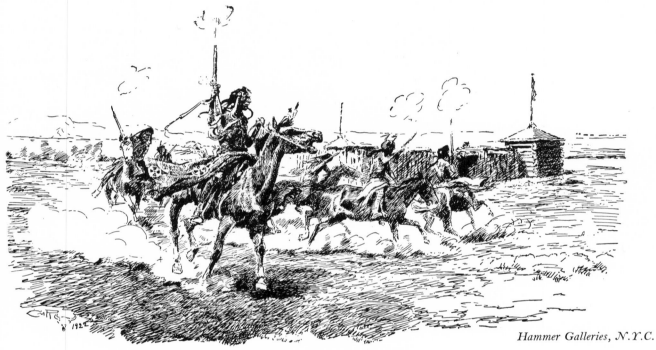

Hammer Galleries, N.Y.C.

SALUTE TO THE FUR TRADERS

exhibition will be held at the Folsom Galleries . . . He will array there his 'Medicine Man' [page 136], of which his wife and artist friends are exceedingly proud—(Russell himself is proud of none of his works)—and his 'Disputed Trail' [page 160], and 'The Wagon Boss' [page 157], and—well, another painting for which the Russell description 'a bunch of Indians just lookin' for trouble' answers better than any conventional label . . . Cowpunchers and redskins—lonely trails—wolves—gun play, simple and compound—bony, wise-looking horses—gaudy trappings and blankets and feathers—buffaloes—that is all you will see at the Russell exhibition. For this new artist out of the west thinks of nothing else, sees nothing else . . . The trips he makes to the east only make him keener to get back to his west. 'Me stay in the city?'—you should hear him say that. It's rough on the city. 'If I had my way I'd put steam out of business!' In those rough words, rapped out beneath scowling brows, Russell, westerner of the past, throws down the gauntlet to the present. 'Gee, I'm glad I wasn't born a day later than I was!'—That's how Russell talks when he is interviewed. 'It's—it's mighty hard to know what to say,' he grunts, taking off his cowboy hat, scratching his head and looking uneasily at the questioner's pencil . . .

" 'Oh, I have always made a bluff at painting,' he explains, when pressed for information as to the beginning of his career . . . He has also been modeling all his life. At a theatre, if he is bored, he takes some wax out of his pocket and shapes it into something . . . He saw the taming of the wild cow towns . . . the whistling of the last bullets that flew in bloody brawls. Ever since he has been driven by an unquenchable thirst to portray the west before it vanished forever . . . 'But look here,' he expostulated, 'don't go and say I'm the only cowboy artist.' "

Charlie made a lot of friends on these trips to New York. It was not just his colorful personality, but his sincerity and challenging ideology that attracted even the most intellec-

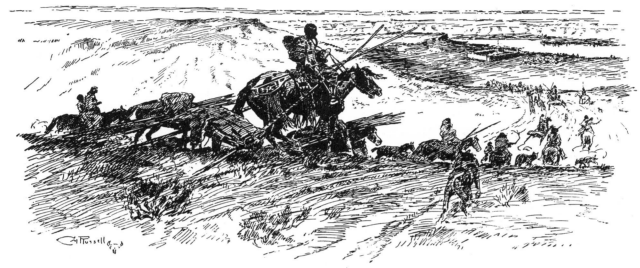

BLACKFEET AT FORT BENTON

tual to his friendship. Other artists were probably quicker than most, however, to recognize the genius in his work. Among them was Edward Borein, the accomplished California etcher and painter of the old western scene, who for a time had a studio in New York. He and Russell became lifelong friends and mutual admirers. In later years these two, along with Will Rogers, spent a great deal of time together. The following reminiscences of the days when the two artists were in New York together, were related by Borein to writer Mark H. Brown in April 1938, as recorded in a letter to the present writer: "If Charlie liked you and you admired something he had made he would give it to you. But Mrs. Russell never gave away anything . . . When he was around the gallery Nancy was pretty particular, even about the appearance he made. She even would not let him smoke when anyone was around. Once when there wasn't anyone around and things had been quiet for a while, Charlie begged Nancy to let him smoke and she finally gave her consent. So Charlie and I sat down on our heels and rolled ourselves a smoke. We had not any more than got lit up when in came a party all decked out with spats and gloves and a hard hat. You had to look twice to be sure it was supposed to be a man. *It* walked in and looked around and then came back to where we were smoking and stood around kind of awkward like. Finally *it* said, 'Are you the Mr. Russell who painted these pictures?' Charlie grunts, 'Yep,' and kept right on talkin' to me. He never looked up. 'How much are they?' asks the dude. 'I don't know,' says Russell,

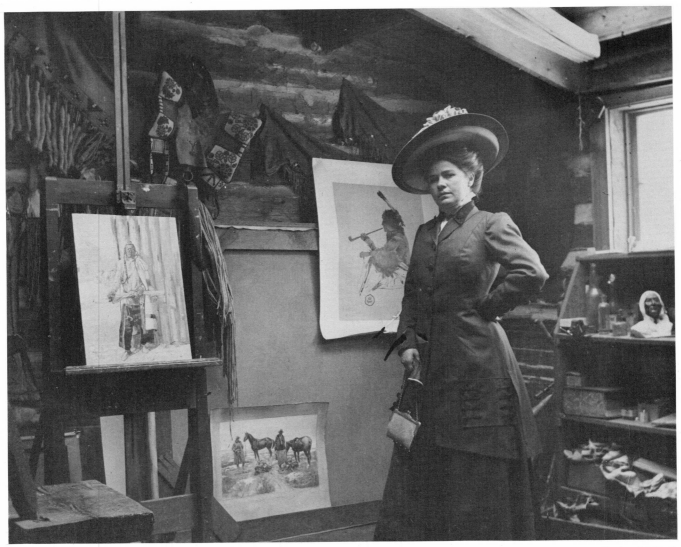

MRS. NANCY C. RUSSELL IN GREAT FALLS STUDIO

never even looking up. 'I paint 'em. My wife sells 'em.' Charlie keeps right on talkin' to me and the dude goes over and talks to Nancy and after a bit he leaves. Nancy then comes over and says, 'I sold *Whose Meat*.' Charlie looks up at the wall and says, 'Sold it? It's still there.' Says Nancy, 'I sold it to that man who was just here for six thousand dollars.' Charlie looked at Nancy kind of funny for a minute and then grunted, 'Who'd have thought *it* would buy a picture?' . . . Then there was another time when I was loafing around the gallery with Charlie when we got to watching a fellow talking with Mrs. Russell. After a while this man walked away from her, muttering to himself, '*It's too much. It's too much.*' Finally he left. By this time Charlie had got interested so he goes over and asks Nancy what was the matter with the guy. 'He wants that picture,' says Nancy, 'but he thinks the price is too high.' 'How much did you ask him?' 'Fifteen thousand dollars,' says Nancy. Charlie went over and stood staring at the picture for some time. Then he grunted, '*It's too much. It's too much.*— and getting his hat he pulled it down on his head and went out.''

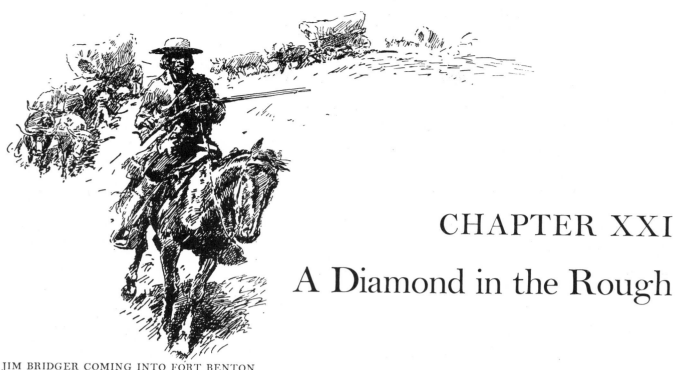

JIM BRIDGER COMING INTO FORT BENTON

CHAPTER XXI

A Diamond in the Rough

NOT LONG after the Russells returned West after that important first one-man show on Fifth Avenue, Mrs. Russell received a letter from the Hon. E. L. Norris, Governor of Montana. Dated June 26, 1911, the official communication requested Mr. Russell to appear before the State Board of Examiners on June 30 relative to the executing of a large historical mural painting, to cover the wall at the rear of the Speaker's desk of the House of Representatives, in a new wing of the State Capitol Building. This project had been under consideration for at least two years. Russell had been discussed as a possible artist to do the work, although there was an influential faction strongly in favor of someone with a wider reputation. Frederic Remington had been foremost among these,[1] but his untimely death on December 26, 1909, had eliminated him as a possibility. The controversy had continued, however, until the governor's letter was dispatched to Mrs. Russell. The local artist's highly successful exhibition in New York City, with its attendant publicity and widespread acclaim, no doubt had considerable to do with the decision. Also, the fact that the preliminary correspondence was addressed to Mrs. Russell strongly supports the assumption that Nancy had been energetically promoting her husband for this important assignment. On July 3 another letter was received from Governor Norris stating that the Board had decided to commission Russell to execute the painting, for the sum of $5,000.

After further discussion, and the submitting of some sketches, it was agreed that the big picture should depict the historical meeting of Lewis and Clark with the Flathead Indians in Ross' Hole near the headwaters of the Bitterroot River, on September 4, 1805, when the expedition crossed into Montana from Idaho on its return journey. Charlie and Nancy made a trip to the exact location to make sketches of the actual background; and the finished picture was delivered about six months after the commission was awarded. The canvas was originally 25'1" x 11'8½", although it had to be trimmed to 24'9" x 11'7½" to fit properly the allotted space. Although not a particularly remunerative project for Charlie Russell, this painting of "Lewis and Clark Meeting the Flathead Indians at Ross' Hole" stands today as the masterpiece of its painter's career. To appreciate fully its real magnificence, however,

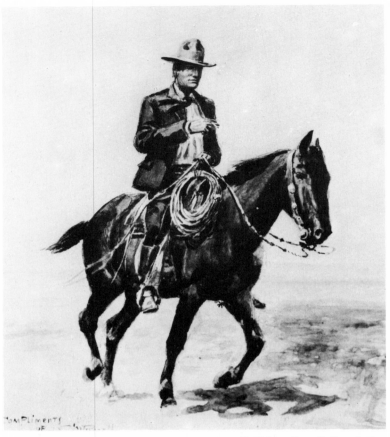

© *Triggs-Russell Foundation*

CHARLES RUSSELL ON RED BIRD

one must stand in person in the silence and subdued light of the great room where it extends like a magic window into the past; and one should also be aware of the meticulous accuracy of its documentary details. Each character is properly portrayed, down to the smallest minutiae—both red men and whites, as well as their horses. The backdrop of the mountains and the colors for early September are as they should be. One of the finest examples of Western Americana art, it is reproduced as a color plate at the beginning of this book.

The same year, 1911, saw publication of the illustrated edition of Owen Wister's classic book *The Virginian—A Horseman of the Plains*, in which Charles M. Russell shared credit with Frederic Remington for the pictures. Significantly, the color frontispiece is by the Montana cowboy, who is also given top billing on the book's title page.

There were more trips to New York, and the demand for Russell paintings increased rapidly from coast to coast. Admirers began collecting his pictures, art prints, and illustrated letters. Among the most energetic of these was Sid Willis, of the Mint Saloon in Great Falls, who had been gathering together a collection which for many years afterward was the most famous in the country. The prices of Russell's work were increasing so rapidly that some dealers and individuals were buying as an investment.

In the early spring of 1914 the Russells packed up a large group of Charlie's best unsold paintings and took them to England. Nancy had raised her sights to the wide world. Arrangements were made for an exhibition at the famous Doré Galleries on Bond Street, the place where the important Doré religious paintings were on permanent display and which was widely renowned for the great art collections that had been hung there. Among the more than a score of Russells hung in the exhibition were titles that are well known today: "The Jerk Line" (pages 138–139), "Wild Horse Hunters" (pages 38–39), "The Queen's War Hounds," "When Sioux and Blackfeet Meet" (not "Counting Coup"), "The West That Has Passed," and others. The London newspapers were very generous in their praise of the work of the picturesque painter from the American Far West who always wore a red sash and cowboy boots. It is doubtful that any foreign artist, exhibiting in staid old London for the first time, had ever created the furor that Charlie Russell did on that occasion. Scores of titled per-

sonalities visited the gallery, and lingered for hours in that section where his paintings were hung. Even the Queen Mother Alexandra and her sister the Dowager Empress of Russia were among the distinguished visitors who expressed their admiration to the cowboy artist. Nor was Russell himself much less of an attraction than his pictures. His striking personality, unassuming ways, and characteristics so typical of the American West, as well as his manner of speech and extensive knowledge of the subjects he portrayed on the canvases, made him extremely popular among all with whom he came in contact. And Nancy was always close by to take full advantage of every possibility for a sale. The trip was an unqualified success.[2]

What fifteen years of consistent determination had brought to Charlie Russell and his wife was demonstrated as a mathematical certainty in their home town of Great Falls. At Christmastime back in 1899 one of his large paintings, "The Last Stand," had been raffled off at the local Park Hotel. But the tickets did not sell very well and just before the scheduled drawing of the lucky number, Frank P. Atkinson, who was cashier of the Cascade Bank, came to the rescue of the unfortunate situation by purchasing all the remaining chances, which cost him about $300. He won the prize; spent another hundred dollars on a handsome frame; and through the years the picture had hung in the Cascade Bank. It had been long admired by John G. Morony, president of the Great Falls First National Bank. After numerous friendly dickerings for its purchase, Mr. Morony finally made an offer of $5,000, which was accepted, and on January 14, 1915, the painting was brought back to Great Falls to be hung in the First National Bank. In fifteen years it had brought its purchaser a profit of more than 1530 per cent.[3]

In 1915 Russell's pictures were successfully exhibited in New York, Boston, Chicago, and elsewhere throughout the country. From this time forward the trail was a comparatively smooth and pleasant one. The days of poverty were over. Charlie and Nancy were very happy together. He was still very much the same old rough and shaggy cowboy, although under the hide he had completely mellowed into a quiet

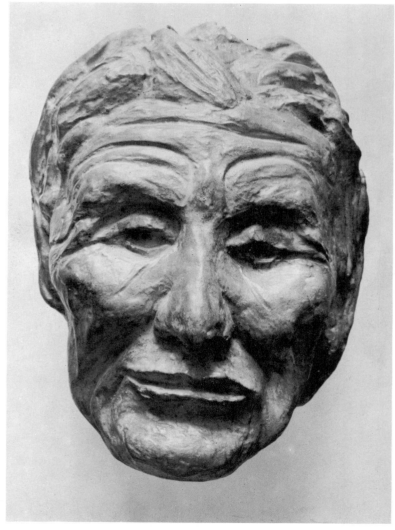

© *Santa Barbara Historical Society*

LIFE MASK OF CHARLES M. RUSSELL (1914)

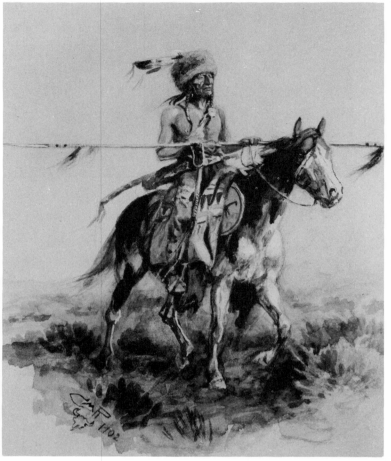

Calvin S. Koch

BRINGING HOME THE SCALP

philosophical patriarch of the tribe. The big log studio had become a sort of Mecca for all the old rawhides and redskins of the days that were now gone forever, except in the realistic reincarnations that were continually taking colorful form on the cowboy artist's easel. Saints or sinners, these old friends were always welcome—the atmosphere brought back all the old memories —and the conversation was always about the things that had become close to their hearts. There was also an increasing host of new friends, who occasionally got off the train in Great Falls or went up to Glacier National Park to enjoy a visit with the Russells at Bull Head Lodge— including such well-known persons as Will Rogers, William S. Hart, Douglas Fairbanks, Fred Stone, Irvin S. Cobb, Will James, and many more, who were all as devoted friends and admirers as the Brother Vans, the Ben Robertses, and the Indians and cowboys.

There was, however, one great void in the Russells' family life: they had both longed to have children of their own. Charlie, especially, had always loved children. Even in his wildest days, he had enjoyed a strong but gentle attraction for the young 'uns: the little "swamp angels" of the Widow Oats in the Judith and the Roberts children in Cascade, for instance. This fondness for children had increased over the years and now frequently found expression among the little groups of friends who gathered around the fireplace in the log studio or at Bull Head Lodge in the evenings—evenings made long memorable by the remarkable raconteur with the graceful hands. It has been stated by old-time traders and tribesmen as well that Charlie Russell was one of the most skillful Indian sign-talkers in all the West. He was also adept at using his hands to make shadow pictures on the wall, to illustrate his stories. Both Will Rogers and Irvin S. Cobb, nationally recognized as masters of the art of verbal entertainment themselves, paid him tribute by calling him one of the most accomplished storytellers in America. Combining the magic of pantomime of talented hands with a keen wit and frontier wisdom produced a doubly extraordinary effect. If the little group happened to be a bunch of hard-bitten old cowpunchers or roughnecks, once his pals of early days, he could tell them the kind of spicy stories they particularly liked to hear. But if the guests were more sedate, he would tell a different kind of tale. And if there happened

to be one or more youngsters among them, no matter how important the grownups happened to be, Russell would always devote his attention and fashion the legendary stories he told to the wide-eyed interest of the young 'uns. One of his greatest sources of enjoyment was entertaining an audience of children.

As the big wood fire crackled on the open hearth and cast its flickering shadows upon the Indian paraphernalia that decorated the log walls of the room, the picturesque cowboy artist would relate his tales of the days when the red men lived in unspoiled freedom among the same big trees that stood silently in the moonlight outside. Squatting on his heels and methodically rolling Bull Durham "makin's" into the brown paper of a cigarette, he would usually begin the narrative with a brief introduction. It might be something like this: "Many many moons ago, me—Big Bear—and five of my Piegan braves started out for a village of

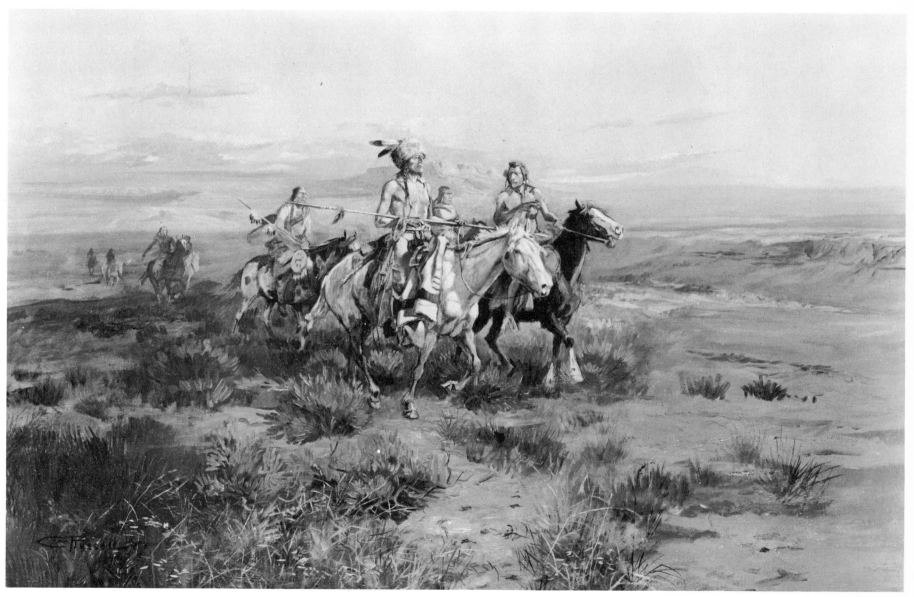

Newhouse Galleries, N.Y.C.

SEEKING THE TRAIL

the Crows to steal horses . . ." He had a knack of giving the stories a personal, intimate touch—and no one ever doubted that they had actually happened. Lighting the cigarette, he would begin moving his articulate hands in eloquent gestures to retell what he had just said. Then, continuing with the pantomime, he would explain such bits of the story as he felt required it. But it was not long before the verbal translations had unconsciously stopped, although there was no difficulty for his audience in following the story. Only now and then would his quiet voice add an occasional explanation, as you followed the soft-footed raiders on their way, over the mountains and across the rivers. Then they would sneak silently up to the tepees of the Crows. "Dog speak!"—the storyteller's terse words would punctuate the graphic gesture which marked the night alarm. "Crows awake!"—his nimble fingers pointing upward and wiggling energetically—you could almost see the savages swarm out to meet the intruders. "Arrows fly!"—and down tumbles one of the Piegans. The action had become fast and violent. A Crow bites the dust. Another Piegan topples to the ground. The herd of horses is stampeded—and the remaining trio of raiders finally race away into the moonlight night with their booty.

Or, the story might be that of a great tribal battle, or a buffalo hunt. Or, some quiet pastoral scene, from the rising to the setting of the sun—how the hero swam across the big river—the falling rain, or how it came gently down to build up again to heap a blanket of snow upon the earth. Russell's repertoire included all the scenes and drama of Indian life before the white man came, and there was very little that he could not make clearly understood through the movements of his hands. At his finger tips were a Fenimore Cooper's creations —Deerslayer, Leatherstocking, and all their counterparts of the Montana prairies and mountains, brought back to life more vividly than in words—by a storyteller whose great warmth and friendliness shone through his rough exterior, and whose deeply lined face had so much the look of a leathery old Indian sage.

At other times, Russell was never so busy that he would not take time out to talk to a young visitor, and he would often model some little figure in clay to be proudly carried away in tiny hands. At Christmastime he would make little religious figures, carefully colored, and similar objects depicted on paper in waterclor, for his friends both young and old.

Although sadly enough Charlie and Nancy never had a child of their own, in 1916, after twenty years of marriage, they decided to adopt a baby boy. Not entirely sure how this new undertaking would work out, they engaged a nurse to help until they got the swing of things and were sure about keeping the baby. But it was only a few days before they were both completely captivated. He was named Jack Cooper Russell.

As the years passed, Charlie Russell's stature and success as an artist continued to increase, and along with it he came to assume a rough-hewn dignity. One small incident bears additional testimony to what lay beneath the crude exterior of this remarkable man. In the summer of 1918 there was an intensive campaign to conserve foodstuffs and other products necessary for supplying our armed forces in World War I. There was an announcement that as part of this program no more Bull Durham tobacco would be available to the public after the supply in the hands of the jobbers was exhausted. Charlie had smoked nothing else for forty years. When he next visited his tobacconist, the dealer suggested, "You'd better lay in a supply while I've got it. Enough for a year at least." "No," replied Russell. "I'll just

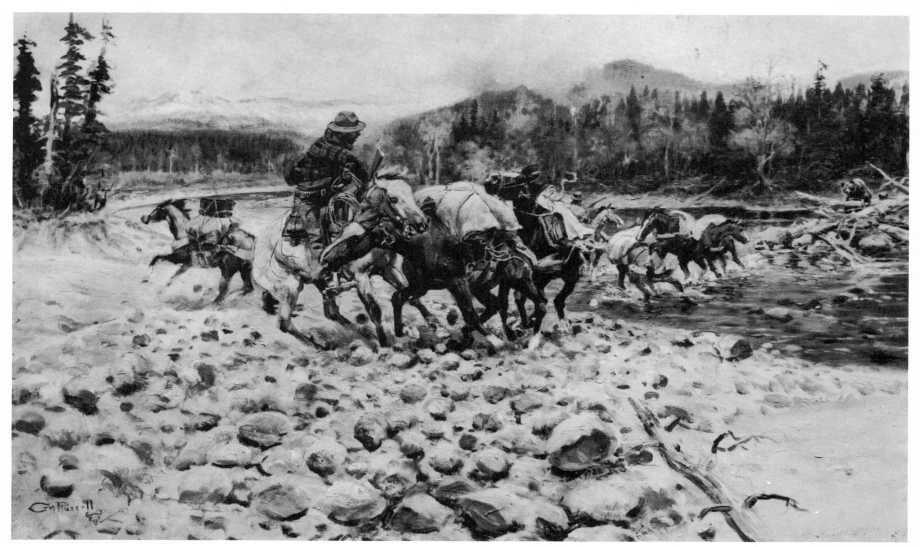

WHEN HORSES TURN BACK THERE'S DANGER AHEAD

take a couple of packs, as usual." "What's the idea?" argued the well-meaning friend. "You don't smoke anything else and we can't get any more." "Well," he drawled seriously, "I wouldn't feel right with a bunch of it in the cellar and knowin' that our boys in the trenches over in France was hungry for a 'Bull' smoke. No, I'll just take my usual two packs."[4]

Russell also contributed a series of paintings to the conservation program which were reproduced in newspapers and made into posters throughout the country. Each of these was accompanied by a verse by the artist, one of which read as follows:

> "I hate to take your grub, Old Hoss, but then
> I'm leavin' meat and wheat to fightin' men;
> And by your handin' in your oats to me,
> The both of us is Hooverizin'— See?
> We're squarin' up with Uncle Sam, Our Friend,
> Just Kiner' Helpin' hold the easy end."

By 1920 Russell reached a peak of success that had been equaled by very few American artists during their own lifetime. Early that year he and Nancy made a picture-selling expedition to sunny California, which had become the home of the wild-spending rich. With

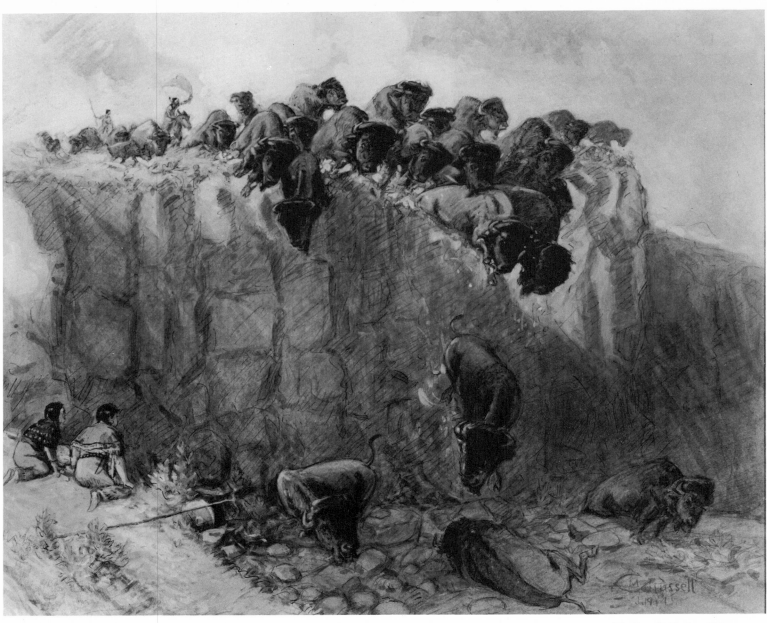

Findlay Galleries, Chicago

THE BUFFALO DRIVE

apparently very little effort Mrs. Russell sold "Salute of the Robe Trade" (page 226) for $10,000. This sale set a new high standard, which the little lady capitalized upon without hesitation or delay; she sold at least three others of her husband's important canvases not long thereafter for like amounts. Among the other pictures that brought a similar high price, unusual for the work of a living artist, were: "When Law Dulls the Edge of Chance" (page 128) and "When the Left Handshake Is the Safest."[5] Works of lesser importance were also going briskly for comparatively high prices; and among the purchasers were such notables as Douglas Fairbanks, Will Rogers, E. H. Manville, the Duke of Connaught, and many more.

Charles M. Russell had at last arrived in that magic Elysium of which every artist dreams. But even now he was still the same old cowboy at heart. Toward the close of that first remarkably successful trip to California he wrote to an old friend back in Montana, in his characteristic paradoxical manner: "for several years old dad time has been handing me things I dident want an I aint been thankful for his favors . . ."[6]

PLANNING THE ATTACK

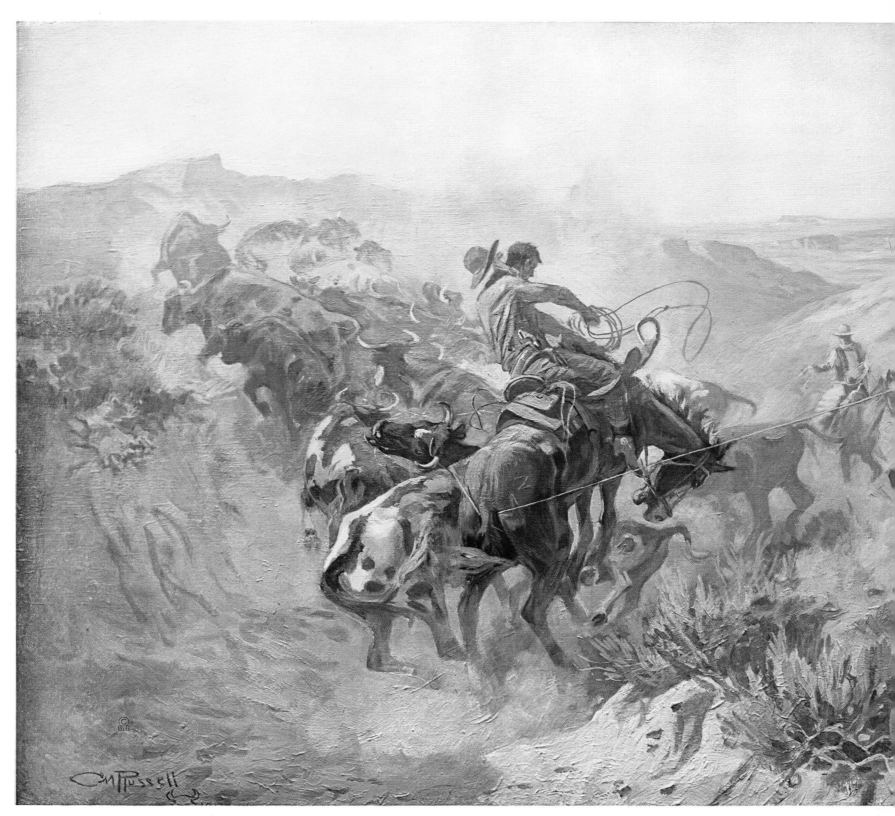

HEADS OR TAILS

LAST OF THE HERD

DOE AND FAWNS

CHAPTER XXII

His Heart Sleeps

SUCCESS carried Charlie and his wife further and further apart in their respective conceptions of what were the most important things in life. These two had been widely different in temperament from the beginning, and their differences had increased as the little lady led her talented husband step by step along the path to success. Now that they were on the sunny side of the rocky divide which Nancy had struggled so hard to climb, the fruits of good fortune were much more appetizing to her than to him. Although Charlie's paintings were bringing prices running into five figures, she still rode herd on him with as unrelenting persistence as she had in the hungry days when they had first come to Great Falls. They were still a devoted couple. But Russell was now past fifty-five and the rigorous years had begun to take their toll. Even when he began to explain, in his quiet way, that he did not feel too well, Nancy kept him steadily at his easel. His fighting days were over; and like the old Indian patriarch, whom he so closely resembled, he wanted just to sit in the quiet of the council lodge and live among the memories of the wonderful past. He was too full of more precious things to think about collecting large checks for his pictures.

In 1921 Russell realized a fond desire, in the publication of the first of his Rawhide Rawlins books.[1] It was a collection of seventeen of the favorite stories he had told and retold through the years. Some of them had appeared in magazines and newspapers. He had created a cowpuncher character whom he called "Rawhide Rawlins," a modest subterfuge to serve as the narrator. Many of the characters portrayed in the yarns were easily recognized by the Montana folks who had known them. The thirty-five drawings accompanying the stories were not intended as "art," but as simple characterizations of the individuals and incidents described. It would have been quite easy to arrange with a firm in the East to put the little book on the market in a grandiose and remunerative manner. Instead, however, Charlie chose to have it published locally; and like Mark Twain, who insisted that his writings be printed at a cost that would enable most any family to own them, Russell saw to it that his own first book retailed at only one dollar. "These are hard times with a lot of folks," he said. "If this book is going to give anyone a laugh, I want the price low enough so that

people to whom a dollar means a dollar will feel they're getting their money's worth."[2] The little paper-covered book went into four editions during the first year—although they must have all been worn out from reading, for copies are scarce collectors' items today. Fortunately these and other of his stories are adequately preserved in *Trails Plowed Under*.

It is often said that a man's friends reflect his character. During his trips around this country and abroad, Russell made many friends, including many celebrities. However, these never quite took the place of his beloved old Montana friends. No old friend, no matter how lowly he might be, was ever supplanted by a new one just because the latter happened to be a somebody. Russell aptly expressed this and much more in the introductory remarks about himself which he wrote for the second Rawhide Rawlins book *More Rawhides*:[3] "The papers have been kind to me—many times more kind than true . . . I have many friends among cowmen and cowpunchers . . . I had friends when I had nothing else. My friends were not always within the law, but I haven't said how law abiding I was myself. I haven't been too bad nor too good to get along with. Life has never been too serious with me—I lived to play and I'm playing yet . . . I was a wild young man but age has made me gentle . . . My friends are mixed—preachers, priests and sinners. I belong to no church, but am friendly toward and respect them all. I have always liked horses . . . I am old fashioned and peculiar in my dress. I am eccentric (that is a polite way of saying you're crazy). I believe in luck and have had lots of it . . . Any man that can make a living doing what he likes is lucky, and I'm that. Any time I cash in now, I win."

It was not just his friends of the old days to whom Charlie Russell never lost his devotion. It was also the Montana mountains and prairies, the pine trees and the bunch grass, the golden glow of the cottonwoods against the fall sky, the colors of the sunsets, the smoky smell of the skin tepees, and all the other inanimate and animate things which were brought to life in his pictures. If he ever had a horse that became his friend, that horse lived with him until its death and in its old age enjoyed a pleasant retirement in a green pasture. There were several of these—Monte, Red Bird, Gray Eagle, and Neenah.

"Time onely changes the out side of things," he wrote in 1920 to Charles F. Lummis, historian and founder of the Southwest Museum,[4] "it scars the rock and snarles the tree but the heart inside is the same . . . Your body is here in a highley civilized land but your heart lives on the back trails that are grass grown ore plowed under." And again on the same theme he wrote to his close friend and neighbor Miss Josephine Trigg in 1924:[5] "Old Dad Time trades little that men want he has traded me wrinkles for teeth stiff legs for limber ones but . . . he has left me my friends and for that great kindness I forgive him . . ."

Russell entertained deep convictions on a large variety of subjects—although nearly every thought he had was in some way associated with the Old West, either directly or by comparison. The parable and the poetic were as natural to him as painting or modeling; and what he wrote was always as sincere, clearly defined, and freshly his own as any picture he put on canvas or paper. One of the most extraordinary things about the literary gems of rawhide wit and wisdom and the scores of fine poems that he wrote is the fact that they were seldom intended for publication, but sent as personal notes or greetings to his friends. Instead of writing a how-are-you note to someone he liked, he might jot off his sentiments

in a long poem and decorate the stanzas with beautifully colored miniatures in watercolor.

The rough and rugged past had become a beautiful thing to Charlie Russell. "at that time baring the Indians an a few scattered whites the country belonged to God," he wrote in a letter to Guy Weadick, manager of the Calgary Stampede[6]—and this was the basis of his belief. "but now the real estate man an nester have got moste of it grass side down . . . but thank God I was here first . . ." In a letter to Douglas Fairbanks in 1921 he had this further to say:[7] "The old time cow man right now is as much history as Richard, The Lion Harted or any of those gents that packed a long blade and had their cloths made by a blacksmith . . . The west was a big home for the adventurer—good or bad —he had to be a regular man and in skin and leather men were almost as fancy and picturesque as the steel clad fighters of the old world. The west had some fighters, long haired Wild Bill Hickok with cap and ball Colts could have made a correll full of King Arthurs men climb a tree." And again in 1921 he expressed himself in a letter to W. M. Armstrong:[8] "The long

SELF-PORTRAIT

horned spotted cows that walked the same trails their humped backed cousins made have joined them in history and with them went the wether worn cow men They live now onley in bookes . . . The west is still a great country but the picture and story part of it has been plowed under by the farmer Prohabition maby made the west better But its sinch bet Such Gents as Trappers Traders Prospectors Bull-whackers Mule Skinners Stage drivers and Cowpunchers dident feed up on cocola or mapel nut sundais."

His love of the primitive was always paralleled by his distaste for urban life. In a letter from New York City to his close friend and fellow artist Ed Borein he wrote:[9] "My Brother we are both from the big hills But our fires have been far apart We met in a strange land Lonesumniss makes strong friends of Shy strangers In this big camp where the lodges hide the Sun and its people rube sholders but do not speek Your pipe was mine It is good our harts are the same." At another time, after spending a short time in the cities of California, he wrote to Bob Thoroughman, an old Montana pioneer friend who lived in Cascade:[10] "Invention has made it easy for man kind but it has made him no better. Michinary has no branes A lady with manicured fingers can drive an automobile with out maring her polished nailes But to sit behind six range bred horses with both hands full of ribbons

these are God made animals and have branes. To drive these over a mountain rode takes both hands feet and head an its no ladys job To sit on the nie wheeler with from ten to sixteen on a jirk line ore swing a whip ove twenty bulles strung on a chane an keep them all up in the yoke took a real man And men who went in small partys or alone in to a wild country that swarmed with painted hair hunters with a horse under tham and a rifel as

THE SCOUT

thair pasporte These were the kind of men that brought the spotted cattel to the west
before the humped back cows were gon Most of these people live now only in the pages
of history. but they were regular men . . ." During a short stay in Chicago he condensed
his whole opinion of cities into the following terse comment, expressed in a letter to his
Great Falls friend and neighbor, A. J. Trigg:[11] "If I had a winter home in Hell and a sum-
mer home in Chicago I think Id spend my summers at my winter home . . . I suppose Great
Falls will be lik Cicago some day but I won't be there . . ."

Russell occasionally sent a descriptive poem with a picture when it was delivered to a
purchaser. The following one accompanied "When Tracks Spell War or Meat" when it
became part of the fine collection of Dr. Philip G. Cole (later acquired by Thomas Gil-
crease):[12]

"Nature taught her child
To read, to write and spell,
And with her books before him
He reads his lesson well.

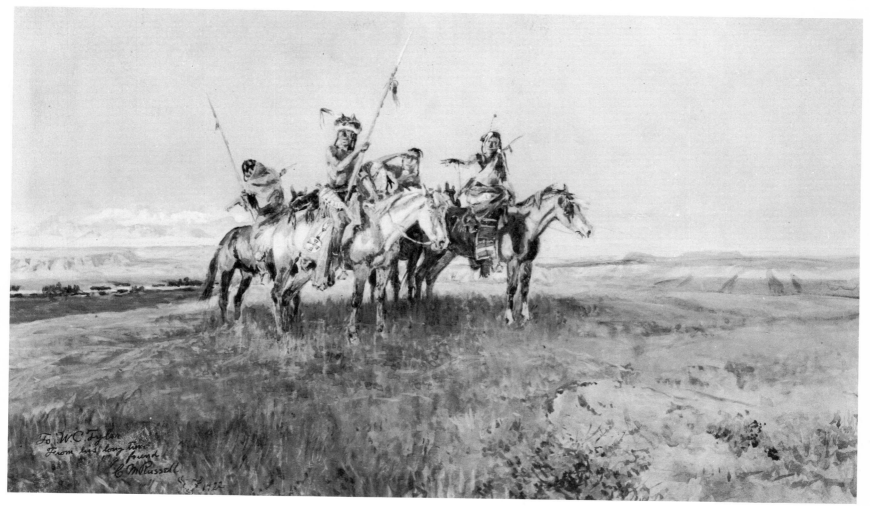

FRIENDS OR ENEMIES?

Findlay Galleries, N.Y.C.

Each day is but a page
His God, the sun, has turned.
Each year, a chapter nature taught
Her child has read and learned.

A broken twig, a stone is turned
Disturbed by passing feet
His savage eye has caught it all
For tracks spell war or meat.

Nature holds his Bible
With pages open wide,
He questions not her miracles
'Tis done; he's satisfied.

He loves his mother country
Where all her creatures trod,
Yet he is called a heathen
Who has always lived with God."

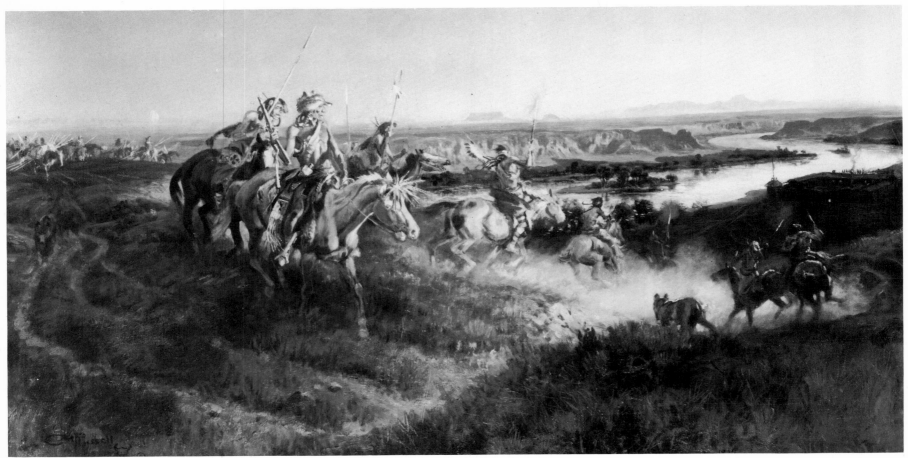

SALUTE OF THE ROBE TRADE

At Christmastime Charlie made beautiful little watercolor paintings for his special friends. These were often of religious subjects, or medieval knights and castles, or lonesome cowboys on a snowy trail. They were invariably accompanied by an appropriate poetic greeting, of which the following is typical:[13]

> "May all thy days be sunshine
> Thy life a pleasant road
> And thy burdens be all good things
> T'will never be a load
> Tis well to seek the good things
> But do not hunt the bad
> For tis those who walk with sorrow
> That find this world but sad."

One of the finest of these Christmas greetings was sent to the Trigg family:[14]

CHRISTMAS AT THE LINE CAMP

> Last night I drifted back in dreams
> To Childhood's stamping ground,
> I'm in my little bed, it seems,
> The old folks whispering 'round.

My sox is hung; Maw's tucked me in;
It's Christmas eve, you see.
I've said my prayers, blessed all my kin,
I'm good as good kin be.

© *Triggs-Russell Foundation*

CHRISTMAS AT THE LINE CAMP

But suddenly I'm wakened wide,
From out this youthful dream
By jingling bells that's just outside
Hung on some restless team.
Reminded by rheumatic shin,
And lumbagoed back that's sore,
Whiskered face, and hair that's thin,
I ain't no kid no more.
And getting my boots I open the door,
And I'm sure surprised to see
An old time freighter I knowed before,
But it's years since he called on me.
He's an under-sized skinner,
Goodnatured and stout,
With a team like himself,
All small.
It's the same old cuss
Maw tells me about,
Just old Santy Claus, reindeers and all.
He's aholding his ribbons like an old timer would,
When he nods his head to me,
"I wish you'd put me right if you could,
I'm way off the trail," says he.
"I follow the trail of the stork—it's strange

Me missing his track," says he,
"But I'm guessing that bird
Never touched this range,
For there's no sign of youngsters, I see.
 You bachellors have a joyful way
 When and wherever you're found,
 Fourth of July, or Paddy's Day
 A-passing the drinks around.
 But to get the joy that Christmas brings,
 You must be acquainted with three,
 A home's but a camp without these things:
 A wife, the stork, and me."

And then my bunk pal gives me a shake,
And growls in a cranky way,
"You've got all the bedding,
I'm cold as a snake.
I wonder what day is today."

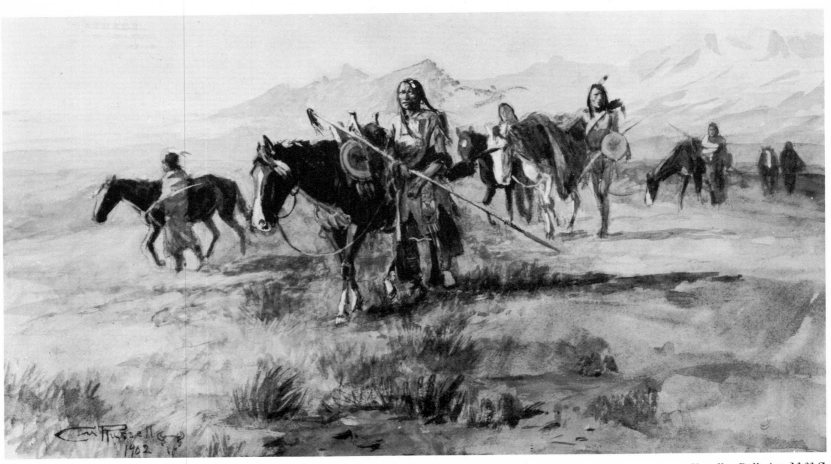

Knoedler Galleries, N.Y.C.

THE WARRIORS' LONG TRAIL

Here's to all old timers, Bob,
 They weren't all square it's true,
Some cashed in with their boots on—
 Good old friends I knew.

Here's to the first ones here, Bob,
 Men who broke the trail
For the tenderfoot and booster
 Who come to the country by rail.

Here's to the man with the gold pan
 Whose heart wasn't hard to find,
It was big as the country he lived in,
 And good as the metal he mined.

Here's to the rustler that packed a notched gun
 And didn't call killins' sins,
If you'd count the cows and calves in his herd
 You'd swear all his bulls had twins.

Here's to the skinner with a jerk line
 Who could make a black snake talk,
An could string his team up a mountain road
 That would bother a human to walk.

Here's to the crooked gambler
 Who dealt from a box that was brace,
Would pull from the bottom in stud hoss
 An' double cross friends in a race.

Here's to the driver that sat on the coach
 With six reins and the silk in his grip,
Who'd bet he could throw all the ribbons away
 An' herd his bronk team with his whip.

Here's to the holdup an' hoss thief
 That loved stage roads an' hosses too well,
Who asked the stranglers to hurry
 Or he'd be late to breakfast in Hell.

Here's to the whaker that swung a long lash
 An' his bulls bawled with fear when he spoke,
He'd swear on a hill he wouldn't drop trail
 If every bull starved in the yoke.

So here's to my old time friends, Bob,
 I drink to them one and all,
I've known the roughest of them, Bob,
 But none that I knew were small.
Here's to Hell with the booster,
 The land is no longer free,
The worst old timer I ever knew
 Looks dam good to me.

Sentiments
of your friend
C M Russell
Nov 5th 1911

The unusual length to which Russell would go to use his talents for the individual enjoyment of a personal friend is clearly exemplified on page 229.[15] This lengthy and poignant poem was sent to Robert Vaughn, an old Montana pioneer and cow-country friend of the cowboy artist. The beautiful watercolor miniature paintings which illustrated each stanza are gems in themselves. The poem and paintings were an altogether spontaneous expression of feeling. Russell entertained no thought of any part of them ever being engraved in perpetuity. Just a simple expression of friendship, they stand like a stone monument to the character of one of the most extraordinary men in American arts and letters.

Success and fame had been intolerably slow in coming to Charles M. Russell, and now ill health was rapidly bringing him to the end of the trail. His last years, however, brought him to heights which he had neither hoped for nor desired. He and Nancy had been making regular trips to California to escape the rigorous Montana winter weather, and on these occasions they were always lionized by the "best people" of the motion-picture, financial, and social world. Charlie would have much preferred to stay with his old friends back in Great Falls, although he entered this new phase of his life with never failing graciousness. Nancy, however, loved this sort of thing; and it was unquestionably her insistence which resulted in their undertaking to build an attractive home in the outskirts of Pasadena, to be called "Trail's End." Made of stucco, pueblo style, it was far removed in every respect from everything that was dearest to Russell's heart—and ironically it was never to be a home for him.

On June 15, 1925, the University of Montana at its commencement exercises conferred upon the cowboy artist the honorary degree of Doctor of Laws. The citation read: "To honor Charles M. Russell . . . who has attained greater prominence in the field of art than any other resident of the state." This was the highest honor within the power of that state educational institution to bestow and it was only the fourth time in the university's thirty-two-year history that the degree had been conferred. Another distinction—his greatest pride of all—came to him in those last years. Among the rank and file of his beloved adopted state, the cowboy artist came to be known as "Mister Montana."

That same year, 1925, Russell made a fateful trip to the Mayo brothers' hospital in Rochester, Minnesota, and was operated on for goiter. Since his health had been steadily failing over the previous several years, he did not do too well through the operation period. Realistically apprehensive, he demanded that the doctor tell him the truth; and learning that he had but a short time to live, he made the doctor promise not to let Nancy know. But she had done the same thing and they went home, each not knowing that the other knew the worst.

On the night of Sunday, October 24, 1926, Charles Marion Russell died, at the age of sixty-two—within twenty minutes after a heart attack, which was an aftermath of the operation. Nancy was sitting by his side when it came.

According to his own expressed wish, his body was taken to its last resting place by a team of black horses, when the funeral was held the following Wednesday afternoon. Handling the reins from the driver's seat was his old friend Ed Vance, who in the days that were long past had been a stage driver and had ridden the cattle range with Kid Russell. Behind the old-fashioned hearse walked three horses. One was ridden by Horace Brewster, who had

given Charlie his first job as a horse wrangler. The second rider was another old cowboy pal and artist, C. A. Beil. The third horse was one of Russell's own—carrying an empty saddle, with a six-gun in its holster hung behind the cantle, a coiled lariat and a pair of his spurs tied to the horn. Around the horse's neck was draped a wide black crepe. Nancy followed in the first of a hundred automobiles. Flags were at half mast on the courthouse and nearly every other building in Great Falls. Official and other businesses were suspended and schools were dismissed during the funeral. As the long procession moved along its course, the streets were lined with silent children and others paying their last respects to a distinguished citizen whom they had all learned to love and respect. Also scattered among those who stood along the way were a considerable number of Indians, come to town to offer their own silent blessings to a friend who was making the long journey to a beautiful Shadow Land. And among the long list of honorary pallbearers were such familiar names as Will Rogers, William S. Hart, Irvin S. Cobb, and Governor J. Erickson—some of whom had come from as far away as New York and California to join the others in the last rites.

Thus he died. The finest tribute that has been paid to his greatness is the widespread and ever increasing admiration for his work. The approximately 2,600 paintings, drawings, and works of sculpture that were fashioned by Charles Marion Russell stand as a lasting testimony to the artist and his singular thesis. A representative collection of the best of these are reproduced in this book. But pictures and bronzes were by no means the only fine things which came from the life of this paradox in chaps. As Will Rogers said, "He wasn't just 'Another Artist.' He wasn't 'just another' anything . . ."

HIS HEART SLEEPS[16]

No flowers deck his resting place
No marble marks the spot,
But nature loves her children—
His child is not forgot.

Oft times she rocks his cradle
Which hangs at river's brink,
Her waters hum his lullaby
Where great herds come to drink.

His God, the sun, rides guard for him
And throws his golden light,
The moon with all her children
Watches o'er him through the night.

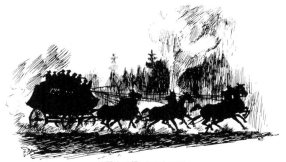

STAGE COACH

Notes

CHAPTER I

(1) Irvin S. Cobb,"An Appreciation of Great Writer's Tribute to Great Painter (Written for the *Democrat-News*)," Lewistown *Democrat-News*, December 16, 1934.

(2) Charles M. Russell, *Good Medicine* (New York: 1929), in the Introduction by Will Rogers, pp. 13–16.

CHAPTER II

(1) Joe De Young,"Charlie Russell's Boyhood Sketchbook Found," Great Falls *Tribune*, Sunday Supplement ("Montana Parade"), October 14 and October 21, 1956.

CHAPTER III

(1) Helena *Weekly Herald*, March 10, 1880.

(2) Al. J. Noyes, *In the Land of Chinook* (Helena: 1917), pp. 119–26.

(3) *Ibid*.

(4) *Ibid*., p. 51.

CHAPTER IV

(1) Ibid., pp. 119–26.

(2) From an account by Charlie Russell of his early experiences, in the Butte *Daily Intermountain*, Christmas issue, 1903.

(3) *Ibid*.

CHAPTER V

(1) An interview with Jacob (Jake) Hoover recorded by David Hilger, October 10, 1924 (MSS in the Library of the Historical Society of Montana at Helena).

(2) Dan R. Conway,"The Prospector – Jake Hoover, the 'Lucky Boy,' Who Discovered More Rich Mines Than Any Other Montana Man," Cascade *Courier*, 1926. (Library, Historical Society of Montana.)

(3) *Ibid*.

(4) Dan R. Conway,"A Child of the Frontier," Winnett *Times*, October, 1926.

(5) Merrill G. Burlingame, *The Montana Frontier* (Helena: 1942), pp. 276–78.

(6) *Ibid*., p. 235.

(7) *Ibid*., p. 231.

CHAPTER VI

(1) Letter reproduced in *Miles City Star*, May 24, 1934.

(2) In their book *Charles M. Russell— The Cowboy Artist* (Pasadena: 1948), Ramon F. Adams and Homer E. Britzman state that Russell left Jake Hoover and returned to St. Louis in March of 1881, after a stay of only eleven months (p. 49). However, the 1882 date is well attested to by Russell's own statements, as well as by Dan R. Conway in several newspaper articles written about the artist, and also by Mary Joan Boyer, *The Old Gravois Coal Diggings* (Festus, Missouri, privately printed: 1952), p. 15.

(3) According to the family research of Mary Joan Boyer as reported in her little book, *op. cit.*, p. 18.

(4) Butte (Montana) *Daily Intermountain*, Christmas edition, 1903.

CHAPTER VIII

(1) In the autobiographical sketch which Russell wrote for the Christmas edition of the Butte *Daily Intermountain* in 1903, he states that after being hired for his first job as night herder in 1882,"for eleven years I sung to their horses and cattle."

(2) "Cattle Raising in Montana," *The Northwest*, January 1884.

(3) The Vigilantes of 1884 (MSS in the Historical Society of Montana at Helena).

CHAPTER IX

(1) *The Northwest*, January, 1884, p. 7.

(2) *Ibid*.

(3) Forsyth *Democrat*, April 7, 1917.

(4) Maiden *Mineral Argus*, October 1, 1885.

CHAPTER X

(1) Fort Benton *River Press*, December 22, 1886.

(2) Records in Historical Society of Montana.

(3) "Special to the *River Press*.—Chicago, November 17," Fort Benton *River Press*, November 23, 1886.

(4) Noyes, *op. cit.*, p. 121.

CHAPTER XI

(1) Ramon F. Adams and Homer E. Britzman, *op. cit.*, p. 92.

(2) Noyes, *op. cit.*, p. 121.

(3) First published in *Outing Magazine*, December 1907, pp. 337–42; later in *More Rawhides* (Great Falls: 1925), pp. 51–57; and also in *Trails Plowed Under* (New York: 1927), pp. 133–44.

(4) The letter, dated September 29, 1902, and addressed to G. W. Kerr, St. Louis, reproduced by permission of M. Knoedler & Company, New York.

CHAPTER XIII

(1) The letter, dated May 13, 1919, is quoted in Charles M. Russell, *Good Medicine*, p. 33.

(2) From a letter written by Joe Scheuerle in 1916, quoted in *Good Medicine*, p. 127.

(3) The letter, dated May 8, 1925, is quoted in *Good Medicine*, p. 53.

(4) Charles M. Russell, "An Appreciation of Edgar S. Paxon," Jordan *Gazette*, November 24, 1919.

(5) Charles M. Russell, *Rawhide Rawlins Stories* (Great Falls: 1921), pp. 57–60. The story was later included in *Trails Plowed Under* (New York: 1927), pp. 107–10.

(6) From a letter to Ralph Budd, president of the Great Northern Railway Company, dated November 26, 1925, quoted in *Good Medicine*, p.37.

(7) Noyes, *op. cit.*, pp. 120–21.

CHAPTER XIV

(1) Printed in the Butte *Daily Intermountain*, Christmas edition, 1903.

(2) Noyes, *op. cit.*, p. 44.

(3) *Ibid*.

CHAPTER XV

(1) As told to Noyes, *op. cit.*, p. 125.

(2) Autobiographical sketch in the Butte *Daily Intermountain*, Christmas edition, 1903.

(3) Noyes, *op. cit.*, p. 123.

(4) *Ibid*., pp. 126–27.

(5) *Outing Magazine*, December 1904, p. 272.

CHAPTER XVI

(1) Havre *Advertiser*, February 7, 1895.
(2) Charles M. Russell, *Good Medicine*, in the Biographical Note by Nancy C. Russell, p. 17. Reprinted with permission of the Nancy C. Russell estate.

CHAPTER XVII

(1) According to information filed by the Registrar of Vital Statistics of the City of Los Angeles, California, upon the death of Mrs. Nancy C. Russell, June 10, 1940.
(2) "How Lindsay Turned Indian," *Outing Magazine*, December 1907, pp. 337–42.
(3) "Fashions," *More Rawhides* (Great Falls: 1925), p. 13; later printed in *Trails Plowed Under* (New York: 1927), p. 161.
(4) Reproduced in facsimile in Ramon F. Adams and Homer E. Britzman, *op. cit.*, p. 185.

CHAPTER XVIII

(1) Charles M. Russell, *Good Medicine*, in the Biographical Note by Nancy C. Russell, p. 23.
(2) Quoted in Ramon F. Adams and Homer E. Britzman, *op. cit.*, p. 144.
(3) Biographical sketch of Charles M. Russell on the occasion of his death, in the Great Falls *Tribune*, Tuesday morning, October 26, 1926.

CHAPTER XIX

(1) Charles M. Russell, *Good Medicine*, in the Biographical Note by Nancy C. Russell, pp. 23–24.
(2) *Ibid.*, p. 24.
(3) Ramon F. Adams and Homer E. Britzman, *op. cit.*, p. 166.

(4) *Ibid.*
(5) "Charlie Russell, Montana's Cowboy Artist," Butte *Evening News*, Christmas edition 1905, second section, p. 9.
(6) Quoted in *Good Medicine*, pp. 66–67.

CHAPTER XX

(1) The story was related to Byron E. Cooney by Doc Flynn in Butte and printed in the Benzien *News*, November 9, 1917.

CHAPTER XXI

(1) Sid Willis, of the famous Mint Saloon in Great Falls, related the details of this controversy to the present writer a number of years ago. According to Willis, it had practically been agreed, shortly before Remington's death, that the latter was to receive a commission to do the painting in the State Capitol.
(2) Great Falls *Tribune*, June 7, 1914.
(3) *Ibid.*, January 15, 1915.
(4) Hardin *Tribune*, July 15, 1918.
(5) Dan R. Conway, "A Child of the Frontier," Winnett *Times*, October 1926; Great Falls (Montana) *Tribune*, July 20, 1941; C. M. Russell Obituary in the Great Falls *Tribune*, October 26, 1926.
(6) Letter to James R. Hobbins of Butte, dated February 26, 1920, from Pasadena.

CHAPTER XXII

(1) *Rawhide Rawlins Stories*, with Illustrations by the Author.
(2) Helena *Record Herald*, November 21, 1921.
(3) *More Rawhides* (Great Falls: 1925), p. 3.

(4) In a letter dated March 10, 1920, quoted in Charles M. Russell, *Good Medicine*, p. 158.
(5) In a letter dated March 27, 1924, *Ibid.*, p. 88.
(6) In a letter dated October 13, 1912, *Ibid.*, p. 42.
(7) In a letter dated only 1921, *Ibid.*, p. 84.
(8) In a letter dated April 9, 1921, *Ibid.*, p. 105.
(9) In a letter dated only 1916, *Ibid.*, p. 100.
(10) In a letter dated April 14, 1920, *Ibid.*, p. 134.
(11) In a letter dated February 24, 1916, *Ibid.*, p. 64.
(12) *Ibid.*, p. 26. Reproduced with permission of the Nancy C. Russell estate.
(13) Reproduced by permission of the Trigg – C. M. Russell Foundation and the Nancy C. Russell estate.
(14) Reproduced by permission of the Trigg – C. M. Russell Foundation and the Nancy C. Russell estate.
(15) From Charles M. Russell *Good Medicine*, pp. 38–39, reprinted by permission of the Nancy C. Russell estate.
(16) Reproduced by permission of the Trigg – C. M. Russell Foundation and the Nancy C. Russell estate.

Index